# *Creative*
# Black & White
# Photography

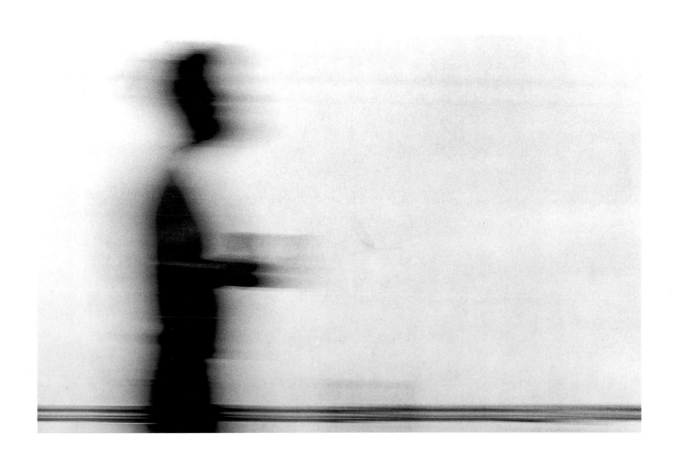

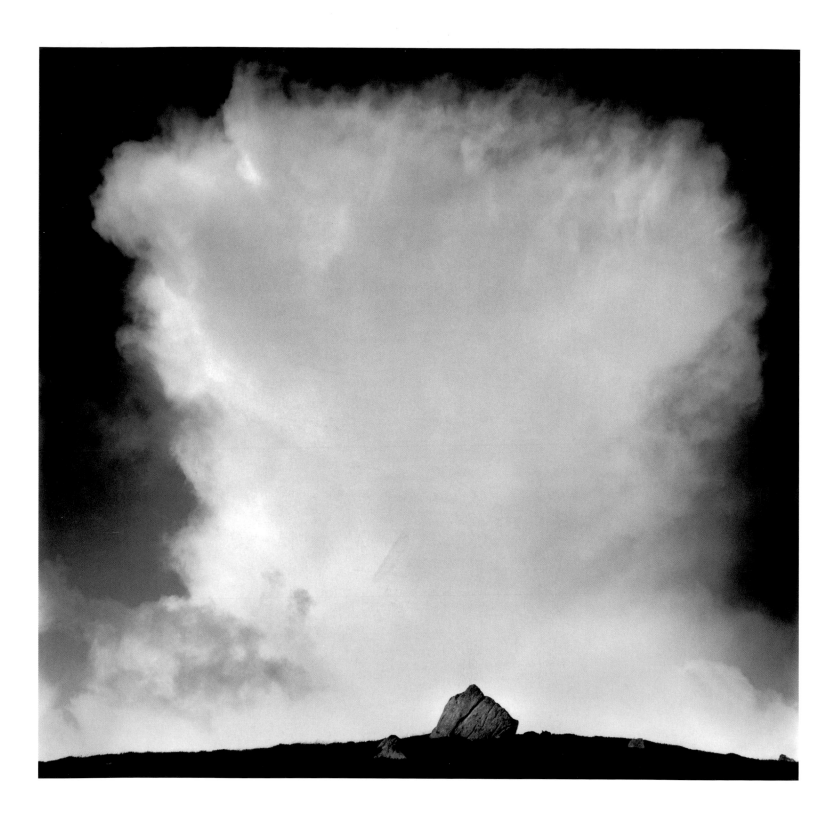

# Creative
# Black & White
# Photography

## Les McLean

David and Charles

**This book is dedicated to the memory of the late Fred James – a friend, photographer and my mentor.**

A DAVID & CHARLES BOOK
David & Charles is a subsidiary of F+W (UK) Ltd.,
an F+W Publications Inc. company

First published in the UK in 2002
First UK paperback edition 2005

A catalogue record for this book is available from
the British Library.

ISBN 0 7153 1280 4 (hardback)
ISBN 0 7153 1448 3 (paperback)

Printed in Singapore by KHL Printing Co Pte Ltd
for David & Charles
Brunel House, Newton Abbot, Devon

Visit our website at www.davidandcharles.co.uk

David & Charles books are available from all good
bookshops; alternatively you can contact our
Orderline on (0)1626 334555 or write to us at
FREEPOST EX2 110, David & Charles Direct, Newton
Abbot, TQ12 4ZZ (no stamp required UK mainland).

PAGES 2 AND 3
**Cloud, Durness**
*Situated in the far north of Scotland, Durness is an excellent isolated landscape location where winds, straight off the sea, bring continually changing cloud formations. This cloud was breaking up when I saw it and decided to make a photograph, so I had no time even to take a meter reading or use some filtration to dramatize the cloud – I did that by burning and dodging when I made the print. I shot the negative on a 6x6cm Mamiya C330 twin-lens reflex with an 80mm Sekor lens.*

ILFORD PAN F RATED AT 50 ISO, DEVELOPED IN AGFA RODINAL 1 TO 50 FOR 9 MINUTES AT 20°C; PRINT MADE ON GRADE 5 ILFORD WARMTONE VC FIBRE PAPER, DEVELOPED IN ETHOL LPD AND TONED IN SELENIUM.

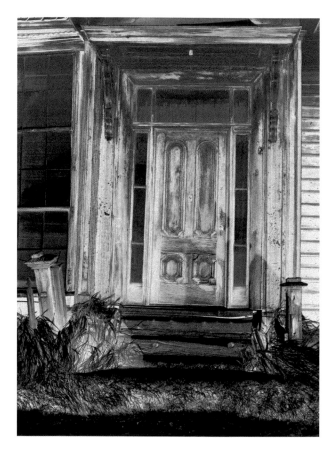

ABOVE AND OPPOSITE
**Door, Bodie**
*The light on the weather-worn door and steps attracted me to make this photograph in an old mining town in California. I shot the negative on a Mamiya 645 with a Sekor 80mm lens. I should have reduced development by 1 stop but did not; consequently, I had to manipulate the print significantly using techniques such as post-flashing, described in chapter 4.*

ILFORD DELTA 100, DEVELOPED IN ID 11 1 TO 1 FOR 9 MINUTES AT 20°C; PRINT MADE ON ILFORD WARMTONE VC FIBRE PAPER USING SPLIT-GRADE PRINTING, DEVELOPED IN FOTOSPEED WARM TONE AND TONED IN SELENIUM.

# Contents

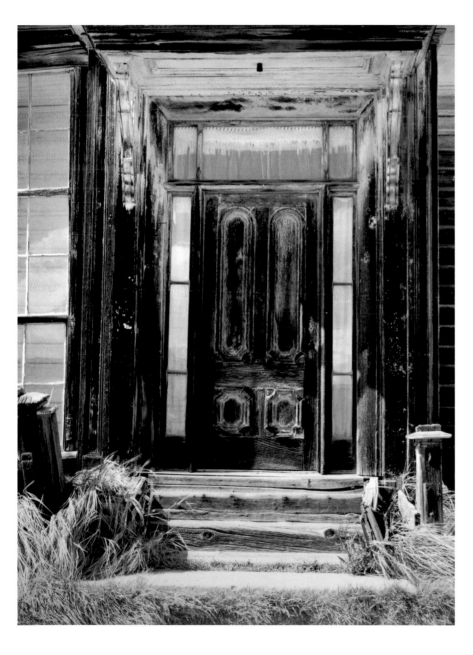

# Introduction

I FIRST BECAME AWARE of 'the arts' in the mid-1950s when, as a teenager, I started a skiffle group with some of my school friends. At the same time, I began to attend a painting class organized by miners in my home town of Ashington, Northumberland, and experienced the power of the way in which their images depicted work underground at the coal face. For five years I worked in the mines myself, but left to pursue a career in music with the rock and roll band that grew out of our early schoolboy skiffle group. Even in those days, I took every opportunity to visit galleries to see paintings by artists such as Rembrandt and Turner, and eventually, when I started making photographs, they influenced my vision. I remember standing in front of their paintings and marvelling at the way they saw and used light, and often see this in my mind's eye when I am making my own images.

Following a career switch to accountancy, I finally gave up music completely in the mid-1970s – just a few years after I discovered photography, which has been a major part of my life ever since. I made my first exposure with a camera loaned to me by a friend to take some holiday snaps in Cornwall. The same friend introduced me to black-and-white photography, when he insisted that I expose a roll of Ilford FP4 that he then developed and printed. When I saw the image appear on the paper, I was hooked – and I still experience the same thrill today as I stand and rock the tray and wait for the magical emergence of the image on the paper. The next step was to purchase a camera, and I was advised to spend £10 on a twin-lens reflex Minolta Autocord. This was quickly followed by the acquisition of a secondhand enlarger and a few developing trays, and my love affair with photography had begun.

Initially, I was happy to 'take' a photograph and see the result when I made the print in the spare bedroom – converted into a darkroom, albeit without running water. At the same time, I began to look at photographic books and exhibitions and discovered three American photographers – Ansel Adams, Edward Weston and Paul Caponigro – who were very influential in the development of my work. The English photographer John Blakemore also became a strong influence in both the aesthetic and technical aspects of photography. Through reading about and seeing these photographers' work, and being lucky enough to meet and talk to John Blakemore, I realized that a photograph was

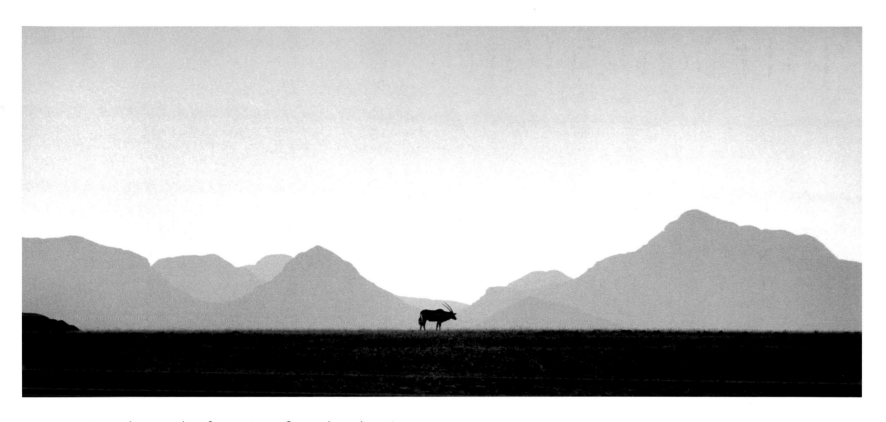

not just the result of a series of unrelated actions – exposing and developing a film, and then producing a mediocre image on a piece of photographic paper. I learned that photographs are made and not taken; I learned that the aforementioned unrelated actions of exposure, film development and print-making should, in fact, be joined up to move in a smooth and cohesive direction towards an expressive black-and-white print.

I was hungry for knowledge of the process of making fine black-and-white prints and spent many hours trying out – and sometimes inventing – methods and techniques to achieve this aim. In those days we did not have the luxury of variable-contrast (VC) papers and the benefits they offer, but I firmly believe that having to use

**Oryx, Damaraland, Namibia**

*When I saw the oryx grazing on the plain about 800m (¹/₂ mile) from where I was standing, I knew that this would be a satisfying image. Because the oryx is a nervous animal it is not easy to get close, so I resorted to crawling along the ground using rocks for cover, until I could frame the image as I wished with the 210mm Nikor lens on my F90X. Even though its markings are quite beautiful, I pre-visualized the oryx as the lowest value in the photograph. I based my exposure on the delicate recession in the distant mountains, which were placed on Zone VI, or overexposed by 1 stop from the reading indicated by the camera meter. In this instance I was pleased that there were no clouds to clutter the sky, as I saw the final print as a simple, almost graphic arrangement of shapes and tones and knew that the oryx would dominate the photograph because of my decision to print it as pure black. I felt that a very warm-tone print would suit this image.*

35MM ILFORD DELTA 400, DEVELOPED IN ID11 1 TO 1 FOR 9 MINUTES AT 20°C; PRINT MADE ON ILFORD WARMTONE VC FIBRE PAPER DEVELOPED IN FOTOSPEED WARM TONE AND TONED IN SELENIUM.

graded papers was responsible for my learning to use many techniques that some photographers consider redundant today, because of the flexibility of modern materials. I still use these techniques and they are described in this book, as I believe they give us even more control over the process. In the 1970s we did not have the wide range of darkroom equipment now available either, and although the photographer's vision is the most important and significant skill, complete and precise control of the printing process helps us to express our photographic and artistic intentions. The advance of digital electronic technology has provided us with the ability to be very precise when timing our print exposures, giving us even better control in the darkroom. I now work in increments of $^1/_{10}$ second – a far cry from 'counting elephants' to estimate seconds, as I was advised to do when I started making black-and-white prints.

The first time I read about visualization was in one of Ansel Adams' books. I was fortunate enough to appreciate the importance of honing the skills required to nurture this ability, and I made a conscious decision to develop them. I consider that decision to have been a very significant step forward in my progress as a serious photographer. My experience has been that as I have developed the ability and skill to pre-visualize the final image, and at the same time worked to improve my control of the technical aspects of photography, my personal vision has become clearer. There can be no doubt that having

full control over the technicalities of photography builds a confidence that is reflected in how you approach your subject, as well as in the seeing and presentation of the final image.

Having spent nearly 30 years seeing and making black-and-white photographs, I have written this book to share my insights, ideas, technical skills and methods, as well as some of my own favourite photographs. While I have attempted to indicate a logical path in the making of a fine black-and-white photograph, we all have personal views, likes and dislikes. The methods you are about to read about have proved to be successful for me, but may need modification to suit you.

Seeing and making black-and-white photographs is a very serious business, but it should also be a pleasure. I hope that you enjoy reading this book and that it helps you to improve both your vision and your ability to express it, while at the same time enabling you to have as much fun as I have had over the years in pursuing my passion for making black-and-white photographs.

OPPOSITE
**Detail, Roughting Linn**
*The level of the water in Roughting Linn, Northumberland, has significantly reduced since I first photographed there nearly 30 years ago. For the past 10 years it has virtually dried up in the summer months. This image was made in the winter of 1990, when the levels were just right to provide me with the triangular shapes of water flowing from the overhanging ledge.*

4x5IN ILFORD FP4 DEVELOPED IN AGFA RODINAL 1 TO 50 FOR 9 MINUTES AT 20°C; PRINT MADE ON ILFORD WARMTONE VC FIBRE PAPER USING SPLIT-GRADE PRINTING, DEVELOPED IN FOTOSPEED WARM TONE AND SPLIT-TONED IN SELENIUM AND GOLD.

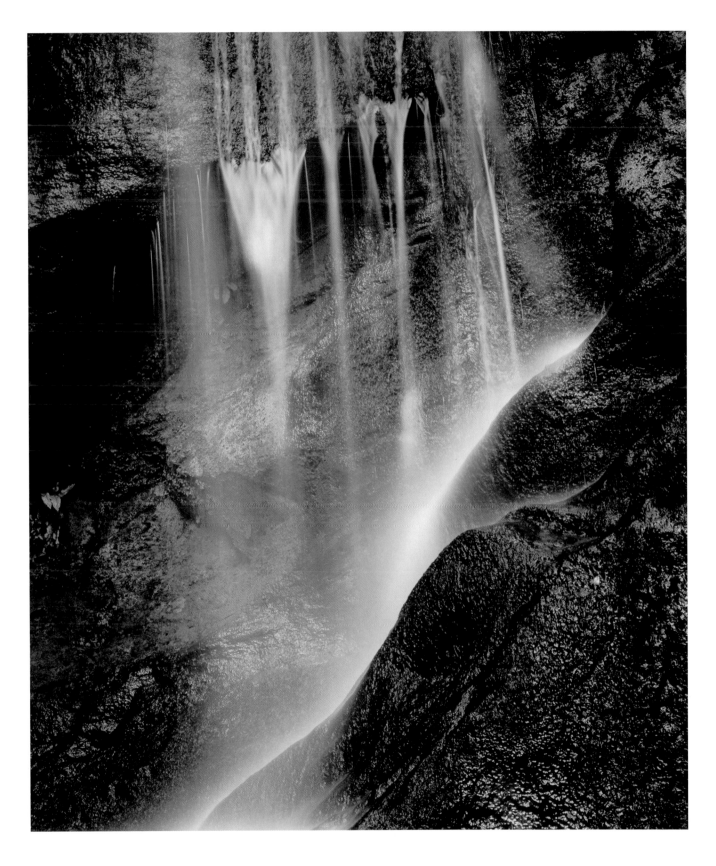

# 1 The Basic Film Test

Satisfying and successful black-and-white photographs are made using a combination of technical and mechanical tools, craft, science, and the personal vision of the photographer. The camera, lens and meter represent the technicalities, while film exposure and processing are the craft and science of photography. Personal vision is a mix of influences absorbed through seeing images made by other artists, and the photographer's own feelings and responses to his or her subject. If we are to achieve our personal vision, we must learn to see what the lens and film see. Only then will we understand and feel comfortable with the process, and begin to make the very important connection between seeing, exposing and processing the negative, and producing the final black-and-white print.

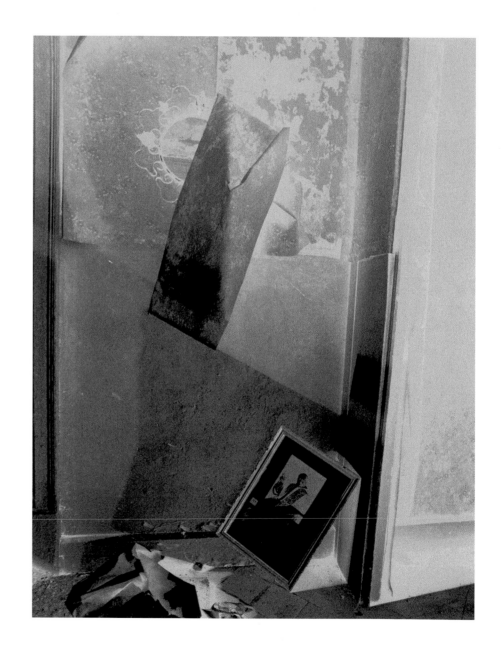

**Doorway, Ennistimon**
*I found a photograph of the Pope, c.1922, hanging on the wall in a derelict house in Ireland. I was amazed that it was still in the house, which had not been occupied for many years. I decided to place the picture in the entrance to make this image, because of the total lack of light inside, and after I had made the photograph I returned it to the wall where I had found it. I used my Mamiya 645 loaded with Agfa APX 100 and shot the image with my 35mm Sekor lens. I had never used the film before, and developed it as recommended in the instructions. But the negative was too high in contrast and it required considerable manipulation when making the print. The lesson to learn here is to test your film before using it on an important assignment.*

AGFA APX 100, DEVELOPED IN AGFA RODINAL 1 TO 25 FOR 8 MINUTES AT 20°C; PRINT MADE ON ORIENTAL SEAGULL GRADE 4 FIBRE PAPER, DEVELOPED IN ILFORD MULTIGRADE AND TONED IN SELENIUM.

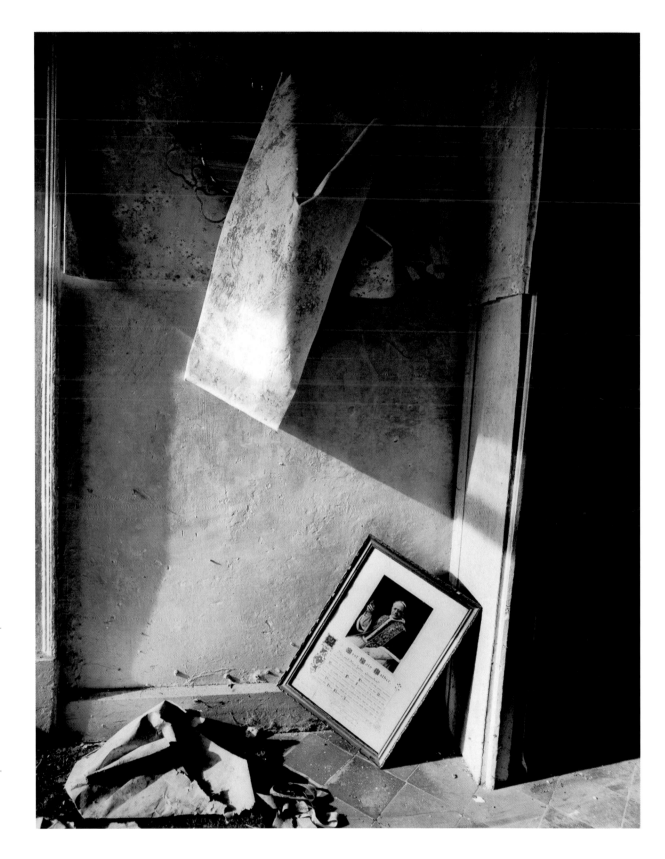

THE HUMAN EYE contains a wonderful lens of the highest optical standard, and sees any subject in a totally different way from the camera lens and film. It automatically deals with extremes of contrast, and most of the time can see into the deepest shadow as well as identifying detail in the brightest highlight. In addition, the eye renders sharp focus throughout and takes care of perspective, all without us having to think of apertures, automatic or manual focusing and focal length. We take all this for granted.

When we point a camera at the same subject, however, we have to begin to ask questions, both of ourselves and of the equipment and materials we are using. How will the lens see the subject? How do I record information on the negative in both the deepest shadow and the brightest highlight? Will I have to adjust exposure and development of the film in order to deal with the contrast range in the subject? How do I interpret the subject to ensure that I communicate the message I want to present through the photograph?

To answer these, and the many other questions that present themselves in the making of a black-and-white print, we need to learn how the film we are using will record the image we have seen – and how, in turn, the way in which we process the negative will affect the results we can achieve at the printing stage.

The negative is the starting point in the search for the fine black-and-white print, so it is logical that we should spend a little time

**Irv at the White House trailhead**

*I was photographing the small detail of this slick rock in Utah when I noticed Irv sit down for a rest and saw the possibility of an image that included my friend in the landscape we both loved. The rock curved up like a canopy with the lines all pointing towards Irv, so I used a 35mm Sekor lens on my Mamiya 645 to emphasize the sweeping lines of the rock face.*

120 Kodak TMAX 100, developed in HC110 1 to 31 for 8 minutes at 20°C; print made on grade 5 Ilford Warmtone VC fibre paper, developed in Ethol LPD.

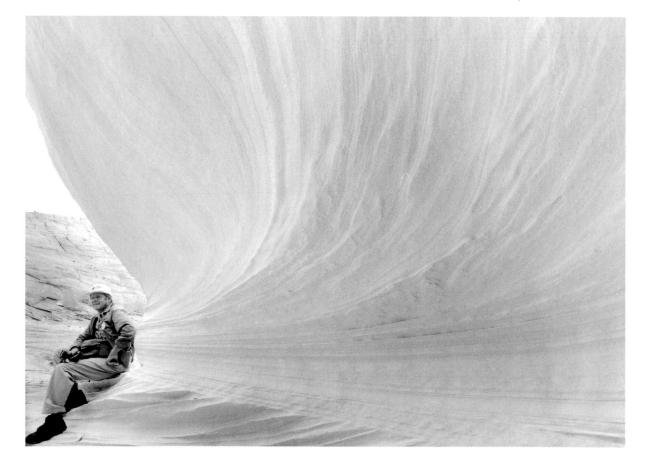

learning how to capture the best and most accurate information on the film to enable us to start with a solid foundation.

Most photographers have a favourite film/developer combination, but how many take the time to carry out their own test to determine personal film speed and development time? Although manufacturers do give accurate product information, they cannot possibly know the individual requirements of every photographer using their products: the film speed and development details they provide are just a starting point and you may find you need to make a minor adjustment to either film speed or development time to help you produce the best possible negative. I have always felt that the route to this information is to test every film stock I use.

Very few of us enjoy the mundane drudgery of testing, but when the end result gives us the control we need in order to realize our creative vision, that time is well spent. We can also be thankful that the tests need be done only once for each film used, although I have got into the habit of checking the results once a year just to cover the possibility of changes made by the manufacturer. The film-testing method I use is simple to execute and requires only the photographic tools that we all use almost every day – namely, camera, tripod, developing tank and materials – and a few hours of my time.

# Why Test?

'Expose for the shadows and develop for the highlights' is perhaps the most frequently used phrase in black-and-white photography. I heard it nearly 30 years ago

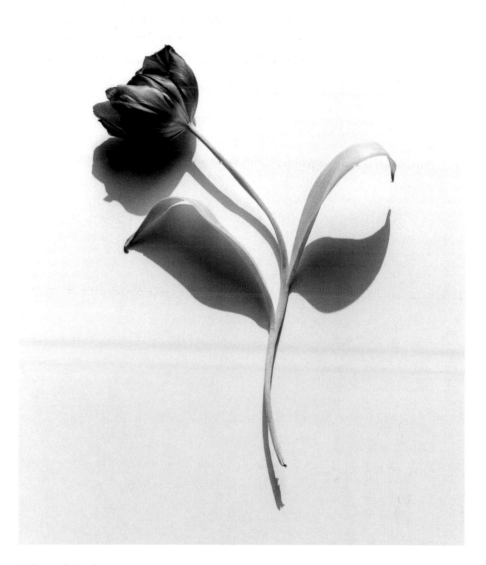

**Tulip and shadow**
*I enjoy making still-life photographs – I find it very relaxing, and it also helps me to experiment with composition and light. I like the elegance of the tulip and used very strong sunlight to light this image. To find the best arrangement, I twisted the flower just above the light-coloured surface to see how the shadows changed.*

120 Ilford Delta 100, developed in ID11 1 to 1 for 9 minutes at 20°C; print made in grade 3 Oriental Seagull fibre paper, developed in Fotospeed Warm Tone.

in the first camera club I joined: the advice was sound then, and remains good today. The first part is saying that unless you give enough exposure to the shadows in your

subject you will not record sufficient information to show detail in the print. The second part is saying that development has a significant effect on the highlights. If you point your meter at a subject and expose as indicated, and then develop the film at the time and dilution suggested by the developer manufacturer without considering the contrast range you are photographing, the resulting negative is likely to present you with a difficult challenge when you try to make the print. To allow the meter to decide the exposure without considering the contrast range of the subject is to allow the tools and materials of photography to control you. Learning about how the film and lens see and respond to light, and then processing to your requirements, will put you in control.

It takes less than three hours to test a film. Most photographers use three or perhaps four different films, which adds up to a maximum of 12 hours spent testing. The time and materials you save in the darkroom as a result of producing the best negative possible will justify the time you spend on the tests. The most significant benefit of carrying out your own film speed and development tests is that you will know you can photograph in the most difficult lighting conditions without having to worry about exposure and development. This knowledge allows you the freedom to concentrate on the creative side of your photography, and to improve your personal vision.

I have made the point that camera, lens and film do not see in the same way as the human eye. Because the camera and lens of your choice have fixed characteristics and cannot change, you have to learn to adapt your seeing to recognize how they see and record what you choose to photograph. In effect, you are a team: the camera and lens cannot identify a meaningful and successful image, but you cannot make the photograph without the camera and lens. Film can be manipulated and controlled to produce the expressive negative that provides the means for the photographer to communicate the reason for making an image. These tests are designed to enable you to do just that.

# Setting up the Test

To carry out this test you will need a camera, a tripod, your chosen film (two rolls if you are using 120 roll film or one roll of 35mm), a developing tank and chemicals of your choice. Remember that the test is designed to help you determine the exposure and development of your film in any lighting conditions you are likely to encounter, so your subject needs to include items that provide a full range of tones from deep black to the brightest white on the exposed film. A black or white material, such as silk or plain card mount board, provides an excellent background for normal household items such glass ornaments, pottery jugs, vases, and stainless steel knives and forks. I also find that odd bits of wood collected on my photographic travels, flowers – both fresh and long since dried up – and even lumps of rusty, twisted metal make excellent material for film tests. I then set up the still life in front of a window where it can be left should I need to test different film stock within the following day or two.

OPPOSITE
**Chess hustler, New York**
*I was wandering around a park in the city one day and was approached by this man, who asked me to play a game of chess for money. I refused, but told him I would like to photograph him. He agreed, and carried on trying to persuade other people to play the game and lose their money. I used a 210mm lens on my Nikon F90X to allow for tight framing. The image was made late in the afternoon when the light levels were low, so I used 35mm Ilford Delta 3200 rated 6400 ISO, developed in Ilford DDX 1 to 4 for 11 minutes at 20°C to give me a little more speed. The print was made on Oriental Seagull VC fibre paper, with grade 4 filtration dialled into the contrast control on the enlarger so as to enhance the grain further. The combination of grain and a darker-than-normal print helps to emphasize the slightly seedy appearance of the subject.*

# Exposure

Before I describe how to take the meter readings, let me explain how exposure meters see photographic subjects. All meters are calibrated to a Kodak 18 per cent grey card, or Zone V in Zone System terms. (There are a few photographers who will dispute this statement. That's fine with me, and I let them get on with trying to prove Kodak wrong and just carry on with the important things in my life.) Every time a reading is made, the meter sees the subject as mid-grey and indicates an exposure accordingly. For example, if you meter white, grey and black material and expose as indicated, you will produce three identical negatives that, when printed, will produce three mid-grey prints. To render the material as white in a print, you need to expose by 2 stops more than indicated by the meter; to render it black, expose by 2 stops less than indicated; to produce mid-grey, expose as indicated by the meter. These placements are guides based on the Zone System and are used here to illustrate the need to adjust meter readings so as to

achieve the correct exposure. In chapter 3 I will explain in greater detail how and why you should make exposure adjustments. However, at this stage it is just important to understand that the meter always sees in mid-grey tones, and that it is essential to adjust the exposure to enable you to produce the expressive negative.

## Metering the Subject

Load the camera with your choice of film and place it on a tripod. For the tests shown on the following pages, I used Ilford HP5 Plus rated 400 ISO. Set the camera meter or the hand-held meter to the manufacturer's suggested film speed. Be sure to use your regular meter for these tests. This is not as obvious a statement as it might appear: for example, if (like me) you use two formats and meter through-the-lens (TTL) with 35mm and with a hand-held spot meter for medium format, you must use the same metering system every time you use that camera.

In the sequence of exposures I am about to describe, it is preferable to use a constant aperture and change the shutter speed. Select the deepest shadow in the subject and read the reflected-light value, making sure that no other area or tone in the image being photographed influences the reading. Make a note of the indicated exposure. Expose in the following sequence:

| | |
|---|---|
| **Frame 1:** | 2 stops less than indicated by the meter |
| **Frame 2:** | 1 stop less than indicated by the meter |
| **Frame 3:** | As indicated by the meter |
| **Frame 4:** | 1 stop more than indicated by the meter |
| **Frame 5:** | 2 stops more than indicated by the meter |

You will need three sets of these exposures for the test. If you are using 6x6cm format with 12 on 120, or 645 with 15 on 120, you should make one set at the beginning and one at the end of the roll of film, leaving an unexposed area in the middle to allow the film to be cut in half for development without cutting through the exposed frames. Consequently, you will need to use two rolls of film to complete the test. If you are using 6x7cm or 6x9cm formats, you will need to expose three rolls of 120 roll film. For 35mm, one 36 exposure roll of film will be sufficient.

The following table shows the exposure sequence used to make the negatives. This is only a guide and you should carry out your own test using your normal equipment.

| Frame no | Shutter speed (seconds) | Aperture | Stops +/– |
|---|---|---|---|
| 1 | $^1/_{60}$ | f/22 | − 2 |
| 2 | $^1/_{30}$ | f/22 | − 1 |
| 3 | $^1/_{15}$ | f22 | Metered exposure |
| 4 | $^1/_8$ | f/22 | +1 |
| 5 | $^1/_4$ | f/22 | +2 |

Because 35mm TTL metering can be used in different modes, the procedure is slightly different. I use a Nikon F90X with the metering set on matrix, which I prefer to centre spot because it takes readings from a number of different areas across the frame. The centre-spot metering used by 35mm cameras covers a larger area – usually 5 degrees or more – that I find less accurate than a 1-degree dedicated spot meter. Modern 35mm cameras offer the option of different metering modes, but an older manual camera is

likely to be limited to centre spot. My suggestion would be to do as I do with my hand-held spot meter and carefully meter the shadow, ensuring that no other area influences the reading. Where there are a number of options available, taking a meter reading is a matter of personal judgment and preference – but again, I stress the importance of being consistent.

Set the film speed indicator on the camera to the film manufacturer's suggested speed, place the camera on the tripod, and then meter the whole of the still-life subject to be photographed. Take a reflected-light reading using your preferred metering method – either centre spot or matrix – make a note of the indicated exposure and then follow the sequence given on page 16. When you have exposed the whole roll of 35mm film, you will have seven sets of the same five exposures. The first part of the test is now complete and it is time to adjourn to the darkroom so as to process the exposed film.

# Developing the Film

In the darkroom, if you are using 6x6cm or 645 cut each of the two rolls of 120 film into two equal lengths. For 35mm cut the film into three equal lengths, and for 6x7cm or 6x9cm process the whole film without cutting. If you are using 35mm, do not worry about cutting through a negative: if you have exposed the film in the sequence described, you will have three complete sets of five negatives with which to carry out the tests. Load one length into your developing tank and place the other lengths in a safe light-tight container. The black plastic bags in which photographic paper is stored are ideal.

Process the first length of film for the time and at the dilution recommended by the manufacturer of your preferred developer, then hang it in a dust-free environment to dry. I prefer to use a one-shot developer for all film processing to ensure consistency. Remember to mark the negatives in some way so that you can identify them when they are dry. I stick a piece of masking tape marked 'normal', 'plus' or 'minus' onto the clip holding the negatives in the drying cupboard.

Load the second length of film using the same brand of fresh one-shot developer and process for 20 per cent less than the recommended time. Then process the third length of film, again in fresh developer, but for 20 per cent more than the recommended time.

**To calculate −1 stop development:**
Normal development time = 10 minutes
1 stop development time = 20 per cent of
    normal time = 2 minutes
Correct development time for − 1 stop = 10
    minutes − 2 minutes = 8 minutes

---

**To calculate −2 stops development:**
Normal development time = 10 minutes
1 stop development time = 20 per cent of 10
    minutes = 2 minutes
10 minutes − 2 minutes = 8 minutes
2 stops development time = 20 per cent of 8
    minutes = 1 minute 35 seconds
Correct development time for − 2 stops = 10
    minutes − 3 minutes 35 seconds = 6
    minutes 25 seconds

---

Work out the adjustment for each stop and deduct separately.

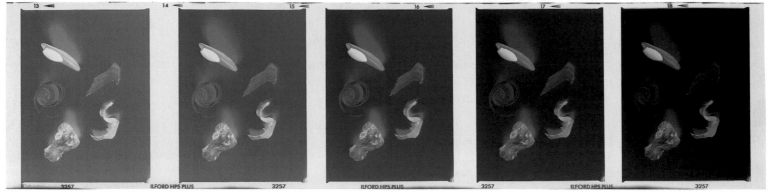

**−1 stop development**

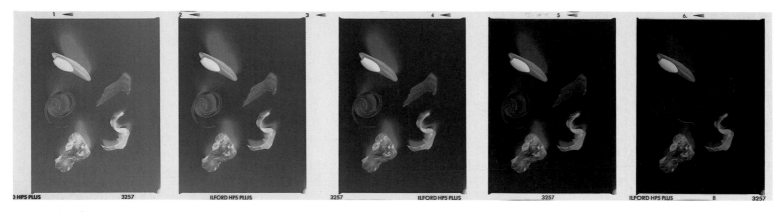

**normal development**

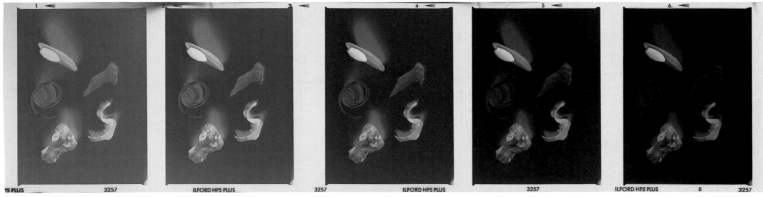

**+1 stop development**

| Frame 1 | Frame 2 | Frame 3 | Frame 4 | Frame 5 |
|---|---|---|---|---|
| *− 2 stops exposure* | *− 1 stop exposure* | *meter exposure* | *+1 stop exposure* | *+2 stops exposure* |

**Film exposure and development test**

120 Ilford HP5 Plus rated 400 ISO, developed in ID11
1 to 1 for 13 minutes at 20°C.

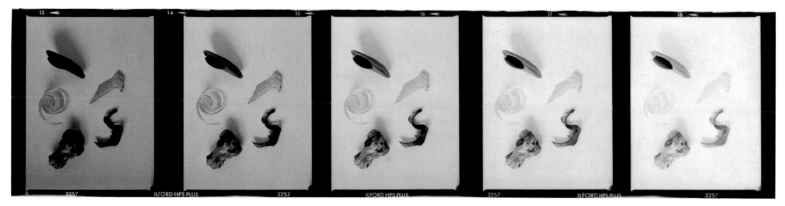

**−1 stop development**

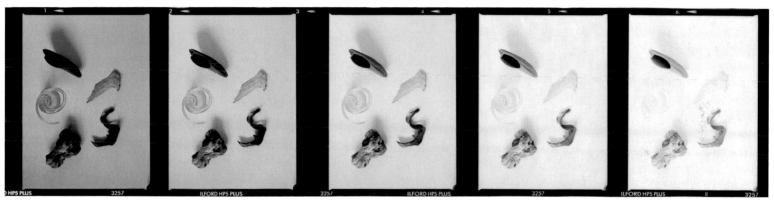

**normal development**

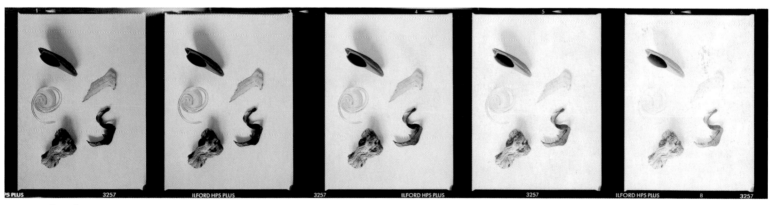

**+1 stop development**

|  |  |  |  |  |
|---|---|---|---|---|
| *Frame 1* | *Frame 2* | *Frame 3* | *Frame 4* | *Frame 5* |
| *− 2 stops exposure* | *− 1 stop exposure* | *meter exposure* | *+1 stop exposure* | *+2 stops exposure* |

**Film exposure and development test contact sheet**

120 Ilford HP5 Plus rated 400 ISO, printed on grade
1 paper.

Plus development is calculated in the same way as minus development, except that the adjustments are added instead of subtracted. The percentage I use to calculate a 1 stop increase or decrease in development is a personal choice that I made a number of years ago after carrying out tests on a range of options. I tested a range from 15 to 30 per cent in 5 per cent increments, and decided that 20 per cent gave me the result that suited my requirements.

Under- or overdeveloped film is quite easy to identify: underdeveloped negatives are thin and lacking in contrast while overdeveloped negatives appear very dense, although exposure also affects contrast and density. If you feel that the development needs to be adjusted, I suggest that as a starting point you increase or reduce the recommended time by 10 per cent.

# Assessing the Test

When the negatives are dry, cut them into strips of five in the same sequence in which they were exposed and place them in an appropriate negative bag. For ease of handling and inspection, you can use a transparent sleeve. Place the negatives in the sleeve with the minus strip first, the normal strip second and the plus strip third, to allow you to make the comparisons required when assessing the test. Remember to mark the sleeve clearly with the development details, although the negatives can be identified easily from their relative densities. Before you begin to examine the negatives make a contact print, preferably on a grade 2 or softer paper. Do not attempt to produce a high-contrast contact print: the object is to see what is on the film, so it is better to use a softer grade. The contrast of the final print can be manipulated and controlled once you have determined the correct exposure and development for your chosen film.

You are now ready to assess the test. The best way to do this is to view the negatives on a lightbox using a loupe, and at the same time inspect the contact print to see how exposure and development affect the film. If you do not have access to a lightbox, hold the sleeve up to a bright light or window light. The first overall inspection will show that the negatives become increasingly dense when viewed from top to bottom. This is the result of exposure. When viewed from left to right the negatives again show an increase in density. This is the result of development. Even though you have not yet made a close examination of individual negatives, you can see from this general inspection how exposure and development affect the film.

# Normal Development

Now examine individual negatives in the strip given normal development. Use a loupe and look at the detail in the darkest shadow in each of the five negatives in the strip. Negative nos 5 and 4, given 2 stops and 1 stop more exposure than the meter indicated, are likely to be too dense to use. Negative no. 3, given the exposure indicated by the meter, will be less dense but may still not be the best overall exposure. Negative nos 2 and 1, given 1 and 2 stops less than the meter indicated, do show shadow detail, and either

one of them could be used to determine your own personal film speed.

At this point, the choice becomes a matter of personal requirement and judgment. I prefer to see good detail in my shadows and therefore I have chosen negative no. 2 as my preferred exposure. For those familiar with the Zone System, this represents a Zone VI shadow placement that is one zone higher than that suggested by Ansel Adams. I am not implying that Adams was wrong in his assessment: it's just that I prefer slightly more information in the shadows. In future, when using HP5 Plus I will set the ISO setting to 400, meter the shadow, and reduce exposure by 1 stop from the indicated reading. If you prefer negative no. 1, you would meter the shadow and reduce the exposure by 2 stops whenever you use your chosen film in future. You may even prefer the exposure indicated by the camera meter.

The whole point of testing the film is to arrive at the type of negative *you* prefer. The exposure, development time and dilution that will provide the negative which in turn produces the contrast and tonality in the final print that you want must be correct for *you*. We all have slightly different requirements relating to tonality and contrast in the final print, so it is logical that our negatives should reflect that. A higher-contrast negative printed on a softer grade of paper will produce a different print to a lower-contrast negative printed on a harder grade of paper. Neither is wrong, but we must plan for these subtle differences if we are to be consistent in our photography. The negative lays the foundation upon which the fine black-and-white print is built. It is therefore worth spending some time working out a consistent method of exposure and development that is personal to you and gives a solid, dependable and repeatable starting point.

You have now arrived at your normal development time and the developer dilution you will use when the subject contrast is normal. However, because the range of contrast differs from subject to subject and day to day, you need to learn how to adjust film exposure and development to enable you to deal with the changes. The correct exposure, and development according to the contrast range in the subject, will give you absolute control over virtually any conditions you are likely to encounter in your black-and-white photography. Let us look at how they work together.

**Pilot print**
*Final print from my chosen test negative (no. 2 in the normal development sequence), given 1 stop less exposure than indicated by the meter.*

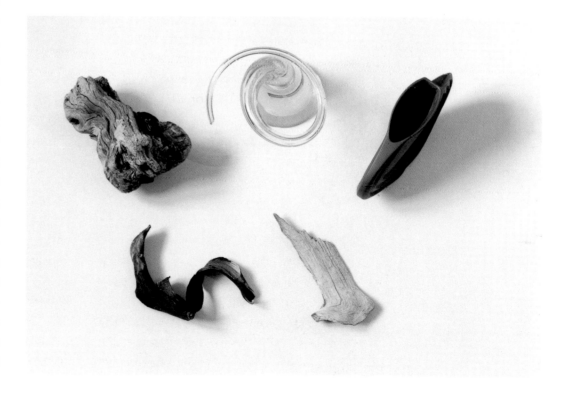

# Minus Development

Examine the strip of negatives given – 1 stop development and you will see that the highlights, or dense areas, are not as dark as the same areas on the negatives that were given normal development. However, the shadows, or light areas, are similar to the corresponding negatives on the normal development strip. In other words, development controls the highlights while exposure records shadow detail. Changes in development will move shadow density slightly and highlight density significantly. Compare negative no. 2 minus development and normal development on the contact print and you will see that the shadows are very similar but the highlights are noticeably darker. However, a 1 stop increase or reduction in exposure will move both shadows and highlights by the same amount. Examine the three strips of negatives and you will see that shadow density is similar when corresponding negative numbers are compared. For example, compare negative no. 4 in each of the three strips and you will see little difference in the shadow density, even though each strip has received different development.

When the contrast range of your subject is more than 5 stops, you generally need to adjust both exposure and development to deal with it satisfactorily. In those circumstances, I give 1 stop more exposure and reduce the development time by 1 stop. Compare negative no. 2 in the normal development strip with negative no. 3 in the minus development strip, and you will see that the densities and contrast are similar.

The object of adjusting exposure and development is to attempt to standardize the contrast of your negatives regardless of the subject's contrast range. Clearly, this is impossible, but by employing the methods and techniques explained here you will learn to control the contrast and achieve consistent results.

Depending on the contrast range of your subject, you can adjust the development by 2 stops, although I would still only increase the exposure by 1 stop, as discussed above. Further reduction in the development should be carried out with care, because you can run into problems such as uneven development if the time is too short. My suggestion would be to carry out a test before trying the technique on an important subject.

On the subject of film development, I would not recommend a time of less than 5 minutes, otherwise you will run the risk of noticeably uneven development. A second and very important consideration is that if your normal development time is 5 minutes or less you leave little room for any minus development adjustment. I generally try to aim for a normal development time of around 9 minutes, which allows enough latitude to reduce development by up to 2 stops and still not have a time of less than 5 minutes.

## Wrecked Hut, Dakota

I saw this old hut from the car and found it interesting, so I pulled over and went in to have a look. The two stuffed figures I found inside looked quite incongruous and, in an odd way, almost real and from another time.

I carry four interchangeable backs for my Mamiya 645 when I am on my photographic travels: one each for normal, minus and plus

development, and the fourth usually loaded with colour transparency. The image of the old hut was made at midday in very bright sunlight, so I loaded the minus and normal development backs with HP5 Plus and framed the photograph.

I used my normal method of taking a reading with my Soligor 1-degree spot meter and metered the deepest shadow followed by the brightest highlight, to determine a contrast range of 8 stops. This reading told me two things: first, the exposure I would give, remembering that in the film test and in normal contrast I meter the darkest shadow and reduce the exposure by 1 stop; and second, how to develop the film.

Because the contrast range was 8 stops, I needed to reduce the development. In the circumstances, I decided to reduce it by 2 stops and marked my exposure record accordingly. Then, because I had decided to reduce development I needed to adjust the exposure to allow for this, and I therefore increased the exposure by 1 stop.

This may sound a little complex, but if you refer to the table, right, it will help you to establish the procedure in your mind. I made a second exposure on the film in the normal

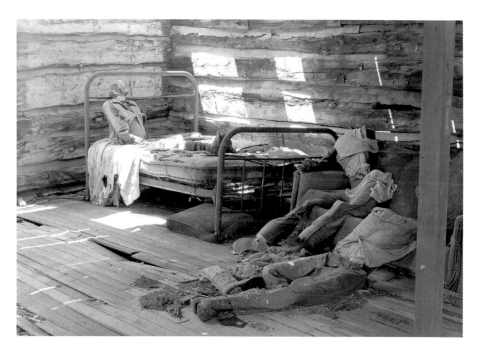

**Wrecked hut, Dakota**

120 ILFORD HP5 PLUS NEGATIVE RATED 400 ISO, EXPOSED +1 STOP AND DEVELOPED − 2 STOPS IN ID11 1 TO 1 FOR 8¼ MINUTES AT 20°C; PRINT MADE ON GRADE 3 ILFORD WARMTONE VC FIBRE PAPER DEVELOPED IN ILFORD MULTIGRADE.

| Condition | Definition | Exposure | Development |
|---|---|---|---|
| Low contrast | Below 3 stops | Underexpose – 1 stop less than used for normal contrast | Increase |
| Normal contrast | 3 to 5 stops | As per test – 1 stop less than indicated by meter | Normal – as per test |
| High contrast | Above 5 stops | Overexpose – 1 stop more than used for normal contrast | Decrease |

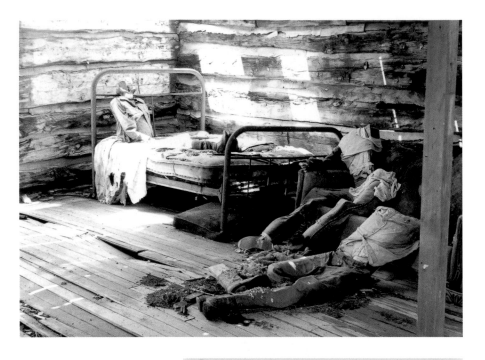

## Wrecked hut, Dakota

120 Ilford HP5 Plus negative rated 400 ISO, exposed normally and developed in ID11 1 to 1 for 13 minutes at 20°C; Print made on grade 3 Ilford Warmtone VC fibre paper, developed in Ilford Multigrade.

### THE PRINTS

The illustrations on this and the previous page show how the exposure and development of the negative affect the print. In order to be consistent, both prints were made on grade 3 paper and given no manipulation, with an exposure based on just holding some tone in the bright highlight in the light hitting the wall behind the bed. You can see that the detail throughout the print made using the negative given minus development is considerably better than in the print made from the negative that was given normal development.

However, the grade 3 print does not portray the mood I experienced when I made the exposure. To rectify that, I made the final print from the negative given minus development but using grade 4 paper, and balanced the image by burning in the left-hand side for 50 per cent of the original exposure. The 2 stop reduction in film development produced the negative that allowed me to use a higher paper grade, to achieve the atmosphere I had visualized.

development back to illustrate the differences between the ways in which exposure and development work.

Remember: the exposure details in this example are based on my preference, which is to meter the shadow and reduce exposure by only 1 stop. In Zone System terms, this represents a shadow placement of Zone VI. Many photographers prefer to place shadows on Zone III, which means that they reduce the metered exposure by 2 stops.

# Plus Development

When the contrast range of your subject is 3 stops or less, you can increase it by extending film development. The same principles apply as in minus development but they are reversed: you underexpose by 1 stop and increase development by 1 stop.

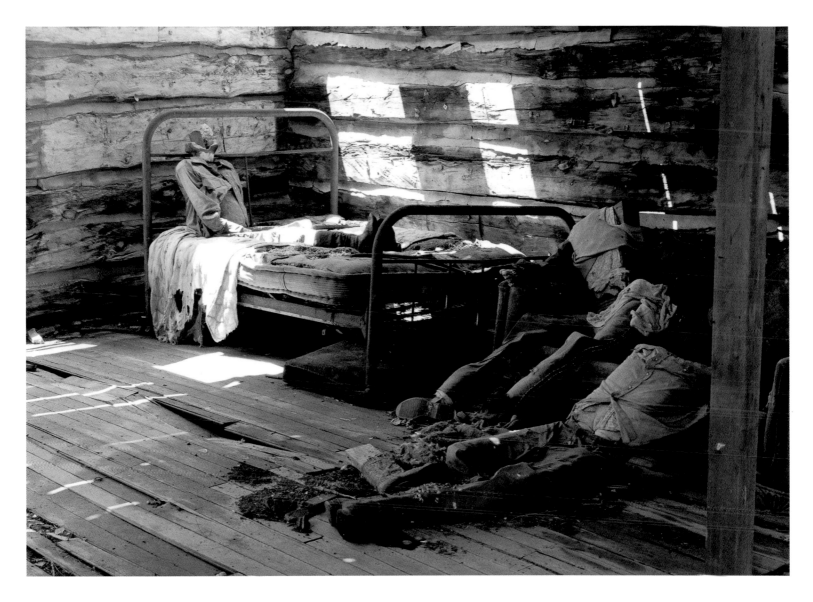

Compare negative no. 2 in the plus development strip with negative no. 3 in the normal strip. If you also add negative no. 3 in the minus development strip to the comparison, you will see that all three negatives are very similar in contrast and density, even though all have received different exposure and development. You can also push development further, but do so with care as increased development can produce more grain.

**Wrecked hut, Dakota**
*Final print.*

120 Ilford HP5 Plus negative rated 400 ISO, exposed +1 stop and developed −2 stops in ID11 1 to 1 for 8¹/₄ minutes at 20°C; print made on grade 4 Ilford Warmtone VC fibre paper, developed in Ilford Multigrade.

## Navajo Power Station

I had photographed the Navajo power station near Page in Arizona a number of times without capturing the impression of the pollution that it produces. A few years back, I happened to be in the area on a particularly dull day and decided to try a different approach from my previous attempts. I felt that the very grainy quality of 35mm Ilford Delta 3200, processed in Agfa Rodinal, would give me the gritty impression I believed the subject warranted. I also felt that a tight crop would further enhance the atmosphere I sought. I underexposed the negative by 1 stop and extended development by 30 per cent, or 1¹/₂ stops, to increase the contrast as described above. From the same viewpoint, I made a second exposure on Ilford FP4 Plus, using a Sekor 80mm lens on a 645 format. This film was given normal exposure and development.

### THE PRINTS

The 35mm negative was printed using grade 5 paper and burned in quite heavily at the bottom as well as the top one-third in the sky to enhance further the drama and grittiness. The print from the medium-format negative was made on grade 4 paper and burned in at each edge of the sky to balance the final image; it is a truer reflection of the day, but fails to convey my feelings and impressions of how the emissions pollute the area.

**Navajo power station, Arizona**

35MM ILFORD DELTA 3200 NEGATIVE RATED 3200 ISO, EXPOSED −1 STOP AND DEVELOPED +1¹/₂ STOPS IN AGFA RODINAL 1 TO 9 FOR 12 MINUTES AT 24°C; PRINT MADE ON GRADE 5 ILFORD WARMTONE VC FIBRE PAPER, DEVELOPED IN FOTOSPEED WARMTONE, FROM 35MM ILFORD DELTA 3200 NEGATIVE.

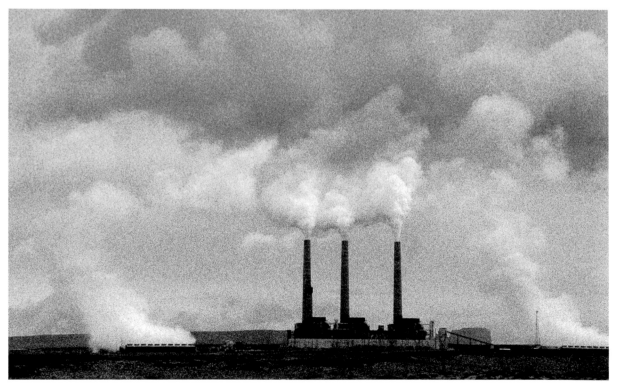

# The Pursuit of Excellence

The tests I have just described form the basis of all the decisions you will make in the quest to produce fine black-and-white prints. We will be looking at the practical use of negative manipulation in chapter 3, but at this point I suggest you go out and expose some film to practise the techniques and methods you have started to learn. After a little practice your vision will improve, because you will be confident in dealing with the technical aspects of your photography.

We have all experienced that stomach-churning feeling when we know we have just made an unforgettable photograph but are uncertain about the exposure we gave and know we cannot repeat it. We have all been bitterly disappointed when, after processing a film, we realize that we gave it too little development and have then struggled to make a less than satisfactory print from the negative. A little time spent testing film will eliminate those worries from your photography.

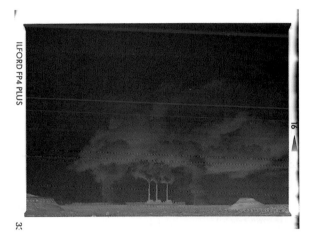

**Navajo power station, Arizona**

120 Ilford FP4 Plus negative rated 100 ISO, exposed normally and developed in ID11 1 to 1 for 8 minutes at 20°C; Print made on grade 4 Ilford Warmtone VC fibre paper, from 120 Ilford FP4 Plus negative, developed in Fotospeed Warm Tone.

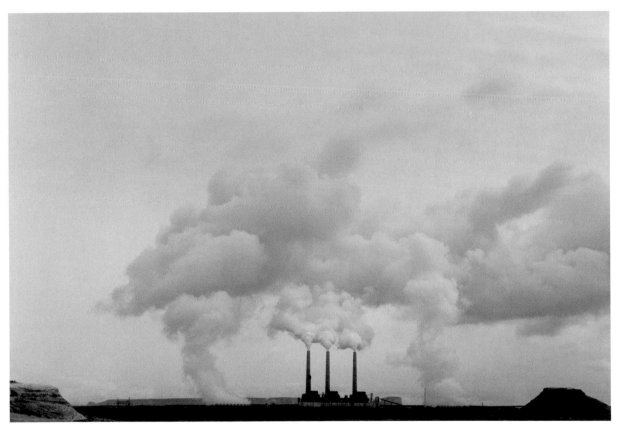

# 2 Pre-Visualization

Having carried out the tests described in the previous chapter to determine personal film speed and development details, you can now be confident of producing good, consistent negatives. The degree of control you now have over exposure and film processing will allow you to concentrate on seeing the images that you want to produce instead of worrying about technical matters. I have always felt the need to 'see' the final print in my mind before I actually make the exposure. How can we know where to start if we don't know what we want in the final print? Would you set off on a journey in a car to a place you had never been to before without first investigating how to get there? Of course, driving a car to a place shown on a map is different from using your imagination to 'see' what the final print will look like before you even expose the negative, but I am sure you can understand the analogy.

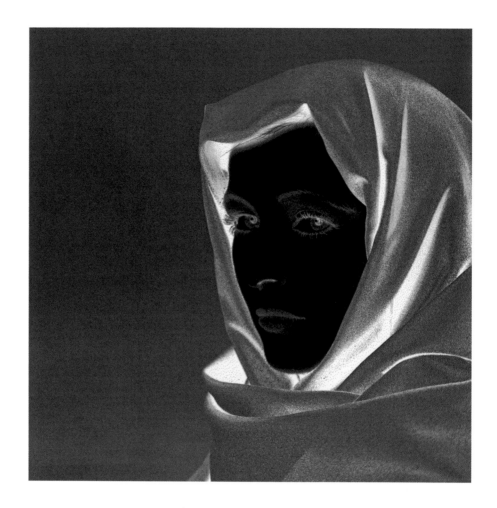

ABOVE AND OPPOSITE
**Fiona**
*I shot this negative on a 6x6cm Mamiya C330 twin-lens reflex with an 80mm Sekor lens. The image represents one of the few times in my photography when I have used studio lighting. I visualized the skin tone as a delicate, almost porcelain white to contrast with the black silk used as a wrap around the model's head. I set up two soft boxes to produce shadow-free light.*

KODAK TRI-X DEVELOPED IN HC110 1 TO 31 FOR 6 MINUTES AT 20°C; PRINT MADE ON ILFORD WARMTONE VC FIBRE PAPER USING SPLIT-GRADE PRINTING, DEVELOPED IN ILFORD MULTIGRADE AND TONED IN SELENIUM.

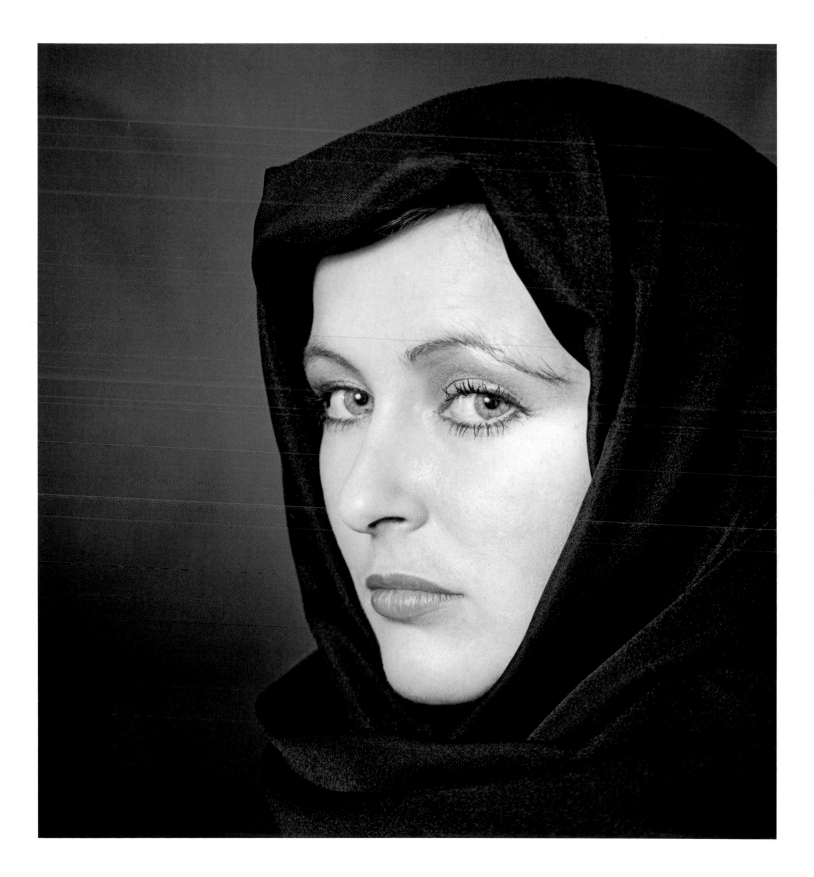

**Sand and feather**

*This is one of a series of photographs I made on beaches while exploring minimalism, after being influenced by the American artist Mark Rothko.*

120 Ilford Pan F rated 50 ISO, developed in Agfa Rodinal 1 to 50 for 8 minutes at 20°C; print made on Ilford Warmtone VC fibre paper using split-grade printing, developed in Ilford Multigrade.

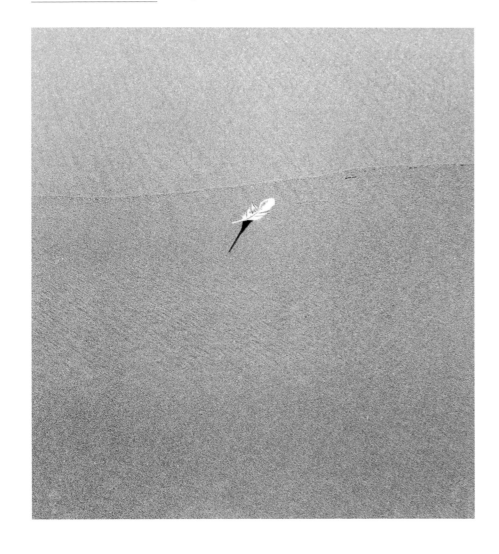

LOOKING at other photographers' work is a practical way to learn about finding effective ways to express yourself in your own prints. I am not suggesting that you set out to copy specific images, I am simply encouraging you to look at and be influenced by photographers who regularly make exciting and original photographs. By spending some time analysing prints made by the likes of Ansel Adams, Paul Caponigro, John Sexton, Don McCullin or John Blakemore you will learn a lot about seeing the subject, using light, and making the most of printing skills to express yourself. Influences are not confined to the

great photographers, of course, and you should always look at any form of visual image with an open mind: image-makers as diverse as first-year photography students on the one hand and Mark Rothko, my favourite artist, on the other have influenced my seeing and the way in which I pre-visualize my photographs.

# Contrast and Tonal Depth

Seeing the final print in your mind is not the difficult exercise you may imagine. You have made a very positive step in that direction when you determine your personal film speed and development times. Being certain of these details at the time of seeing the subject gives you control over the two strongest technical elements at this stage of the photographic process – namely, contrast and the tonal depth of the final print.

Manipulation of these two elements is the major control left at your disposal at the printing stage. Certainly, type of paper, with bleaching, toning and various other manipulations, will have a bearing on the appearance of the final print (see chapter 4). However, contrast and tonal range are probably the two most important ways of determining *mood*. The combination of high contrast and dark tones in the final print usually suggests a sombre mood; on the other hand, a print soft in contrast, where the darkest tone is mid-grey, can generate a much more gentle response in the viewer's mind. These are generalizations, and exceptions can and do apply. I am not suggesting that you resort to formula photography and fall into the bad

habit of making all your prints using the same contrast and tonality, just illustrating the importance of using contrast and tonality to help create the mood and story of any photograph you present.

To see the final print in your mind before you expose the film requires you to know what you are trying to say to the viewer. You may want to make a strong political statement, or capture a 'magic moment' of light striking the landscape: these messages are totally different, but the tools and techniques you use to express them are the same. To learn how the tonal range can

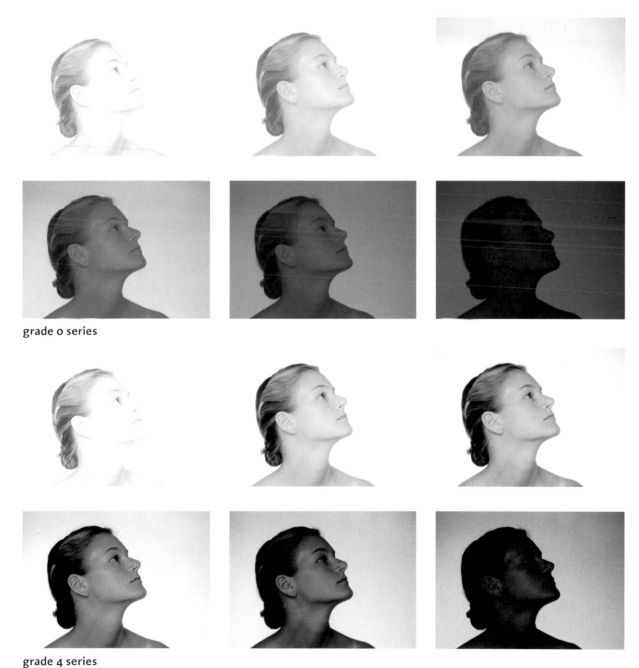

**grade 0 series**

**grade 4 series**

**Ali**
*These two sets of six prints were made from the same negative on Ilford Warmtone fibre paper grade 0 and grade 4 to illustrate the effect of tonality and contrast. Compare the second and third images in the two series and see how the soft version generates a much more gentle feel. The eyes are the key element – the high contrast of the grade 4 version brings a hardness to the portrait that negates the femininity of the subject.*

change an image, select a few negatives, make a number of both high- and low-key prints of different contrast, and spend some time living with them. You will find that sometimes the image works with only one interpretation, while others can be printed in a number of ways to evoke a range of responses. Make six prints from the same negative using the same paper grade but with a range of tonality from very high to very low key, and note how your response to the image changes.

If you really want to learn how contrast and tonality affect an image, do this exercise with every paper grade. Learning to understand the effects of tonality and contrast is essential and will prove a very useful aid in helping you to pre-visualize the final print.

Contrast in the print is established by the combination of paper grade and the negative. Generally, to ensure that all tones in a high-contrast negative are recorded in the print, a lower paper grade is used, while a higher paper grade is required to make a satisfactory print from a negative lacking in contrast. Clearly, there are times when, for aesthetic reasons, the opposite applies (see chapter 5). I recommend that you select a negative and make a straight print on every paper grade from 0 to 5 to see how contrast alone affects the same image. You will find that sometimes you prefer a gentle, low contrast version – then, just a few days later, you may change your mind in favour of a darker, more satanic print. This is not unusual: our response to potential subjects can be driven by our own mood. The same applies when I make new prints from some of my old negatives and decide to change the tonal range and contrast from that of previous prints.

# Learning to Apply Pre-Visualization

You are now ready to learn how to apply pre-visualization skills in the real world of making photographs. We need to strike the right balance of all the elements in black-and-white photography if we are to produce successful and memorable images. The best photographs are likely to be the result of understanding, and of thinking of the process as a whole. Successful photography is not defined solely by the knowledge and control of technique: pre-visualization of the final image is an essential link between technique and communicating through the final print.

You should always observe light, texture and form wherever you are, with or without a camera. These are key elements of any photograph, regardless of the actual subject, and practising pre-visualization as you go about your day-to-day routine will help you to 'see' the final print in your mind's eye when you are making a photograph. The more you practise, the better your vision will become. Observe people going about their daily business and you will see patterns emerging; spend some time each day watching light illuminate the same place and make a note of the changes that occur; select five different potential photographs that are close to your home, and over the space of one weekend visit each location at least three times each day and write down a description of the changes you see.

Finally, load a film into your camera and, using the same focal-length lens, expose one frame every 25 steps until the film is completed. You can walk in any direction, even

grade 0

grade 1

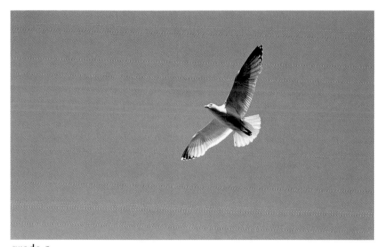

grade 2

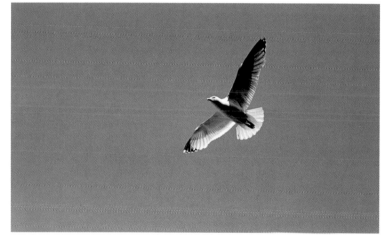

grade 3

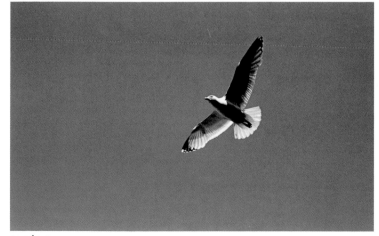

grade 4

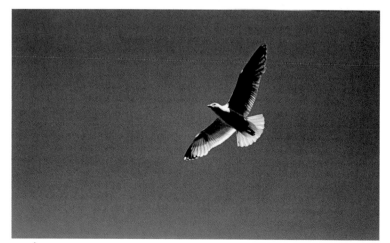

grade 5

retracing your steps, and point the camera anywhere, but you must make an exposure after every 25th step. These exercises are designed to make you look at, but most importantly, *see* the world around you and learn how light and situations change.

In addition to pre-visualizing the final print, you must learn to anticipate how and when the light will change or, when you are photographing people, how their faces will change in expression in response to changes in their situation.

When you are carrying out these exercises, visualize a contrast and tonal range in your mind that you think would best express the message behind the photograph you are planning to make. Then, when you are next in the darkroom, make a print to match your pre-visualization. You will soon learn to apply these judgments quickly, and to respond to the prevailing light and the situations that are presented when you are on a photographic outing.

I have done most of these exercises from time to time for many years, just to help hone the skills needed in pre-visualization. Making a fine black-and-white print is not simply a series of technical exercises: the end result should express clearly your reason for making the photograph and reflect the emotions you felt at the time you made the exposure. In a way, pre-visualization is a photographic expression of your response to the world around you.

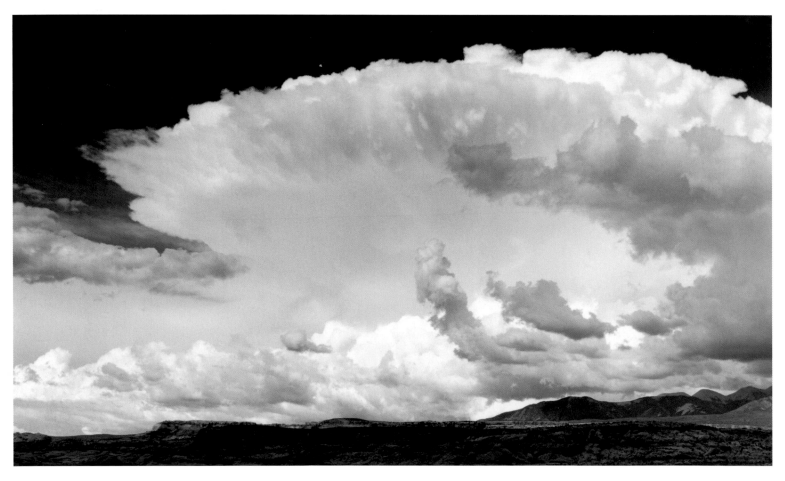

# Filters and Pre-Visualization

Understanding how filters change the tones in black-and-white photography will further enhance your ability to pre-visualize the final image and provide you with an invaluable tool in your search for the expressive print. We see the real world in colour, but as black-and-white photographers we have to learn to see it in tones of white through grey and into black. The distinction between different colours in the real world is not rendered in the same way in black-and-white photography, so we have to use filtration to achieve this. For example, in a black-and-white print red and green appear to be very similar in tone, but when a red filter is used they are clearly separated – as they appear to us in reality – because the red is rendered as a lighter tone of grey.

I use yellow, orange, red, green and polarizing filters in my landscape photography. You can see from the table below that a yellow filter will slightly darken the blue in the sky and therefore increase the contrast with clouds and land. I find this to be the best filter to use when I wish to portray the sky as gentle reality. However, when I wish to add drama to the same sky in a photograph I use a combination of red and polarizer, which significantly increases the contrast by rendering the sky as black.

A valuable exercise in learning how filters change the tonality of a print is to carry out the test reproduced on page 36. Using colour transparency film, I photographed a vase of flowers beside a chart showing the colour spectrum and used yellow, orange, red and green filters to demonstrate how colours are rendered in black, grey and white tones when photographed in black and white.

I recommend you test for yourself the exposure factors you need to apply when using filters – the manufacturer's suggestions are simply a starting point from which you can work out your own exposure adjustments. The test is quite simple: take an accurate meter-reading of a subject with a full range of tones, such as an open landscape on a sunny day, and make an exposure without a filter. This is your reference negative. Attach the yellow filter to your camera and make an exposure based on the manufacturer's suggestion, then bracket 1 stop less and 1 stop more. Follow this procedure with each filter you intend to use and process the film

| Filter | Effect |
| --- | --- |
| Yellow | Slightly darkens blue and lightens yellow and green |
| Orange | Darkens blue more dramatically than yellow and lightens yellow and green |
| Red | Significantly darkens blue and lightens red and yellow |
| Polarizer | Darkens blue and removes reflections from surfaces such as glass and water |
| Red and polarizer | Darkens blue dramatically |
| Green | Darkens red and lightens green |

**Flowers and test chart**

*These five prints show how different filters change the tonality in a black-and-white print. Note how the red filter lightens the rose and the green filter lightens the leaves.*

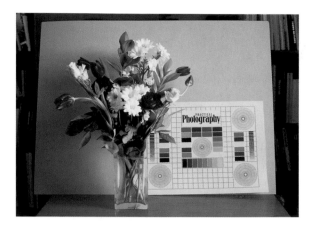

*Reference for the filter test.*

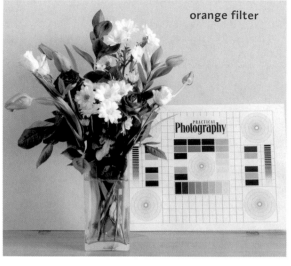

orange filter

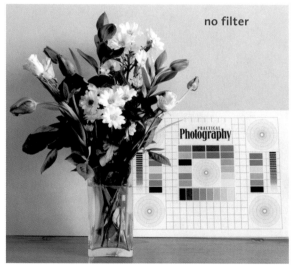

no filter

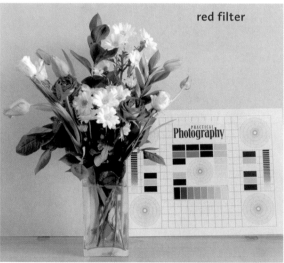

red filter

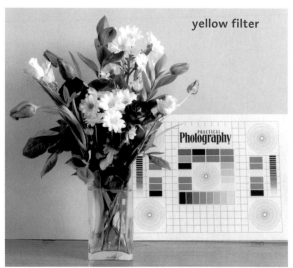

yellow filter

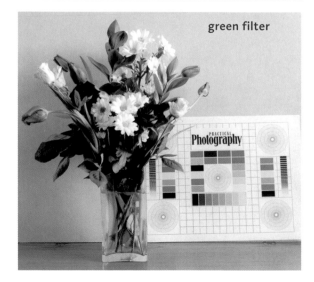

green filter

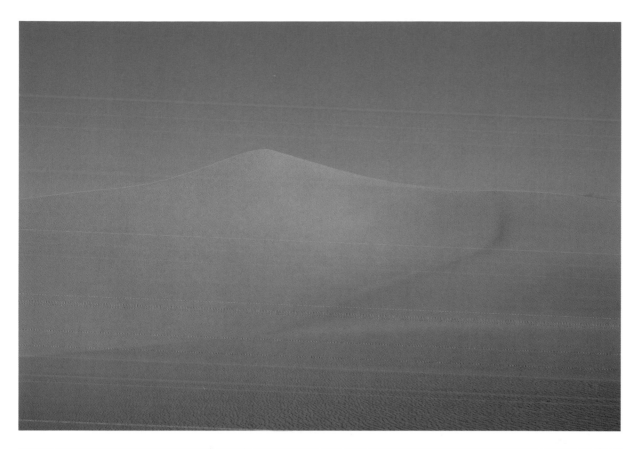

**Death Valley**
*The colour reality of the scene.*

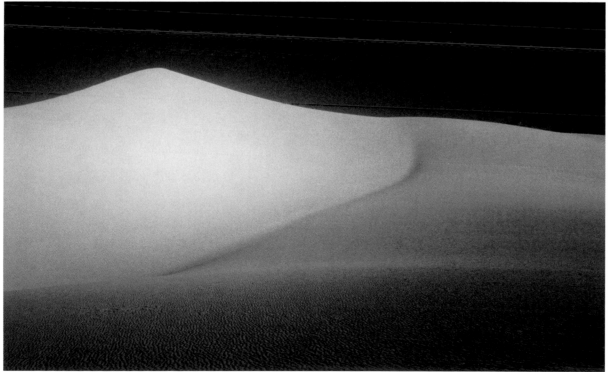

**Death Valley**
*The pre-visualized version of the colour scene. Red and polarizing filters were used together to render the sky as black and increase the contrast in the final print.*

120 ILFORD SFX 200, DEVELOPED IN ID11 FOR 10 MINUTES 1 TO 1 AT 20°C; PRINT MADE ON ILFORD WARMTONE VC FIBRE PAPER USING SPLIT-GRADE PRINTING, DEVELOPED IN ILFORD MULTIGRADE.

as normal. Keep a note of the frame numbers and corresponding filters used, to make sure you relate the information to the relevant filter. To determine the correct filter factor for you, compare the shadow detail in the negative made without a filter with the three negatives made using the filter. The negative made using the filter that shows the same detail in the shadows as the unfiltered negative gives you the exposure factor that suits your equipment and tastes.

# Making the Exposure

There are many factors involved in making the decision to release the shutter. The time of day, the time of year and even the precise moment all have a significant effect on how the final print will look. When other people view the print they may well have a different interpretation from yours, their own emotions and memories coming into play. Clearly, you cannot be expected to anticipate how others will perceive your way of seeing and expressing the subject, but you can help to guide the eyes of others to where you wish them to look, and influence the way in which they might respond to the contents of the photograph.

## Light

Landscape photography is greatly influenced by the light. Early morning or late evening – when the sun is low in the sky, creating long shadows – opens up the possibility of adding mood and drama to a scene. If you visit your favourite landscape location and the conditions are not right, do not make an exposure just for the sake of it. Get into the habit of observing how the light strikes the landscape and work out the best time to go back and make the exposure that captures the mood and atmosphere you want to convey. You can do this by finding out when the sun rises at that time of year and estimating when it will light the area you want to photograph. Take into account any hills or mountains that may block the light, and always arrive at your chosen location early to allow you to find the viewpoint and prepare your equipment.

You will soon learn to pre-visualize your photographs by observing how the landscape is transformed by the changing early morning or late evening light. Many years ago I was told by John Delaney, a photographer who influenced my early landscape work, to 'photograph the light, not the landscape'. I have found that advice invaluable, enabling me to pre-visualize and make many of my successful landscape photographs. Even when I have no camera with me, I still look at the light in the landscape and store the effects in my mind to use in the pre-visualization of future photographs.

I have made many of my most successful landscape photographs using the early and late light, but I do not pack away my camera as the sun rises high in the sky. Good, expressive photographs can be made at any time of day, but you have to see the landscape in a different way and learn to exploit the prevailing light. There is no point in trying to create a very moody landscape with a dramatic sky if the original exposure was made in mid-afternoon with soft, fluffy white clouds filling the sky. The end result will look false and contrived. When the sun is high in the sky, move your viewpoint closer to the landscape to

OPPOSITE
**The Chimney**
*A well-known feature of Antelope Canyon, Arizona, the Chimney is a large formation of rock spiralling down from the top of the canyon. Instead of exposing for the shadow, I deliberately exposed for the highlight to introduce a dark mood to the image, as I feel that this slit canyon has a sinister feel when you first enter it.*

120 Kodak TMAX, developed in HC110 1 to 31 for 10 minutes at 20°C; print made on Ilford Warmtone VC fibre paper using split-grade printing, and developed in Fotospeed Warm Tone.

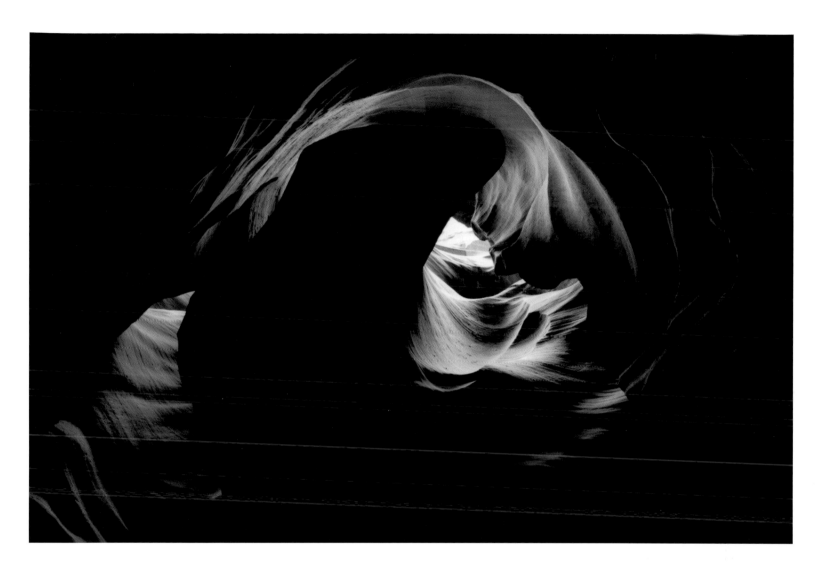

eliminate the sky, and photograph small elements such as hedgerows, rock pools and intimate details of the landscape.

When you are pointing your camera at people in the street, or when you are making a body of work for a documentary, you are likely to be interested in making photographs of facial expressions and people reacting to events or to each other. When photographing in these situations you have to accept the prevailing light and concentrate on the people, and I often decide to use a particular film/developer combination not only to help me deal with the light (usually very dim), but also to add another dimension to the photograph. For example, the addition of grain to certain types of photograph introduces a grittiness that I personally find effective. This approach is not restricted to people and documentary photography: I often choose to make landscape photographs using film/developer combinations that will produce quite coarse grain. Planning your pictures in this way will help you to predict the end result and in your pre-visualization.

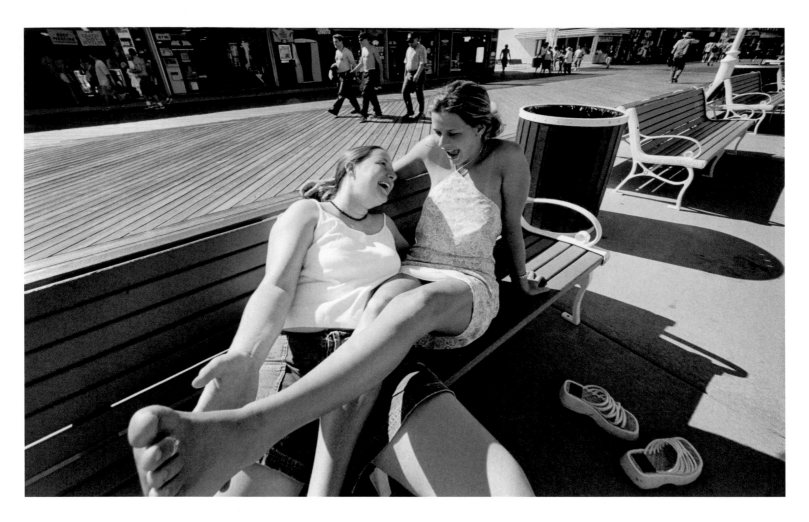

**Girls on Bench**

*This image was made using a very wide-angle lens for maximum coverage, with the camera, a Voigtlander Bessar, only 23cm (9in) from the girl's foot in the foreground. The girls were having a happy day out in the sun and the use of this wide lens produced a feeling of involvement in their obvious fun. At the same time, it enabled me to show the surroundings and space of the location. Because I tilted the lens there is some distortion, but I find it quite acceptable. When I saw these girls as I walked along the boardwalk I immediately visualized this image as presented, but when I processed the film I realized that serendipity (see page 48) had offered me a second element in the form of the skeletal figure at the top of the frame directly behind the girls. Once I had noticed this I could not stop myself looking at that area of the photograph – I think this is because the figure suggests a feeling of isolation that contrasts with the obvious closeness of the girls.*

35MM KODAK TRI-X, DEVELOPED IN FOTOSPEED FD30 1 TO 9 FOR 6 MINUTES AT 20°C; PRINT MADE ON GRADE 3 ORIENTAL SEAGULL FIBRE PAPER, DEVELOPED IN ILFORD MULTIGRADE.

## Viewpoint and Choice of Lens

Finding an interesting and novel viewpoint can transform an image and support your pre-visualization of the subject. The temptation to make every exposure from normal eye level should be avoided at all costs, although there are occasions when it is just the right height to place the camera.

Given that you have time, it is always advisable to explore camera placement. When I photograph in the landscape using a medium- or large-format camera, I always use a tripod, although I do sometimes handhold 35mm. I choose the exact spot to place my camera by exploring the location I intend

to photograph, to determine how the light is changing the appearance of the subject. I also work out whether a high or low viewpoint will be best by getting my eyes into exactly the correct spot for the camera lens, and then set up the tripod accordingly. Viewpoint can be critical and there are times when a minimal change will be significant in determining how the final image communicates the feeling, mood or atmosphere you wish to convey.

Using a low viewpoint in the landscape will often introduce a sense of space, especially with a wide-angle lens. Try making a photograph with an empty foreground using a standard lens and then repeat the exposure with a wide-angle lens, and note the difference in the impression of space that is created. Try the same experiment again, but this time change the viewpoint to include a dominant object in the foreground and discover how you can introduce tension and sometimes mystery into your photographs.

Wide-angle lenses offer a number of advantages, both practical and aesthetic. The main practical advantage is that they are quick to use, because they have such good depth of field that focusing is generally not an issue. I usually set my wide-angle lens to focus at about 1m (3ft) and use it at the widest aperture to gain as much shutter speed as possible. The aesthetic advantage is that you can use angles and a close-in viewpoint to give the impression of space and, at the same time, involvement with the subject.

The standard lens gives a 45-degree angle of view and is sometimes considered too conventional a choice by those who prefer the wide or long lenses available today. I do not subscribe to this view, and I encourage my students to use lenses of all focal lengths and recognize their strengths and weaknesses. I used only a standard lens for the first 15 years of my photographic career, and firmly believe that this helped me learn to see and use different angles. I am not suggesting that you use only one lens for so long, but I do urge you to get to know what each lens can see. Again, do not always make the exposure from eye level: put the camera down at ground level, point it upwards or downwards to introduce distortion deliberately, and you will create more interesting photographs.

Depth of field is a very creative and useful tool, and you should carry out a simple test to see the effect of using different apertures. Set up a number of objects on a flat surface at varying distances from the camera. Focus on the object that is one-third of the way into the arrangement. With the lens at the widest aperture, make one exposure. Leave the camera in the same place and expose the rest of the film, stopping down the lens by one step with each exposure but keeping the point of focus the same. When you process the film, you will see the effect of depth of field.

When I make photographs in the landscape, I tend to work with the lens fully stopped down to ensure that the image will be sharp throughout. This approach usually means I must use a tripod, because the shutter speed is likely to be quite slow. When using the lens fully stopped down, I choose a point of focus about one-third into the photograph I have framed, as this ensures sharpness throughout.

When making candid photographs using a hand-held camera and the standard lens – or, for that matter, any lens – I prefer to work at

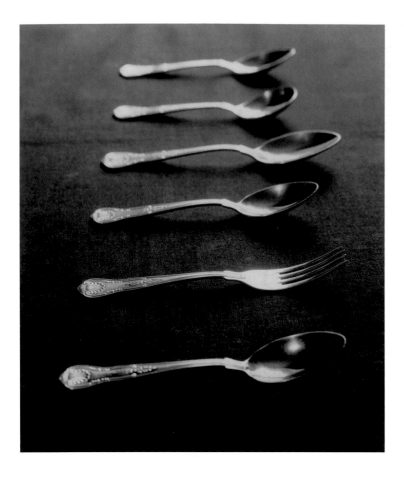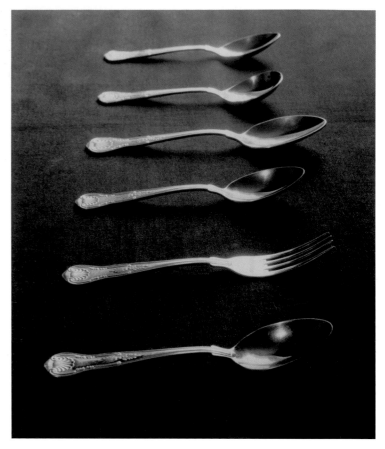

**Spoons and fork**

*This test demonstrates how changing the aperture will change the depth of field. The aperture on the 80mm Sekor lens used for this test was set at f/2.8 for the first print (left) and f/22 for the second print. The point of focus in both cases was the fork; the gap between each piece of cutlery is 8cm (3in). Note how in the first print (left) the fork is the only piece of cutlery that is in sharp focus, but in the scond print the increased depth of field created by stopping down the lens puts the first three pieces into focus.*

ILFORD DELTA 100 DEVELOPED IN ID11 1 TO 1 FOR 8 MINUTES AT 20°C.

the widest aperture to give me the fastest shutter speed available. I also use the limited depth of field that this produces to isolate the subject within the picture – and, because of the limited depth of field, it is essential to focus accurately on the subject. I have also made photographs where the subject has been deliberately thrown out of focus to try to create a certain feeling or atmosphere. This is a technique that will work occasionally, but you should use it sparingly.

The telephoto lens, such as a 210mm on 35mm, is very useful in both candid and landscape photography. The narrow field of view helps to isolate objects in the landscape or people in a busy street environment.

## Weather Conditions

In the landscape, especially, the weather plays a significant role in photography, and different conditions can work for and against you. A scene photographed in winter, for example, will look totally different in summer or autumn, but both images can work. Learning to read the changes that take place

will provide you with a valuable aid to achieving success in pre-visualization. Weather conditions change continuously, but although exciting light effects may be fleeting, they are likely to be repeated, offering you another attempt to make the photograph. I have often watched photographers chase the light, travelling long distances in a futile effort to catch and photograph it. You have a greater chance of success if you learn to read the pattern of changes, then get yourself to a location and let the light come to you. Relating tonality and contrast to the weather conditions you photograph will help you to express the mood and atmosphere that you experience and wish to convey in the black-and-white print.

Using weather conditions and the resulting changes in the light is not confined to landscape photography. Inclement weather, such as heavy rain or snow, will provide the documentary or candid street photographer with interesting and evocative conditions to record. On a dullish day the inclusion of wet surfaces or water will add light to any photograph if you get the right angle from which to make the exposure. Once you are aware of this you can use it in your pre-visualization of the scene to add the impression of light.

# Planning

In my image-making, I have worked hard to improve my ability to pre-visualize the print before making the first exposure. I have explained how observing light and weather conditions can help you to learn to anticipate these events. Pre-visualizing photographs requires planning, so let me now explain the methods I use to enable me to respond to potential photographic situations.

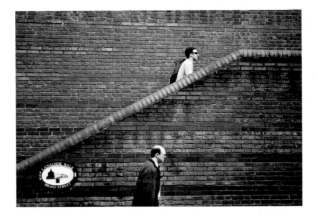

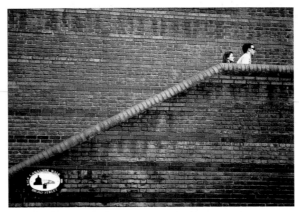

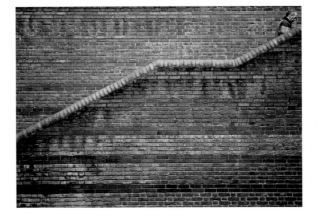

**Broad Street, Birmingham**
*These three prints illustrate how I use a stage. The inclusion of a figure or figures in different parts of the stage can work either for or against you. Here, the first two examples (top and centre) do not work because they are predictable and have no distinguishing features to lift them out of mediocrity. The third photograph (bottom) shows a better arrangement, mainly because the figure almost disappears into the background and his body language seems to echo the gloomy surroundings. I also moved slightly to the right and changed the focal length of the zoom lens from 70mm to 28mm.*

PRINT MADE ON ORIENTAL SEAGULL GRADE 3 FIBRE PAPER DEVELOPED IN ILFORD MULTIGRADE. KODAK TRI-X DEVELOPED IN FOTOSPEED FD30 1 TO 9 FOR 6 MINUTES AT 20°C.

## The Stage

In my reportage photography, I often look for a location that presents an interesting backdrop for possible photographs – I call it my stage. Look for interesting light that will add to your pre-visualized image; find a spot where people will stop or hesitate (the corner

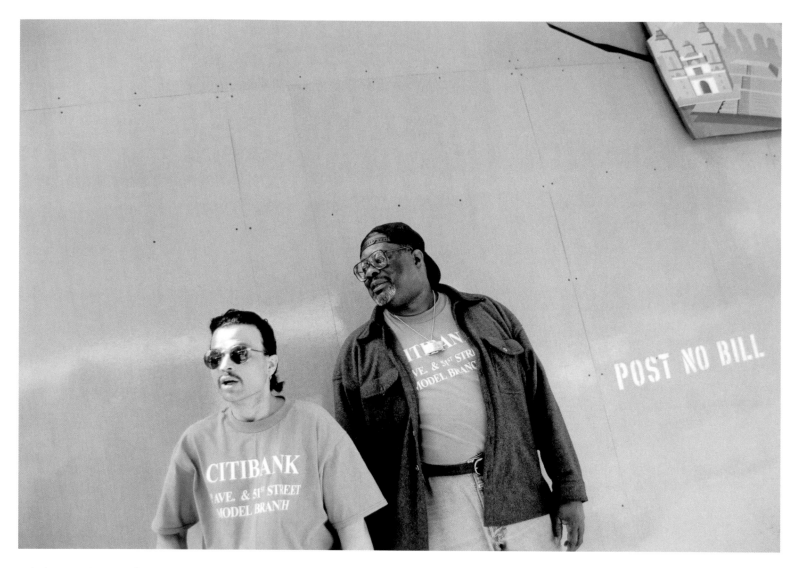

**5th Avenue, New York**

*I was attracted to make this photograph by the way in which the men are juxtaposed against the wood background. The style of the 'Post no bill' sign is echoed by the 'Citibank' T-shirts worn by the men. As I walked past, I pointed my Nikon back at them from below my hip to make the exposure. I used a 20mm Nikor lens that is a favourite for this type of photography.*

KODAK TMAX 400, DEVELOPED IN HC110 1 TO 31 FOR 7 MINUTES AT 20°C; PRINT MADE ON GRADE 3 ORIENTAL SEAGULL FIBRE PAPER, DEVELOPED IN ILFORD MULTIGRADE.

of a busy street is useful); use juxtaposition to make a point with the photograph. Having decided on the boundaries of the stage, simply wait for an interesting photographic opportunity to present itself.

## On the Hoof – and From the Hip

I love to wander around the streets, camera in hand, observing people and situations, knowing that sooner or later a photograph will be there for the making. I plan for these situations by taking a light reading from the back of my hand and then set up the camera by giving 1 stop more exposure than is indicated by the meter. If the light is likely to change – for example, where one side of the street is lit by bright sun and the other is in

shade – I check exposure details in both and change the camera settings accordingly. By being prepared in this way, I can respond immediately to subjects of potential photographs without having to worry about giving the correct exposure.

I use a camera with an autofocus facility and find this extremely useful when photographing 'on the hoof', especially when the exposure is made without looking through the viewfinder. Shooting 'from the hip' as I pass produces interesting angles and allows me to make photographs without being spotted by the subject. How can you ask permission to photograph a fleeting expression or situation? Sometimes I do not wish the subject to know that I have made a photograph – I accept that this method can attract the criticism of invading privacy, but I do apply certain principles and ethics. I will not publish an image that, in my opinion, removes the dignity or compromises the privacy of the subject. Certainly, this is a highly emotive subject and I believe that all photographers should think seriously about it and apply their own standards.

## Setting up the Photograph

Not all candid photographs are made without the permission of the subject. There are situations where successful expression is dependent on arranging the elements of the photograph. Obviously, this approach requires you to talk to the subject and put together information relevant to the photograph you have in mind.

Engaging people in conversation is a skill we should all learn if we are to explore candid and street photography to the full. Most people are happy to be photographed and will

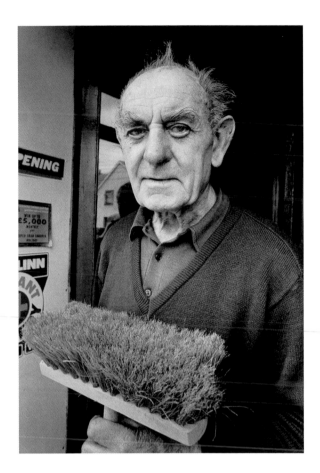

**Shop owner, Ireland**
*This elderly Irish gentleman was cleaning the path outside his shop when I enquired whether he minded if I asked him a few questions. He was quite happy to stop sweeping and chat, and rested on the brush as you see in the photograph. I had been attracted to make a photograph by his untidy hair and eyebrows, and when he placed the brush with the head pointing up he introduced the third and most important element into the image. There is a degree of serendipity in this image that would not have presented itself had I not engaged him in conversation.*

ILFORD HP5 PLUS, DEVELOPED IN ID11 1 TO 1 FOR 10 MINUTES AT 20°C; PRINT MADE ON ORIENTAL SEAGULL VC FIBRE PAPER USING SPLIT-GRADE PRINTING, DEVELOPED IN FOTOSPEED WARM TUNE.

co-operate, provided you treat them with respect and explain why you wish to make their photograph.

## The Photo Essay

I enjoy making a series of photographs to tell a story, rather than always looking for the one magic moment that captures all in a single image. A photo essay requires a very different approach and you do need to carry out some research into your chosen subject.

Look at magazines such as **National Geographic** to see the type of photographs they use to tell a story: many are stock shots that work because they are shown together and collectively tell the story. I am not rubbishing the stock photographs, for I believe

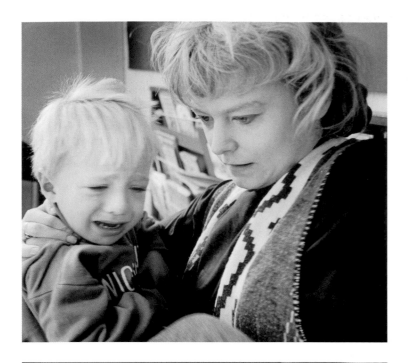

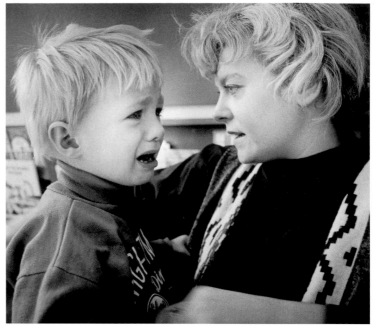

**Crying child**

*This child had been left in a crèche for the first time and was clearly upset. Tracy spent more than 45 minutes getting him settled, and during that time I exposed a number of frames and selected the four shown here to tell the story. None is a 'stand alone' image, but collectively they are effective.*

Fuji Neopan 400, developed in HC110 1 to 31 for 6 minutes at 20°C; prints made on grade 3 Oriental Seagull fibre paper, developed in Ilford Multigrade.

that they are probably the most important part of the photo essay. The magic moments that produce the stunning images for which we all strive will still happen, and will form key elements in the completed photo essay.

# Post-visualization

Ansel Adams, comparing photography to music – which was his second great passion – described the negative as the score and the print as the performance. Making fine black-and-white prints is a very creative skill and you should expect to apply some manipulation in the darkroom, which provides another opportunity to enhance further your pre-visualization of the original scene you photographed.

There will be times when you apply pre-visualization, expose and develop the film to produce the negative you envisaged – and yet when you make the print it does not convey the pre-visualized result. This does not necessarily mean that you made a mistake in how you saw the scene, since many factors affect your response to your chosen subject. To revise your first response to the scene when you are making the print is simply to apply post-visualization.

When we make photographs we are emotionally involved in the subject, and this influences our judgments and decisions. How often have you been excited by the light or situation at the point of exposure, only to find that the final print, made some weeks later, does not reflect those feelings? This is part of the joy of learning to make photographs, for while not every exposure will result in a fine black-and-white print, you have nevertheless observed light and events that will influence how you pre-visualize future photographs. I store these images away in my mind and they then influence my future work, either when I am out on a photographic trip or when I am making a print in the darkroom.

However, when the pre-visualized result does not work, the image can often be printed in a totally different way and perhaps express a very different feeling from your first response to the subject. To print differently from the way you first envisaged the shot is not an admission of failure to pre-visualize your subject. Printing is not only a creative part of photography in its own right but also a perfectly valid tool to use in your search for expression. This is post-visualization at work.

I attempt to pre-visualize the end result every time I make an exposure, but often when I process the film I find there are negatives that offer a different image to the one I had seen when I released the shutter. Even the negatives that yield a print as it was pre-visualized at the time of exposure should be open to further interpretation and can be given a different treatment and meaning. Sometimes this approach will work in your favour – sometimes it will not, and you will decide that you prefer to show the image as first visualized. However, the more you experiment in the darkroom with interpretation of the image, the more you will learn about seeing the final print at the time you make the exposure.

On occasion, when making a print as pre-visualized I have been influenced to change my original concept by the tonality I see on the test strip. The test strip is the starting point in the search for the fine print (see

**Nude dune,
Death Valley**

*I saw this image as a
very low-key print, even
though the dunes at
dawn are very bright
and flooded with light,
and quite low in
contrast. When I took
the negative to make
the first print (top), I
decided to use split-
grade printing to
achieve the subtleties
I had visualized.
However, having made
the grade 0 exposure
as described in chapter
4 (see pages 82–3),
when I saw the test
strip I knew that the
image would work
much better as a very
delicate high-key print.
My pre-visualized
interpretation still
worked, but was not as
effective as the final
version made using
grade 0 (above).*

120 Ilford Delta 100,
developed in ID11 1 to
1 for 8 minutes at
20°C; top print made
on grade 0 Ilford
Warmtone VC fibre
paper, bottom print on
grade 5, developed in
Fotospeed Warm Tone.

chapter 4) and you will make all decisions based on the information it provides. That information relates to tonal range and interpretation as well as development time and contrast, and I always keep an open mind when assessing my test strips. No matter how I have pre-visualized a subject, I still view the test strip as a very important starting point and reference for the final black-and-white print, and keep my options open on how I intend to present that final interpretation.

Most of my prints are made as I had pre-visualized, but occasionally I do have a change of mind, sometimes after I have been happy to make and live with the original interpretation for some time. Learning to

control negative density and contrast will provide you with the means to consider this sort of change in your first vision of a subject, and demonstrates once again the importance of creating a continuous link from visualization to the final, expressive black-and-white print.

# Serendipity

Careful planning and control is not always required in order to make a black-and-white image that conveys your feelings when you made the exposure. I do prefer to try to take everything into account when I set out to make photographs, because that puts me in control of the process. However, there are always those fortunate occasions when circumstances conspire to provide you with an unexpected turn of events that work in your favour. These happy accidents are known as serendipity, and its place in photography should not be dismissed. If we look at our best images, I am sure that we all find we owe serendipity quite a debt.

Serendipity is defined as luck, coincidence, accident. You cannot predict it, but you can learn to recognize when it might happen and set up a situation in which you can use it to your advantage, by observing ordinary events and everyday life. My own photographic definition of serendipity is 'an unexpected happening'. If you observe light in the landscape as well as people going about their normal routine, you will soon recognize that the best photo opportunities arise when extraordinary things take place. Being there with your camera, being patient, and drawing on your observation of people and light to anticipate the extraordinary will always offer

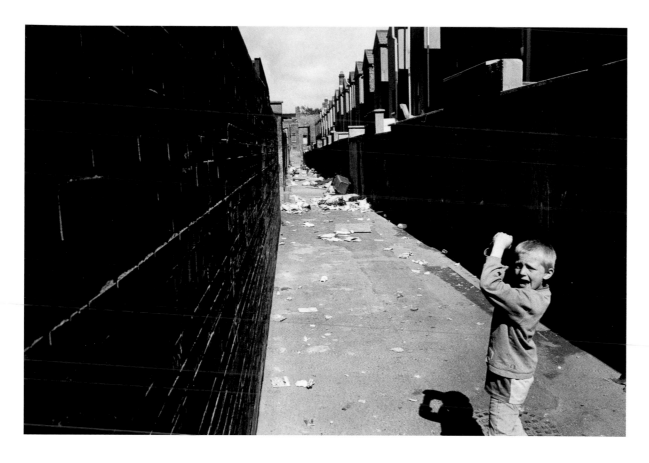

**Back street, Belfast**

*This photograph was improved as a result of the boy running in front of me just as I was about to release the shutter. My original intention was to show an empty back street for a project on which I had been working for some time. The inclusion of the figure and his gesture adds another important element, and changes the image from being merely informative padding in the context of the whole body of work, to expressing the behaviour of the children of the area. Photographing children always offers interesting images, for they are never totally predictable and are always likely to do something out of the ordinary; as photographers, we merely have to be ready to react. I never did make the exposure of the empty street.*

35MM NEOPAN 400, DEVELOPED IN HC110 1 TO 31 FOR 6 MINUTES AT 20°C; PRINT MADE ON ORIENTAL SEAGULL FIBRE PAPER USING SPLIT-GRADE PRINTING, DEVELOPED IN ILFORD MULTIGRADE.

the likelihood of a worthwhile photograph. You also have to learn to respond very quickly in these situations and release the shutter when the moment presents itself, as you are unlikely to get a second chance. Cameras with autofocus features are a definite asset when serendipity arises.

# Creating a Personal Vision

Pre-visualization is a very personal area of the photographic process. Because we all have different experiences and views, which influence how we see and what we wish to say with our images, there can be no definitive rules relating to pre-visualization and personal vision. We can only work with and learn to control and then use the tools and materials of photography, together with the outside influences that help shape our vision. In the beginning, when trying to pre-visualize your photographs you will experience failure and perhaps begin to doubt that it can be done. Do not give up: with perseverance and practice you will succeed, going on to broaden your vision and confidently 'see' the fine black-and-white print when you make the exposure. Then you will very quickly learn to apply the characteristics of the materials you use to future work in your chosen field of photography.

# 3 The Expressive Negative

The vision we use to pre-visualize how we wish to convey our response to a subject is not confined just to seeing what is there in front of us when we set out to make photographs. We have to consider how best to use the equipment and materials at our disposal to convey that vision to the viewer. We have to make judgments as to whether the message of the photograph would be best served by using high contrast or low contrast, fine grain or coarse grain, sharpness throughout the whole photograph or even movement and blur with little or nothing of the image in focus. We have to consider what to include and what to leave out of the image, and where to place the subject within the frame. To achieve the best possible results from our forays into the streets or the landscape – or from any subject we choose to photograph – we have to consider the issue of the expressive negative.

**Chair**
*I shot this negative on a Mamiya 645 with an 80mm Sekor lens using Ilford Delta 400, developed in ID11 1 to 1 for 6 minutes at 20°C. This represents a 2-stop reduction in development.*

## Chair

*I found this chair in an old building near Salisbury, Maryland, where I was leading a workshop, and used the image as an example of how you can manipulate development and produce an expressive negative in a very high-contrast situation. The inside of the building was gloomy but the bright early summer light produced the high contrast that dictated how I should expose and develop the film. Because I controlled the film exposure and development to suit the conditions, I made the print without using any darkroom manipulation.*

PRINT MADE ON ILFORD VC WARMTONE FIBRE PAPER WITH GRADE 4 DIALLED INTO THE CONTRAST CONTROL ON THE ENLARGER, DEVELOPED IN FOTOSPEED WARM TONE.

# What is the Expressive Negative?

Creating a successful print is not just a case of exposing your favourite film and processing it in the one developer you have in the darkroom, hoping that the film will 'come out', then spending time and possibly wasting materials trying to make a meaningful print in what becomes a salvage operation in the darkroom. How many times have you

**Night safe, Enniskillen**
*This photograph demonstrates the use of fast film to introduce grain to the image. It was made early one morning: I was attracted to the old, battered night safe and its striking contrast with the new version.*

35MM FUJI NEOPAN 1600, DEVELOPED IN FOTOSPEED FD30 1 TO 9 FOR 10 MINUTES AT 20°C; PRINT MADE ON ILFORD WARMTONE VC FIBRE PAPER, DEVELOPED IN FOTOSPEED GRADE SELECT.

done just that, and then been very disappointed with the final print because it does not convey what you saw, thought and felt when you made the exposure? I know I often did exactly this, until I realized that making successful black-and-white prints to convey my emotions and message did not, in fact, consist of a series of single, unrelated actions and events.

The fine black-and-white print is the result of linking all the factors in the chain effectively. You have to consider the whole process as one, knowing what you want to see in the final print and how to achieve that, and at the same time how to calculate and make the correct exposure and control film development. Included in these considerations are judgments about the right combination of film and developer to provide the negative that enables you to express your feelings for the subject in the final print. The expressive negative is the combination of simple photographic control, your own views and feelings about the subject that you are photographing, and knowledge of the materials you are using.

To some people, the appearance of grain or blur in the final image is distasteful, to be dismissed instantly as poor photographic and aesthetic judgment. To others, the hours some of us spend improving the darkroom skills needed to make fine black-and-white prints is time wasted. They feel that time would be better spent exploring different ways to tell the story we all try to communicate with our images. In a way, neither view is wrong, but when the aesthetics and technique are brought together in one image we have the strongest vehicle for our message. I believe you should not close your mind and

vision to any means you can use to communicate through your photographs. The expressive negative should contain all the information required when you go into the darkroom to make the print that carries your message. That information not only relates to the correct exposure, with detail throughout the whole negative, but should also reflect the aesthetic and emotional response you experienced when you made the exposure. To achieve this, you need to have an open mind and be prepared to consider any option that will help you convey this experience in your prints.

# Making the Expressive Negative

When thinking of creating expression in your photography, the film/developer combinations available are the logical starting place. We all have particular favourites that we know will work for us and we should never abandon them, for they will act as a very good reference point for future experiments and exploration.

Over the years that I have been making photographs, I have tried most of the new films that have been introduced to the marketplace. Some I have discarded, while others have gone on to join my growing list of tried and tested favourites. I have learned a lot about black-and-white films simply by experimenting, trying to find different ways to convey my feelings about the subjects I choose to photograph, and I would encourage you to do the same.

| Film | ISO | Format | Developer | Dilution | Time | Temperature |
|------|-----|--------|-----------|----------|------|-------------|
| FP4 Plus | 100 | Medium | ID11 | 1 to 1 | 9 minutes | 20°C |
| Delta 100 | 100 | Medium | ID11 | 1 to 1 | 8 minutes | 20°C |
| Delta 100 | 100 | Medium | Tetenal Neofin Doku | 1 to 16 | 10 minutes | 20°C |
| Pan F | 50 | Medium | Rodinal | 1 to 50 | 9 minutes | 20°C |
| Delta 400 | 400 | Medium | ID11 | 1 to 1 | 9$^1\!/_2$ minutes | 20°C |
| Delta 400 | 400 | 35mm | ID11 | 1 to 1 | 8 minutes | 20°C |
| HP5 Plus | 400 | Medium | ID11 | 1 to 1 | 13 minutes | 20°C |
| Delta 3200 | 3200 | 35mm | DDX | 1 to 4 | 9$^1\!/_2$ minutes | 20°C |
| Delta 3200 | 3200 | 35mm | Rodinal | 1 to 10 | 10 minutes | 20°C |
| Delta 3200 | 6400 | 35mm | Rodinal | 1 to 10 | 12 minutes | 22°C |
| Delta 3200 | 25,000 | 35mm | Rodinal | 1 to 10 | 14 minutes | 24°C |
| Neopan 400 | 400 | 35mm | HC110 | 1 to 31 | 6 minutes | 20°C |
| Tri-X | 400 | 35mm | Fotospeed FD30 | 1 to 9 | 6 minutes | 20°C |
| Tri-X | 400 | Medium | HC110 | 1 to 31 | 6 minutes | 20°C |

The table above lists my favourite combinations of film and developer. I have used all of them and arrived at the development times by testing in the manner described on pages 17–20. The results I have obtained with each combination suit my taste, and in some cases the times are the same as those suggested by the manufacturers – but I have arrived at those times by carrying out my own tests.

You will notice from the table that when I use the same film in different formats I use different development times. My experience is that 35mm film is generally higher in contrast than larger-format film of the same type. I do not know why this should be, and to be honest I'm not really interested, because I am only concerned with producing results that suit my photography and taste. The fact is that when I have tested the same film in different formats, the results have always confirmed that 35mm is a little higher in contrast.

## Prevailing Conditions

Regardless of the weather and lighting conditions, when I go out on an assignment or to do some work on my own behalf, I am always confident that I can make photographs. Sometimes, adverse conditions provide the element that makes the image exceptional, and help me to produce the expressive negative. Such conditions may force me into going beyond the recommended limits of the film, but we should always be prepared to push boundaries and experiment. Expression is not just about technical matters – it is also about using light and imagination.

### WOODLAND SCENE: COMPENSATING DEVELOPMENT

In chapter 1 I explained how to control high contrast by using minus development (see pages 22–3), but other methods can provide you with a negative that will produce an entirely different feeling in the final print. Because I wanted to see detail in the trunks

**Woodland scene sequence**
*The three prints showing this scene are different in contrast and demonstrate the benefits of learning how developers work.*

120 ILFORD FP4 PLUS; PRINTS MADE ON GRADE 2 ILFORD WARMTONE FIBRE PAPER WITH NO MANIPULATION, DEVELOPED IN FOTOSPEED GRADE SELECT.

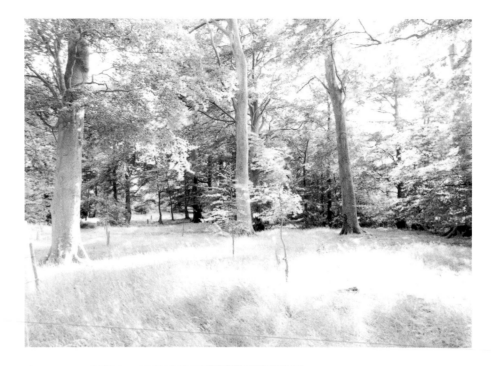

of the distant trees in this wood, I exposed for the shadows. Consequently, the bright highlight on the grass in the foreground would produce a very dense area in any negative processed as normal in my standard developer, and therefore prove almost impossible to print. I could have reduced development by 2 stops, but this would still have produced too much contrast – hence the decision to use compensating development. Paramount in this decision was the tonal range of the final print I intended to make. Even though in reality the wood was quite dark and sombre, I wanted to make a print that depicted an open, light feel – and compensating development gave me that option.

Let's examine the methods I used to make a very soft, gentle print from a negative I exposed where the subject contained over 9 stops of contrast. When using minus development I would not recommend a reduction of more than 2 stops. However, because the contrast in the woodland scene was too high for even a – 2 stop development to be effective, I decided to use two different methods to arrive at the type of negative I knew I needed.

Because of the high contrast range, I knew that Tetenal Neofin Doku, a very soft film developer, would reduce contrast and produce a negative that would enable me to achieve the result I had visualized. The final print from this negative produced the result

ILFORD FP4 PLUS

**ABOVE**
**Woodland scene**
*This version, from a negative processed in compensating developer, is a total failure, as it has too much contrast.*

FILM DEVELOPED IN TETENAL NEOPRESS 1 TO 100 FOR 11 MINUTES AT 20°C.

I wanted when I made the exposure. The gentle tonality throughout gives the print the light summer feel that I saw on that balmy afternoon.

Processing film in Pyro, a staining developer that is designed to limit the development of highlights, will produce a negative that is flat in appearance, with more density than normal negatives but relatively easy to print. It will also require more time – about

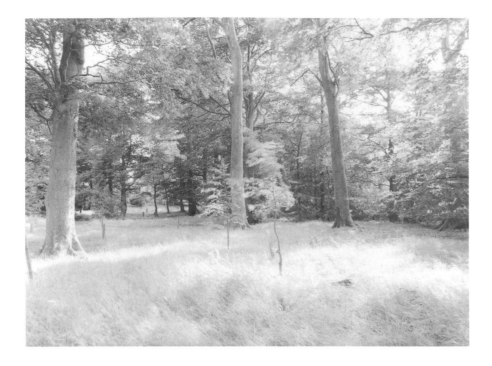

**Woodland scene**
*This print, from a negative processed in Pyro (see text for details), lacks the required contrast.*

result in streaking. Develop for 10 minutes and do not discard the developer, as it is used later in the process to induce stain.

3   Pour in stop bath and agitate every 30 seconds for 2 minutes. I use plain water, but if you wish to use a stop bath, dilute to 25 per cent normal strength.

4   Pour in non-hardening fixer and agitate every 30 seconds for 10 minutes.

5   Pour back the used developer, after fixing but before washing, and agitate every 30 seconds for 4 minutes.

6   Wash for 30–45 minutes in running water to intensify the stain further.

I also use compensating development when I have to deal with a very high-contrast subject, such as interior architectural work. The developer is diluted up to five times more than recommended by the manufacturer and has the effect of significantly reducing development of the highlights compared to the mid- and lower values. It is advisable to use developers such as Kodak HC110, Agfa Rodinal and Tetenal Neopress, my choice for the picture here.

I dilute Neopress 1 to 100 instead of the normal 1 to 15 or 1 to 31 recommended by Tetenal. When using these extreme dilutions there is a very small amount of the developing agent in the solution, so you should develop only one roll in a tank to eliminate the risk of the developer becoming exhausted during the process. When using compensating development, it is advisable to use a tank that holds several reels, though just one loaded with the film, to ensure that there is enough developing agent in the tank to process the film properly.

35–40 minutes, with another 30–45 minutes' wash – but it can be well worth the effort when you are faced with a very high-contrast subject.

**To process film using Pyro developer**
1   Pre-soak the film in plain water for 4 minutes.

2   Pour in the developer and agitate every 15 seconds – inadequate agitation can

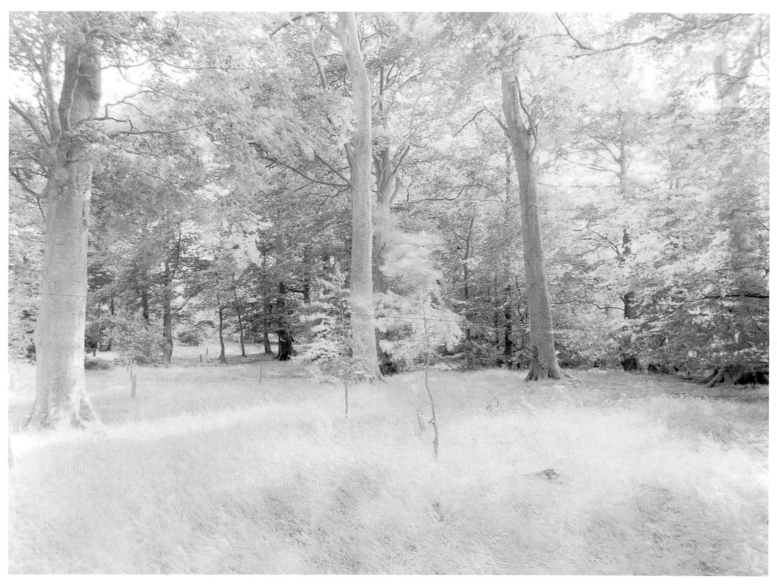

### Woodland scene

*The woodland glade was quite dark with pools of light in the foreground, but I visualized the soft result shown here. This was achieved by using a very soft developer and there is a feeling of soft, gentle light and the impression of movement created by a light breeze.*

FILM DEVELOPED IN TETENAL NEOFIN DOKU 1 TO 16 FOR 10 MINUTES AT 20°C.

# Using Grain for Expression

When I first started making photographs, the many photographers who told me that I should avoid excessive grain in my negatives had an influence. Consequently, I did everything I could to produce grain-free negatives. I used only medium- and large-format cameras, fine-grain film such as Ilford Pan F or FP4, and took great care not to overexpose and overdevelop my negatives. It was not until a few years later, when I made my first documentary photographs, that I realized how grain can be a very powerful and expressive tool. It can add a dimension to a photograph that is impossible to capture with large-format and almost grain-free prints. Please do not think that I am not in favour of prints made from large- or medium-format negatives: I just feel that we should explore every avenue in the search for expression in our photography. Since I discovered the power of grain in my own pictures, I have tried many ways to produce negatives that yield crisp, sharp grain.

## Ilford Delta 3200 and Agfa Rodinal

By far the best – and my favourite – combination is Ilford Delta 3200 developed in Agfa Rodinal, a developer known for its propensity for producing grain. Used at its recommended speed, Delta 3200, developed in Rodinal 1 to 10 for 10 minutes, will enlarge to 12x16in and show surprisingly little evidence of excessive grain, but when pushed to speeds of 6400 to 25,000 ISO the combination produces crisp and very sharp grain. When using it at these speeds, you need to find subjects that are fairly high in contrast in order to achieve the best results. Because the Rodinal is quite strong, normal dilution is usually 1 to 50 or more. Delta 3200 tends to show quite a high base fog level, but I have never found this to affect the contrast in the final print. Another plus point with this film is that you can carry it through airport X-ray machines without having to worry about it becoming fogged.

## DD/FF (Dilute Developer/ Fast Film)

Many years ago, I met an old press photographer who told me of a method they used in the days when 400 ISO was the fastest film available. When they found themselves in a low-light situation without a flash, they resorted to a process they called DD/FF, which is Dilute Developer/Fast Film. He told me to expose Kodak Tri-X at 400, 800 and 1600 ISO all on the same film and develop it as follows: dilute Kodak D76 at 1 to 30 instead of the normal 1 to 1 or 1 to 3, pour into the tank and agitate by inversion for 5 minutes. Place the developing tank in a water bath at 24°C and leave for 6 hours without agitation, then fix and wash as normal. The negatives will show good, sharp grain and will print beautifully. Again, subject matter that has some contrast is preferable if you are to achieve the best results from this technique, although I have used it successfully in heavy, foggy conditions. Because the developer is so dilute, there will be only a small amount of developing agent present and it is advisable to place only one film in the tank when using this process.

Two other combinations I have used occasionally are Fuji Neopan 1600 processed in

Fotospeed FD30, a developer designed for push processing but which also works very well when used to process films rated at their recommended speed. Fast film processed for 4–5 minutes in an E6 colour transparency chemistry first bath will also produce good, crisp grain.

# Camera Technique and the Expressive Negative

Producing the expressive negative does not depend only on using different film/developer combinations. The object of making the negative is to capture the mood, feeling, memory, emotion or impression of the subject you are photographing. Why, then, should you limit the tools of expression to type of film and development? Why not include camera technique in the field of the expressive negative?

## Multiple Exposures in the Camera

I have used multiple exposures to create a number of evocative photographs, especially when I work in the landscape. The technique requires a good, sturdy tripod and (obviously) a camera with a multiple-exposure facility, usually medium or large format.

Multiple exposures can be used when photographing anything that moves – water, clouds, trees and grasses are favourite and obvious targets when working in the landscape. In an urban environment just about everything moves, so there is an abundance of material to be captured on film. A single

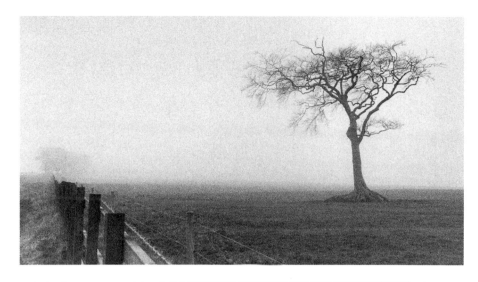

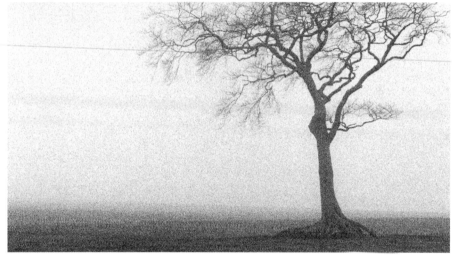

**Tree in mist**
*To try to convey the feeling of a damp, misty day, as an experiment I used the DD/FF technique because I know that it enhances grain. The first print (top) was cropped slightly at top and bottom to make an 8¹/₂x5in print. The print below is from a section of the negative enlarged to make a 14x11in print to illustrate the increase in grain.*

35MM KODAK TRI-X, DEVELOPED IN ID11 1 TO 30 AT 20°C FOR 6 HOURS.

exposure will produce a totally different result from a series of multiple exposures, even when the single exposure is quite long. The shutter speed chosen for use in multiple exposures will also produce a variety of effects. The best way you can learn about the

**Tide, Artog, Wales**

*This image was made using multiple exposures and shows just one of the effects that can be achieved. It was made on a dull day in quite heavy rain. The metered exposure was 30 seconds, taking reciprocity failure into account, and I decided to use the multiple-exposure technique to create a misty atmosphere on the moving tide. Instead of selecting one shutter speed to use as a multiple, I used a number of different times from 5 seconds to $^1/_{125}$ second. I added up the different exposures in my head as I made them, so that I would know when the correct exposure had been given – in total, I made 200 separate exposures. To create the misty effect, some of the exposures were made when the tide was fully out and all the rocks visible, and some when the tide covered the bottom of the rocks so that they received no exposure.*

120 Ilford Pan F, developed in Rodinal 1 to 50 for 9 minutes at 20°C; print made on grade 3 Ilford Warmtone fibre paper, developed in Fotospeed DV10 Varigrade.

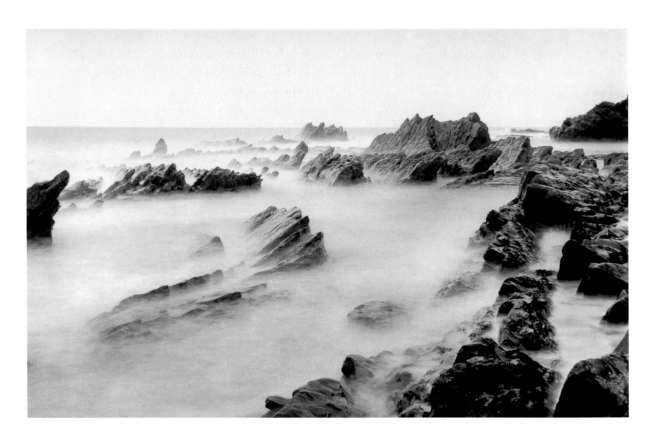

subtleties created by multiple exposures is to experiment with different combinations of shutter speed relative to the degree of movement in the subject. For example, when the same shutter speed is used, fast-flowing water will be rendered in a very different way from water that is moving along slowly.

### CALCULATING EXPOSURE

The calculation of how many exposures to make is really quite simple, although I would warn you not to try to relate it to f-stops, which does appear to be the logical approach. If you do this, you will take yourself down a very frustrating road and arrive at the wrong calculation. The method I use is simple, does not require complicated calculations or a portable computer, and the correct answer is calculated very quickly.

When you plan to use multiple exposures, you first have to decide on the aperture and shutter speed that you think will produce the best effect. Clearly, after you have experimented with the technique you will learn to recognize how different shutter speeds affect the end result. I usually stop down the lens fully, to produce the slowest shutter speed possible in the lighting conditions in which I am working. This is not an essential requirement, but I would suggest you use it as a starting point. When you have learned more about multiple exposures you can experiment with many different combinations.

Having decided on the shutter speed I intend to use, I take a meter reading using my normal method: that is, to determine the correct exposure to provide detail in the deepest shadow (see pages 16– 17). This is

followed by taking a meter reading of the brightest highlight in order to determine the subject contrast range by counting the stops between the two. Having done this, I now know not only the correct exposure but also how I intend to develop the film (see pages 17–20). Let's assume a simple example, where the single exposure indicated by the meter is 1 second at f/22 and I have decided to use a shutter speed of $\frac{1}{60}$ second at the same aperture. The question I ask myself is: how many exposures at $\frac{1}{60}$ second are needed to make up 1 second? The answer is 60, and it is pretty clear how I arrived there.

Now consider the slightly more difficult equation of a single exposure of $\frac{1}{4}$ second at f/22, with the same shutter speed of $\frac{1}{60}$ second as the multiple exposures to be used. How many exposures at $\frac{1}{60}$ second are required to make up $\frac{1}{4}$ second? Dividing 4 into 60 gives an answer of 15, and again the method used is clear. To summarize: divide the bottom digit of the single-exposure shutter speed into the bottom digit of the chosen multiple-exposure shutter speed and you will arrive at the number of exposures required to produce a properly exposed negative. One elementary point to remember is that the multiple-exposure shutter speed must be shorter, or faster, than the single exposure indicated by your meter, otherwise you will overexpose the negative.

To help you confirm that you have made the correct number of multiple exposures when using this technique, first make a single exposure at the indicated meter reading to use as a reference point. Make the multiple exposures on the next frame, and when you process the film you can compare the two negatives to see if the densities are similar. You will very quickly confirm that the method used to make the calculation is correct and you can then stop making the single reference frame.

When I first made multiple-exposure photographs, I used an old non-electronic medium-format Minolta Autocord and found that the shutter speeds were not absolutely accurate. I carried out the check outlined above and found that the multiple-exposure negative was slightly underexposed, so for future multiple-exposure pictures I added another two or three exposures to compensate. Because modern black-and-white films have good latitude, it is not absolutely critical that the negatives be exact in densities, but I would err on the side of over- rather than underexposure.

## MULTIPLE EXPOSURES IN PRACTICE

Using the multiple-exposure technique will open up a creative tool in making expressive negatives and, ultimately, prints that successfully show your pre-visualized image. I have used multiple exposures to great effect in many landscape images I have made – and I know that I have barely scratched the surface of the possibilities offered by the technique. I have never used it in my documentary photography, preferring other methods to imply motion (see next page), but I am certain there are ways to exploit this technique when photographing in the streets and when making a series of documentary images.

To help you get started, here are a few suggestions for situations in which you can use multiple exposures. The first and most obvious is in the landscape, where you have waterfalls, flowing rivers and the incoming

These are just a few of the applications that can be successful when using multiple exposures in your photography. In the end, you need to experiment to discover the combinations that are best suited to your requirements and visualization.

## Blur and Movement Created in the Camera

There are occasions when your representation of the subject can be enhanced by moving the camera during exposure. Indiscriminate camera movement and poor camera technique are clearly *not* what I mean when I suggest using this method of creating the expressive negative. Certainly, there are those serendipitous occasions when happy accidents occur (see page 48), but here I am suggesting that you should plan to use camera movement.

The normal method – sometimes used by sports photographers – of panning the camera in a straight line in the same direction as the movement of the subject is a simple example of deliberate and controlled camera movement. I often deliberately move the camera when I want to create a feeling of action or movement in the subject I am photographing. Sometimes I use the straight panning method, but often I prefer to move the camera in a circular motion or sometimes in a wavy line in the same direction as the subject's movement – or even in the opposite direction. Try out these ideas, and any others that you can think of, to produce the creative element in the final image that will enable you to express the meaning and message of the photograph successfully.

**Blurred men**

*Deliberate upward movement of the camera during exposure created this ominous portrait, made in a rather dark seafood café in Maryland. I used a shutter speed of ¹/₄ second with the 20mm lens wide open at f/2.8.*

35MM KODAK TRI-X, DEVELOPED IN FOTOSPEED FD30 1 TO 9 FOR 6 MINUTES AT 20°C; PRINT MADE ON GRADE 4 ORIENTAL SEAGULL FIBRE PAPER, DEVELOPED IN ILFORD MULTIGRADE.

tide – all prime targets for the technique. (A word of warning: when you go to the beach to make photographs using multiple exposures, check the time of the high tide and make your photographs as it starts to go out. There will then be no chance of you becoming trapped by an incoming tide, as once happened to me as I made photographs on an isolated beach in Wales.)

Trees on a windy day are an excellent subject with which to create an impressionist expression of the prevailing conditions – the sturdy trunk is usually still and sharp, while the smaller branches and leaves can show quite violent movement. Clouds present some problems: huge thunder clouds tend to look messy, so it is better to choose a simpler cloud formation. It is also helpful, although not essential, to include in the image something that is sharp in order to create a contrast with the implied blur that is generated by the multiple exposures.

# Framing the Image

The arrangement of the elements within the photograph has a significant effect on how the viewer will respond to the message or story it holds. It is therefore essential that you learn to recognize how placement within the frame will work to create the expression you seek in your photographs.

We have all heard of, and no doubt discussed, the use of the rule of thirds, the golden mean, and the many other rules and requirements that are considered essential by some if the image is to work. I fear that this approach carries the risk of becoming formula photography, and consequently can make the work very predictable. I do make photographs where the traditional rules of composition are used, but I also feel strongly that you should not work to a formula and need not always follow the rules. The only rule I apply is: if I feel comfortable with the framing of an image, then I make the exposure and live with it – regardless of whether or not it follows the so-called rules.

An image in which the main element is placed near to the edge of the frame, or even partly cut out of the frame, will generate a different response to one in which that same element is in a more traditional position. Edges can be used to create a degree of discomfort and tension in the photograph. Try it: place the subject on the third in the approved way, then make a second exposure in which the subject is on the edge of the image and partly cut off. The traditional placement will have a softer, more comfortable feel that the viewer will accept without question. The unconventional placement on the edge will generate questions, argument and even rejection by some

**Dublin**
*These two images show how the introduction of a figure as a point of interest near to the top edge of the frame can add strength to the image.*

35mm Kodak TMAX 400, developed in HC110 1 to 31 for 7 minutes at 20°C; print made on grade 4 Ilford Warmtone fibre paper, developed in Fotospeed DV10 Varigrade.

**Lady on the boardwalk**

*This photograph was made at the same time and place as the image on page 106. It was framed as presented here, with the lady deliberately placed on the very edge of the frame to add tension. As I released the shutter she spotted me, and I think this adds to the tension I was aiming to convey.*

35MM KODAK TRI-X, DEVELOPED IN FOTOSPEED FD30 1 TO 9 FOR 6 MINUTES AT 20°C; PRINT MADE ON GRADE 2 ILFORD WARMTONE FIBRE PAPER, DEVELOPED IN ILFORD MULTIGRADE.

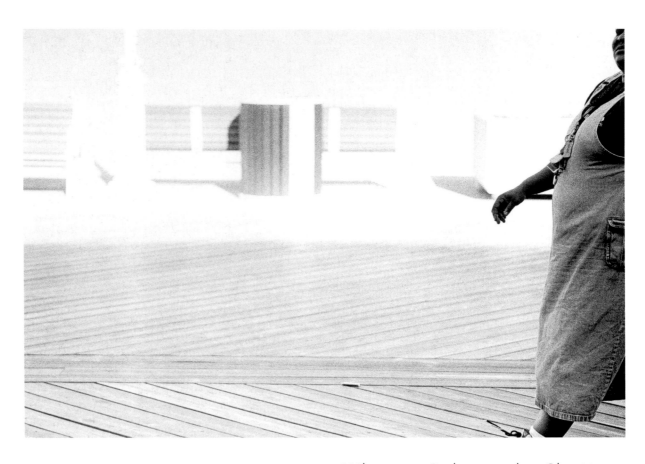

viewers, but I would consider this version to be the more successful because it has created comment and caused an emotive response in others. It has therefore communicated a message or a story – and that is what we are trying to do when we make photographs.

Framing the subject in an unconventional way will not be successful every time. You need to consider what you are trying to achieve when you are about to make the exposure; you also need to learn to make the right decision as to how to arrange the elements of the image in a particular way (and understand why it works). Being different or unconventional for the sake of it will not produce a successful black-and-white image: it will merely produce a formula photograph of a different kind.

## When to Release the Shutter

A not unimportant aspect of making the expressive negative is the question of when to press the button to release the shutter. There can be no hard-and-fast rules as to the precise moment the exposure should be made, since the very reason for making photographs is that you are responding to light, expressions, relationships and many other factors. There are some situations in which you can plan the precise moment to release the shutter – the instant the sun rises above the horizon is a simple example. And there is still a degree of planning required in committing the magic moment to film: you have to know where the light is going to fall; you have to consider the movement of clouds if there is a breeze about.

**Billy waiting for his pigeons**

*I used the subject's arm to frame both his own profile and the pigeon loft in the background as he waited for his birds to return from a race. The framing and the low-key print convey the concern he had for the late arrival of his favourite pigeon.*

35mm Kodak TMAX 400, developed in HC110 1 to 31 for 8 minutes at 20°C; print made on grade 3 Oriental Seagull fibre paper, and developed in Dektol.

When photographing people, how can you plan for a reaction and change of expression? All you can do is observe and be ready to release the shutter, by always having the camera set up to give the correct exposure in the prevailing light. Anticipation is the most important factor in any field of photography, such as landscape or documentary, where conditions and the elements are constantly changing. It is a skill that can be improved, simply by observing how light transforms anything on which it falls and spending time watching how people relate to their surroundings and to other people, and learning to look for the unexpected. The more you practise, the more adept you will become. Your visualization and photography will improve, because you will release the shutter that tiny fraction earlier and capture the critical change of light, moment or expression.

Making the expressive negative is the result of a combination of mundane testing of materials to build your knowledge of them; knowing what you want, honing the skill of seeing and then quickly reacting to what you see; and careful attention to detail in exposing and processing the film. These factors are all brought together by the application of your own personal vision and, most importantly, your judgment. Making the expressive negative is the penultimate step in producing the fine black-and-white print that carries your message and the reason for making the photograph. All there is left to do is to apply darkroom skills and make the print.

# 4 The Fine Print

What is the fine print? Some photographers consider that a fine print should be grain-free and show a full range of tones, but if that were the case then a great number of prints would, unjustly, fall by the wayside. A grain-free print with a full range of tones is a joy to view, but it is not the only consideration in defining a fine print. I'll ask a second question to help answer the first: why make the fine print? Photography is essentially about communication. In making a photograph we are trying to communicate an idea, a story, an emotion, a memory, a mood or a message by means of a one-dimensional image on a piece of photographic paper. If you have seen an Ansel Adams print of his work in Yosemite Valley, or a Paul Caponigro print from his Stonehenge series, you will know how the fine print communicates. Both Adams' and Caponigro's prints

glow as if they have an inner light, a quality that is the result of knowing precisely how they wanted the print to look, plus a wide knowledge of photographic technique and the judgment and ability to use it.

**Tidepool and rocks**
*I shot this negative on my trusty old medium-format Minolta Autocord with a fixed 80mm Rokkor lens.*

Kodak Tri-X, developed in HC110 1 to 31 for 6 minutes at 20°C.

### Tidepool and rocks

*No matter what the prevailing conditions, beaches are full of photographs. If the light is poor and is not good for open landscape or seascape images, you can move in close to make intimate studies of the detail to be found. This photograph was made on a bright, sunny but very windy day, on a beach in Northumberland close to my home. The tide was going out, leaving wet sand, so I moved down to the water's edge. I quickly found these rocks in a tidepool and liked the arrangement, particularly when the wind rippled the water. The sand in Northumberland is almost white in colour, but I decided to make the print quite low key and therefore had to carry out extensive burning and dodging in the darkroom.*

PRINT MADE ON ILFORD WARMTONE VC PAPER USING SPLIT-GRADE PRINTING, DEVELOPED IN FOTOSPEED WARM TONE.

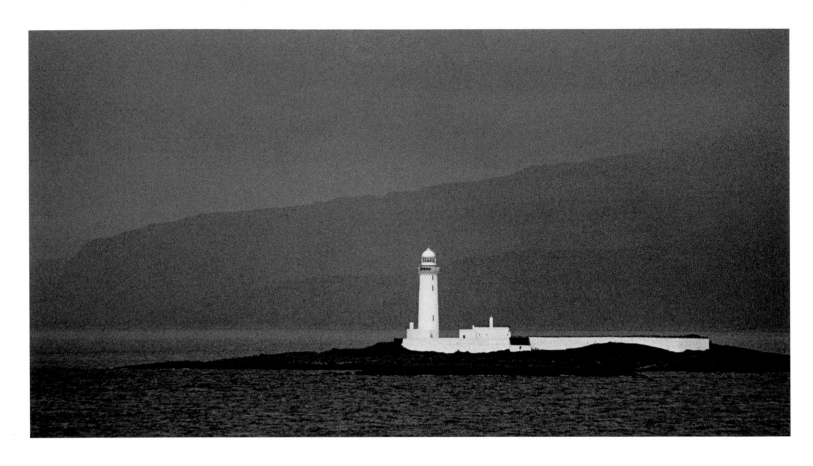

**Lighthouse,
Isle of Mull, Scotland**

*Although I made this
photograph on a warm
summer morning, I
visualized a stormy
image. Using my Nikon
F90X with a 210mm
lens, I exposed Kodak
Tri-X normally because
there were 5 stops of
contrast. The print
was made on Ilford
Warmtone VC fibre
paper using grade 4,
developed in Fotospeed
Warm Tone, to help
increase the contrast
and drama.*

Film developed in
Fotospeed FD30 1 to 9
for 6 minutes at 20°C.

I HAVE always believed that photographers must produce the best possible print in order to compel the viewer to stop and read the message that the photograph embodies. Therefore, the print should be made using whatever means will best tell the story. We have to search for, and use, the photographic qualities that are needed to combine with our personal vision and communicate the message contained in the print. Grain and a limited tonal range can do that job just as well as a grain-free print with a full range of tones, for different reasons. When we have these elements together, I believe we have a fine black-and-white print. Attention to small details can and will make a good print into a fine print, and in so doing will add considerable strength to its content.

The making of the fine print begins with pre-visualization of the subject and continues with the correct exposure and development of the film. The final step takes place in the darkroom, when all that has gone before is brought together in the process of successfully putting the image onto the photographic paper. Your responsibility now is to encapsulate all your work in the best possible fine black-and-white print.

There can be no doubt that the subject is by far the most important element. A powerful subject poorly printed will gain my attention every time before a beautifully crafted print with nothing to offer but technique. But when the powerful subject is shown in a well-crafted fine print, you can do little more to communicate your message.

For these reasons, I believe that all black-and-white photographers have a responsibility to work hard to learn the techniques required to make excellent black-and-white prints. There can be no room for sloppy procedures and guesswork. I approach the making of the print in much the same way as testing film.

Every decision I make is based on making and assessing a test strip. A properly made test strip will provide all the information you require to produce the expressive fine print. It will confirm the choice of paper grade; it will guide you towards the correct exposure; it will help you in judging the contrast and tonality that best express your message. The test strip is probably the most important step in the making of the fine black-and-white print. Never compromise or accept second best. Be your own toughest critic, and keep a large waste bin in your darkroom in anticipation of dumping anything but the best result. The photographic process is a science and a craft, but I believe that the end result is art.

### Speakers' Corner, Hyde Park, London

*This man was preaching his religion and was very proud of it, and I think this is reflected in the image. There was a lot of distracting detail all around him, so I chose a viewpoint that placed him in front of trees. I based the exposure on his skin and increased the meter reading by 1 stop. I used Kodak Tri-X in my Nikon F90X, with a 210mm lens used wide open at f/2.8 to throw the background out of focus.*

FILM DEVELOPED IN FOTOSPEED FD30 1 TO 9 FOR 6 MINUTES AT 20°C; PRINT MADE ON ORIENTAL SEAGULL VC FIBRE PAPER USING SPLIT-GRADE PRINTING, DEVELOPED IN FOTOSPEED GRADE SELECT.

# Equipment

I do not intend to spend too much time discussing equipment, but it is necessary to mention one or two darkroom items that I use.

## Enlargers

Enlargers have three different light sources: condenser, diffuser or cold cathode. For any one negative, it is generally thought that the print made on a condenser enlarger will be higher in contrast than that made on a diffuser, which in turn will be higher in contrast than the print made on a cold cathode. Therefore, when carrying out film tests you can adjust the contrast of your negatives to suit the light source of the enlarger. I have always used a cold-cathode light source – at the time of writing I use a Zone VI variable-contrast (VC) enlarger.

## Timers

Enlarger timers have greatly improved with the introduction of digital technology. There are many excellent digital enlarger timers that count in $\frac{1}{10}$-second, 1-second and 10-second increments, and will give consistency and repeatability. Because I choose to use the f-stop printing method I have the Stop Clock Professional Enlarging Timer, which allows me to use increments of an f-stop as short as $\frac{1}{6}$ stop with a high degree of both accuracy and repeatability.

## Darkroom Safelights

The safelight is one essential item of darkroom equipment that many photographers take for granted and tend to ignore once it is installed. I have lost count of the number of photographers I have spoken to who have never checked the safelight in their dark-room, yet it could be the cause of prints that lack sparkle and life. Depending on the papers you use, you may need different safelights for different types, so it is worth checking the instructions included with the paper to see which filter is recommended. Even if you know that you have the correct filter for the paper you are using you should test it once a year, as filters fade and change over a period of time.

# Controls Used in Making Fine Prints

The methods I currently use have been modified over the years during which I have been making fine black-and-white prints. I also know that I will modify these techniques as and when better methods, materials and equipment become available, for I believe that we should never close our minds to any new development. Every photographer works in different ways and uses variations of the same techniques. The methods I describe are used in the making of all my fine prints and no doubt some widely used techniques are not mentioned. That is not to say that I do not approve of them: I just happen to use a different technique that I find more effective and that suits my way of working.

In describing my methods, I have assumed that you understand the various terms I use and are making black-and-white prints regularly. Improvements in variable-contrast (VC) paper over the past few years have provided a very powerful tool in black-and-white printing. Because of the nature of VC paper, it can be used as a single-graded paper, or more than one grade can be applied to different

parts of the same print, so I will explain the two processes separately. The techniques are discussed in general terms here, while more specific details relating to individual images are covered in the case studies in chapter 5.

## Single-Grade Printing: the Test Strip

A good test strip is the starting point and is essential in making a good black-and-white print, as you cannot guess the correct exposure. The test strip is your reference point and is the basis for all the decisions you will make in the production of the print. For the illustrations on these pages I used a full sheet of paper, but it is not necessary for you to follow this example – I normally cut a sheet of paper into three along the shorter length.

To ensure that you get maximum information from the test strip, take care to place it on the easel so that it covers all the tones in the projected image. Accurate timing is essential in order to be consistent and to achieve repeatability in making black-and-white prints. Use a starting time that is as short as possible, to give better and more accurate information on each increment of the test strip. For example, if you use 10-second steps each increment will be far less informative than if you use 3-second steps. When assessing the test strip, never choose the first or last increment as the exposure, as you have no reference point before and after these respective steps.

## The Pilot Print

Having chosen the base exposure time from the test strip, it is sensible to make the pilot print to help you identify where you need to manipulate the final print. The pilot print is

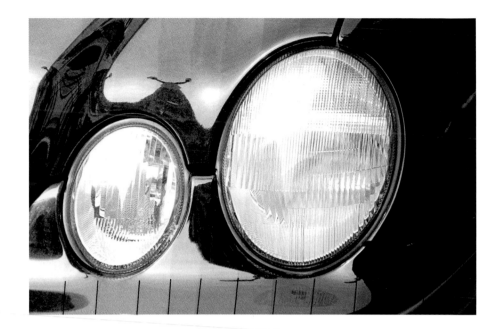

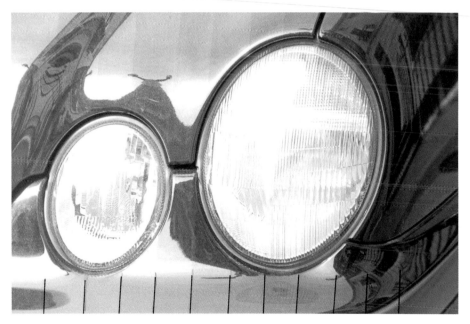

**Car headlights**

TOP

TEST STRIP MADE ON GRADE 2 ILFORD WARMTONE VC FIBRE PAPER, USING F-STOP TIMING. BASE EXPOSURE PLUS 11 X $^1/_6$ STOP INCREMENTS.

ABOVE

*This strip failed because there is not enough information in either the highlights or the darkest shadow.*

TEST STRIP MADE ON GRADE 2 ILFORD WARMTONE VC FIBRE PAPER.

**Car headlights**

simply an un-manipulated print made using the base exposure only. As you improve your printing skills, you will learn to assess the manipulations required direct from the test strip and thereby eliminate the need to make the pilot print. When I am faced with a negative that presents difficult decisions relating to contrast and burning and dodging, I still make a pilot print since I find that it helps to clarify my thinking and point me in the right direction. The pilot print is a very useful learning tool and I strongly recommend that you get into the habit of making one until you feel happy to assess the manipulations from the test strip.

## Print Developers

It is worth spending some time experimenting with different print developers. I know many photographers who use only one print developer, at the time and dilution recommended by the manufacturer. Perhaps they think that all developers, no matter which brand, do the same job – but I would encourage you to experiment, even with the one developer you prefer. The suggestions given in this chapter will help you to achieve subtle contrast control and colour changes in your black-and-white prints. In fact, no two developers will produce the same results, so it is worth trying a few different brands to compare the results before you decide which is best for you.

There are two main types of developer that are used to make normal black-and-white prints. The first, a **hard** developer, is any propriety brand, such as Ilford's Bromophen or Kodak's Dektol. Using these developers, and given that you expose the paper correctly, you will produce deep, rich blacks in your final print. The second type is a **soft** developer that will not produce deep rich blacks but will help to control subtle highlight tones. Centrabrom S by Tetenal and Grade Select by Fotospeed are two of the best of this type currently available.

## Dilution

The dilutions recommended by the manufacturers will produce good, consistent results and should always be the starting point in making black-and-white prints. However, changes in dilution should also form part of your thinking, especially when dealing with difficult high- or low-contrast negatives.

A stronger or weaker dilution than that recommended is a very useful tool in controlling contrast. For example, if the recommended dilution is 1 part developer to 9 parts water, I have improved contrast significantly by using a 1 to 3 dilution. This works especially well in conjunction with a harder paper grade and when the negative is lacking in contrast. A hard developer used with increased dilution, such as 1 part developer to 20 or 30 parts water, instead

of the recommended 1 to 9, is useful in helping to reduce contrast when printing a high-contrast negative.

When using a soft developer, I always use a much weaker dilution than recommended. For example, the dilution of Centrabrom S is normally 1 part developer to 9 parts water, but I prefer to use it at 1 part developer to 20 parts water as this allows the highlights to develop slowly and is very useful when making high-key prints.

I believe that print colour is an important consideration in making a fine print. Viewers are likely to have a different response to warm-toned prints than they do to prints that are cold-toned. I generally prefer my landscapes to be warm and my documentary and people photographs to be cold in print colour. Different photographic papers have warm or cold characteristics, and the colour can be further controlled by developer dilution. For example, try using warm-toned paper, such as Ilford Warmtone VC, in a very dilute developer and you will find that the final print is much warmer in tone than normal. The print exposure will have to be adjusted, but this is automatically taken care of when you make and assess the test strip that has been processed in the dilute developer. Reduced and extended development times will have a bearing on print contrast and colour.

I have spent considerable time experimenting with developer dilution and time, in conjunction with different papers, to learn about how these things change the final print. It has been well worth the effort, and has taught me a great deal about how to get the best out of a negative and control the contrast and colour of the final print.

## Burning and Dodging

Most prints need some manipulation in order to communicate the message contained in the image. Contrast and tonality are very influential in achieving that communication. No matter how the film is exposed and developed, whether filters are used, or which paper grade is selected, almost all prints require some burning and dodging. I have made thousands of negatives over the many years that I have been obsessed with photography and still have no more than a handful that will print without some manipulation.

There are a number of reasons for burning or dodging a print. Perhaps the most common reason to burn in is to darken the sky and thereby add drama to a landscape photograph. Sometimes prints need to be balanced because one side is lighter in tone than the other, while fussy background detail can be subdued by careful burning in. Dodging, or holding back, an area of the print is often used to lighten a skin tone, especially in candid photographs, when the available light cannot be controlled by the photographer. Whatever the reason for using it, burning and dodging is a darkroom skill that is essential in the creation of a fine black-and-white print.

**Near Fort William, Scotland**
*Test strip to determine burning in for the sky. I selected the last step as the burning-in exposure.*

## Near Fort William, Scotland

RIGHT

*Final print made on grade 3 Ilford Warmtone VC fibre paper: sky burned in 1 stop using the light area just above the hills as a buffer area when using black card to reduce the halo effect. This image was made at dusk – the early-evening light was quite dark but gentle, and there was a quiet stillness broken only by the sound of the water in the loch splashing on the rocky shore. The dark tonality of the print is my way of reflecting that mood.*

PRINT MADE ON GRADE 3 ILFORD WARMTONE VC FIBRE PAPER.

BELOW

PILOT PRINT MADE ON GRADE 3 ILFORD WARMTONE VC FIBRE PAPER.

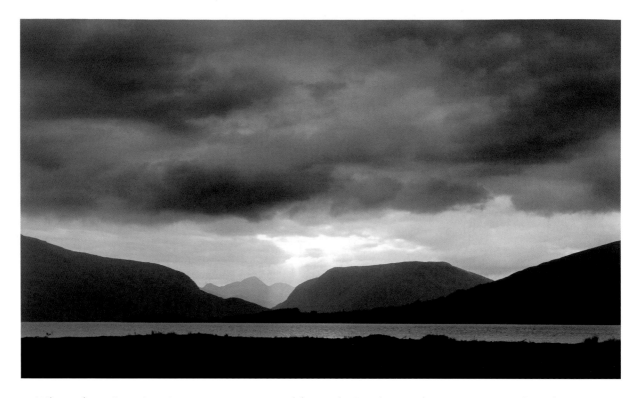

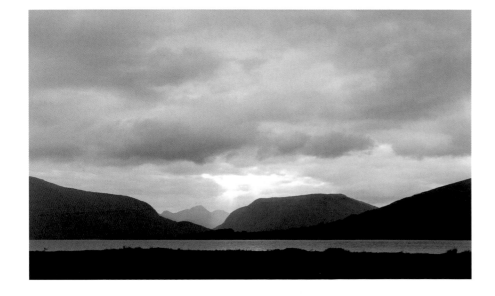

When burning in, I use a 25-year-old piece of black mount card that is now very flexible due to continual bending during its life. The flexibility makes the card a very useful tool, as it can be bent and twisted when required to suit the shape of the area being burned in. For most of my burning in I tend to work on small areas and keep the card moving at all times, at the same time bending it into a 'V' shape. I also exaggerate the movement across the area I am burning in and allow some light to spill into the part of the image I do not wish to darken. This method is very helpful in eliminating the halo effect.

By holding the card as near to the enlarging lens as possible, you will create an effect known as the penumbra. This is a soft, feathered shadow that can be used to blend the burning in to help reduce the halo further. When you are next in the darkroom, hold a piece of card near to the enlarging lens and then near to the easel and note the difference in the shadow cast by the card. When I need to burn in a very small area, I use a large black card with a ragged aperture cut into the centre, no larger than 2.5cm (1in) on the

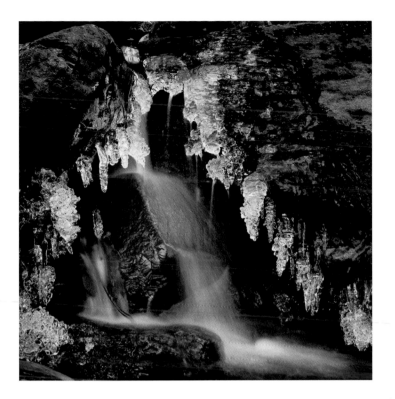

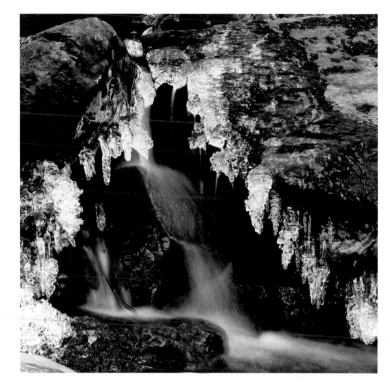

**Ice cave**

*Final print. The triangles at the top right and top left were burned in ¹/₂ stop, picking up bright highlights on the ice by allowing a small amount of light spill; the base on the left-hand side was burned in 3 stops, and the central area held back ³/₄ stop. All burning in was carried out using black card to create a soft penumbra. I found this area on a small stream in the English Lake District. I had been photographing there for nearly a week and during that time, because of the continued extreme cold, the ice gradually built up on the rocks around the stream, creating this frozen canopy.*

PRINT MADE ON GRADE 4 ORIENTAL SEAGULL FIBRE PAPER DEVELOPED IN FOTOSPEED GRADE SELECT.

**Ice cave**

PILOT PRINT MADE ON GRADE 4 ORIENTAL SEAGULL FIBRE PAPER DEVELOPED IN FOTOSPEED GRADE SELECT.

strip and, to some extent, on experience. The information provided by the test strip is based on continuous exposure, with each increment receiving a pre-determined exposure. When burning in, the card is continually moving, so the exposure is not exactly the same as that on the test strip. Therefore, I use the information on the test strip as a guide but increase the time, sometimes by as much as 100 per cent. This may seem excessive: I would suggest that you carry out a test to prove this point to yourself. First make a pilot print, then make another three or four prints with increasing amounts of burning in using the method described above, from, say, 25 per cent to 100 per cent more than the base exposure.

A useful tip when burning in next to a very light area such as white water is to dodge the water for a short time during the base exposure. When you burn in the adjacent area, you

longest side. The edges of the aperture are deliberately not clean-cut to ensure that the light projected through it is softened, thereby helping to eliminate evidence of the burning in.

The calculation of the burning-in exposure is based on assessing the steps on the test

**Beech wood**

TOP

GRADE 2 ILFORD WARMTONE VC FIBRE PAPER. STRAIGHT PRINT DEVELOPED FOR 2½ MINUTES IN UNDILUTED BEERS HARD DEVELOPER ONLY.

ABOVE

GRADE 2 ILFORD WARMTONE VC FIBRE PAPER. STRAIGHT PRINT DEVELOPED FOR 2½ MINUTES IN BEERS SOFT DEVELOPER DILUTED 1 TO 3.

can allow light to spill on to the water to bring it back to the desired tonality. You will find that as you produce more prints and make these judgments and decisions, you will quickly learn to assess the burning and dodging times accurately.

# Contrast Control

I have already mentioned the importance of contrast and tonality in communicating the message held in the final print. You therefore need to learn about the controls and techniques used to achieve the contrast you require.

There are many techniques that can be used in the battle to control contrast. We have considered the benefits of developer dilution; two-bath and water-bath development offer subtle variations and controls; pre- and post-flashing is an old and little-used technique that I feel is sadly neglected by printers. Local bleaching, which can be carried out in normal white light after the print has been made and fixed, is a powerful tool. Even toning in selenium and gold can change the contrast as well as the colour of the final print.

## Paper Grade

The first consideration is your choice of paper grade, which can have a significant effect on the visual and emotional impact of the final print. Generally, a high-contrast grade will produce a more dramatic end result, with a softer grade yielding a more gentle final print. There is a school of thought that we should aim to produce the negative that will always print on one grade, usually grade 2. I agree that we should be

consistent in negative production, but I believe that the final print can be made on any of the grades. The prints will be different, but that is partly as a result of your personal vision and expression.

## Two-Bath Development

Two-bath print development is a very useful tool that allows for subtle variations in contrast control. The procedure is quite flexible as there is no set time in either bath, although I always give a full development time – usually 3 minutes. The print can be moved from one developer to the other, depending on the contrast required in the final print. My method is as follows.

Expose the test strip as normal and develop fully in the hard developer – do not use the soft developer at this stage. When I am assessing the test strip, I note the overall contrast in the chosen increment. If I feel it is too high, I then need to decide whether to use a lower paper grade or some other method to achieve the required contrast. In these circumstances, two-bath development can be invaluable, as the soft developer allows the highlights to develop slowly and while the shadows and dark tones continue to develop they will not block up. I frequently use a very low-dilution hard bath together with a high-dilution soft bath, which allows me total control over the contrast of the final print.

## Water-Bath Development

A water bath used in conjunction with a normal developer such as Bromophen or Dektol is a good method if you have a high-contrast negative and experience difficulty getting detail in the highlights without blocking up

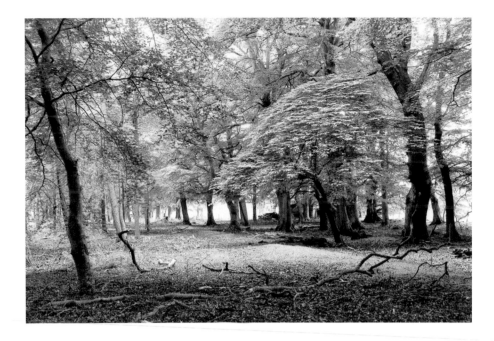

the shadows. I assess the test strip and choose the exposure that gives just a hint of detail and tone in the highlight. Usually, a high-contrast negative given this exposure would result in blocked-up shadows if only normal developer is used. However, by dividing development between the developer and plain water this can be avoided.

Prepare a tray full of plain water at 20°C and place it next to the developer tray. Give the print the exposure you decided on after assessing the test strip and place it in the normal developer until the image starts to appear. Using two hands, lift the print out of the developer and, without draining, smoothly slide it into the water bath and allow it to sit in the tray without giving any agitation. Observe the print while it is in the water and you will notice that the highlight continues to develop after the shadows have stopped. The reason for this is that the developer quickly exhausts on the shadow areas but continues to work on the highlights. It is

**Beech wood**

*The three prints above and opposite show how using different methods of development can change the feel of the final print. I prefer the straight print processed in soft developer only, because it conveys the softness of the wood that I find attractive and enjoy when I go there to take pictures.*

Grade 2 Ilford Warmtone VC fibre paper. Divided development in Beers two-bath developer, 10 seconds in hard developer only, followed by 2¹/₃ minutes in soft.

**Harley Davidson**

PILOT PRINT MADE ON GRADE 3 ILFORD WARMTONE VC
FIBRE PAPER. EXPOSED FOR THE HIGHLIGHTS AND DEVELOPED
IN NORMAL DEVELOPER BROMOPHEN 1 TO 3 FOR 2$\frac{1}{2}$
MINUTES.

BELOW LEFT

EXPOSURE REDUCED BY $\frac{1}{3}$ STOP TO COMPENSATE FOR
INCREASED DEVELOPMENT. PRINT DEVELOPED USING THE
WATER-BATH TECHNIQUE, DEVELOPMENT TIME 1 MINUTE IN
BROMOPHEN AND 6$\frac{1}{2}$ MINUTES IN WATER.

essential that you do not agitate the water bath at any time, as this would remove the developer that is sitting on the surface of the print. The print can be left in the water bath for up to 1 minute and then returned to the developer to recharge, before being put back into the water bath. I have used this method for up to 12 minutes to develop the highlight to the required density, though if you intend to prolong the development you will need to adjust the exposure time to compensate.

# Pre- and Post-Flashing

Pre-flashing is a method of controlling contrast by pre-sensitizing the paper with an exposure to white light. It reduces the contrast and improves the tonal range, and while generally used to improve highlight detail it also opens up the shadows. The initial exposure to light does not produce any tone on the paper – it simply eliminates the inertia to light. When controlling contrast by sensitizing the paper, it is usual to flash before exposing the paper to image-forming light; however, there are circumstances when I would suggest post-flashing is preferable to

| 12 seconds | 10 seconds | 8 seconds | 6 seconds | 4 seconds | 2 seconds | No exposure |

pre-flashing, as it provides significant improvements in control of the technique.

When faced with a particularly difficult high-contrast negative, in which the highlights appear to be completely burned out, I use controlled fogging to help print in the detail. Fogging actually puts tone on to the paper, but it is possible to fog a sheet of paper and retain delicate highlight detail without ending up with a degraded, flat image.

## Method for Pre-Flashing

First you need to carry out a simple test to determine the exposure to white light that is required to sensitize the paper. Because all papers have different speeds, you must test each paper separately. White light can be from any light source, but you also need an accurate method of timing the exposure. I use a Print Flasher that has a battery-driven light source which can be attached to the enlarger lens panel, and a built-in timer. If you do not have a Print Flasher, a second enlarger can be set up as a flashing enlarger, which eliminates the need to remove the negative from the working enlarger. If you have only one enlarger available, the flashing exposure can be carried out by removing the negative and the carrier and replacing it with a second carrier which has no negative in it. Leave the enlarger head at the height selected for the enlargement as this will cover the area to be flashed. Stop down the lens fully and place a strip of photographic paper on the easel.

Using a piece of black card, cover a 2.5cm (1in) section along the whole length of the test strip. With a pencil, put indicator marks at about 2.5cm (1in) intervals along the opposite edge of the test strip – eight to ten should be sufficient. Using a second piece of black card, cover the test strip up to the first of these marks and expose to the white light of the enlarger – I normally use 2-second intervals. Move the card in sequence through each of the remaining indicator marks, exposing each one for the chosen time. Process the test strip as normal, and after a short wash, dry it either in a microwave oven or with a hair dryer.

The test strip is now ready to assess. The maximum pre-flash exposure is the one before the first step on the test that shows tone. To

**Boy on Brighton pier**

PRE-FLASH TEST STRIP MADE ON ORIENTAL SEAGULL GRADE 4 FIBRE PAPER. CORRECT PRE-FLASH EXPOSURE 4 SECONDS.

*Half the paper has been given a 4-second pre-flash exposure, followed by the image-forming exposure. You can see the improvement in the detail on the side that has been pre-flashed.*

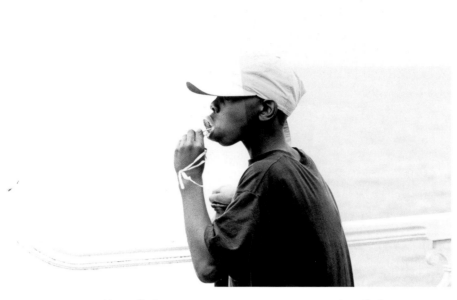

*No pre-flash exposure*      *4-second pre-flash exposure*

maintain consistency when making a print that requires a pre-flash exposure, all tests and prints should be flashed prior to the image-forming exposure. When the flashing exposure has been made, replace the carrier with the negative in the enlarger and check the focus to ensure that it has not moved during the flashing procedure. If you are reluctant to remove the negative, a second way to flash with only one enlarger is to place a diffusing material in front of the lens when you make the flashing exposure. The exposure will be somewhat longer but the result will be the same.

## Method for Post-Flashing

I use post-flashing to help improve delicate highlight detail or to deal with overexposed highlights when printing a high-contrast negative. Post-flashing can be described as a technique used to rescue a negative that has been both overexposed and overdeveloped.

First make a test strip, with the negative in place in the normal manner when making a print, to determine the correct image-forming exposure. When you have selected the desired exposure for the print from this test strip, place a second test strip in the easel and give the whole strip the image-forming exposure selected from the first test strip. Leave this test strip in place, cover part of it with a piece of card and expose up to ten increments to white light in the same way as described above for pre-flashing. When this test strip is processed, you will see the image with a series of grey tones across

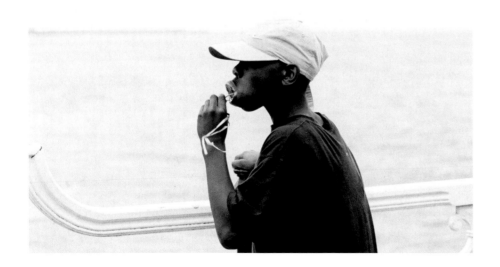

**Boy on Brighton pier**

*The whole sheet has been given pre-flash, followed by the image-forming exposure with no manipulation. I was leading a candid photography workshop in Brighton when I saw this boy with some of his friends eating lollipops. He responded immediately to the camera when I approached to ask if I could take a photograph.*

35MM KODAK TRI-X, DEVELOPED IN FOTOSPEED FD 30 1 TO 9 FOR 6 MINUTES AT 20°C; PRINTS MADE ON ORIENTAL SEAGULL GRADE 3 FIBRE PAPER, DEVELOPED IN ETHOL LPD.

it: these are the post-flashing exposures. You will also see that the detail in the image is significantly improved. Select the post-flashing exposure that gives the required detail and apply it to the final print, but only after you have made the image-forming exposure.

# Split-Grade Printing

VC paper has given the black-and-white printer a versatile tool in the search for the fine print. The convenience of having five grades in one box and being able to use all five on one print is a huge benefit.

VC paper has also given us the possibility of using split-grade printing as a tool with which to control contrast. During my early sessions with VC paper in the darkroom, I realized that not only could I make a print using a single grade but I could select different grades to use on various parts of the same print when the contrast of the negative was high. A few weeks later, when working with a particularly difficult high-contrast negative, I realized that the contrast was, in fact, working *for* me rather than against.

## The High-Contrast Negative: Why Split-Grade Printing Works

Before going into the fine detail of the method of split-grade printing I use, let me first explain how it works and why I now consider high contrast as working for me. I believe that split-grade printing works because the high-contrast negative acts as a mask when the paper is being exposed to the hard grade. The highlights are the densest part of the negative, and the combination of this together with grade 5 filtration acts as a mask, which blocks the light from reaching the paper. So, the higher the contrast in the negative, the more efficient the blocking effect, which in my view gives the printer a wonderful tool in the search for the fine print that glows. I no longer worry too much about the contrast range of the subject, because I know that my method of split-grade printing will deal with most high-contrast negatives. When I do produce an extremely high-contrast negative – we all make mistakes – I use white light as an additional contrast control, as described on pages 79–80.

## Why Grade 0 and Grade 5?

When split-grade printing with VC paper I use only grade 0 and grade 5, and refer to them as soft and hard filtration. I am not really interested in knowing which grade I have used: my only concern is to achieve the level of contrast I judge to be correct for the print I am making. When making a print, I make two exposures. The first, using grade 0 or soft filtration, determines the exposure time for the highlights only. The second, using grade 5 or hard filtration, is overlaid on to the soft, and this determines the density of the shadows and establishes the contrast of the final print.

I have found that by using the extremes of soft and hard filtration I can achieve maximum control over the black-and-white printing process. I use the soft filtration, grade 0, together with the shortest exposure possible to establish my print highlight value. Using the combination of hard filtration, grade 5, and careful exposure control I produce maximum black through the thinnest part of the negative. This in turn gives me

Base
exposure

Soft
exposure,
grade 0

Soft
filtration
exposure
only,
grade 0

Base
exposure,
hard
filtration,
grade 5

Hard
exposure,
grade 5

the best possible separation in the shadows. Having established the required tonality for the highlights and shadows, I can manipulate the mid-tones by adjusting the exposure times of soft and hard filtration without affecting the tones at the top and bottom end of the tonal scale. In effect, I am controlling the contrast by time and not by paper grade. This method of using VC paper has eliminated the need to use grades 1 to 4, as I believe it allows for more control in the process and results in better prints.

## The Process

As a starting point in split-grade printing, I always establish the exposure time for the highlights, which means that soft filtration or paper grade 0 will be used.

Select grade 0 and make a test strip in the usual way, process as normal and then view it to determine the best exposure to establish the desired tonality of the highlights only. I place great importance on making the test strip, because this is the reference point that will be referred to at each stage of the print-making process. Ignore the low values at this stage as they will look very flat and muddy on

## Car headlights

SPLIT-GRADE PRINTING. STRAIGHT PRINT, GIVEN GRADE 0 EXPOSURE FOLLOWED BY GRADE 5 EXPOSURE.

*Final print, given the same exposures as the straight print. The dark areas to the right and left were held back 3/4 stop, and the highlights in both headlights burned in 1/2 stop, during grade 0 exposure.*

PRINTS MADE ON ILFORD WARMTONE VC FIBRE PAPER, USING SPLIT-GRADE PRINTING, DEVELOPED IN ILFORD MULTIGRADE.

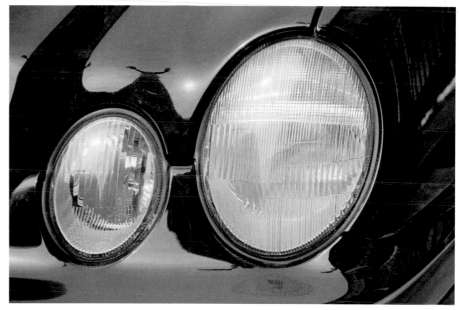

this test strip, although the information there will be used at a later stage in the process.

Select the exposure that you consider will give you the highlight tonality you require, then lay a second test strip across the base board in the same place as the first test and expose the whole piece of paper for the time selected for the soft filtration. Without moving the test strip, select hard filtration or grade 5 and expose as if you are making another test strip. You will now have a second test that has been given an overall soft exposure, overlaid with bands of hard exposure. When exposing the hard filtration it is a good idea to cover the first band of the test strip, leaving it as a reference point of the soft filtration exposure only. Process the second test strip as normal and assess it, this time to determine the exposure required for the hard filtration; at the same time, note how and where the hard filtration has affected the highlights.

The first thing to note is that the highlights will look considerably brighter when compared to the first band on the test strip, the soft filtration reference point. The most delicate area of highlight remains relatively

untouched by the hard grade laid over the top of the soft. However, those areas of the highlight that are of a slightly lower value will be a little darker than when printed with the soft grade only, which increases the local contrast of the print.

The decision as to how much exposure to give the hard grade now has to be made, and

after assessing the depth of tone in the lower values I select the band that shows richness and depth but no loss of detail. The highlights will be of the same density when compared to the soft test strip, but there will be a significant increase in the contrast. Having selected the required exposures for both soft and hard grades, now make a print.

It is important to be consistent and always make the soft and hard exposures in the same order. I suggest you make the soft exposure first. The reason for this is simple: if the first test strip is made using grade 5 and establishes the maximum contrast available from the paper you are using, any soft filtration subsequently added will reduce the contrast and the resulting print will be significantly lower in overall contrast than you had visualized. Try it for yourself.

The prints reproduced here demonstrate the steps in the process of split-grade printing. I always work methodically and make decisions based on tests. I deal with one step at a time and move on to the next only when I am happy that the previous step is correct. In a sense, I build the print in much the same way as building a house: beginning by laying a good foundation. Simple split-grade printing has improved the control I can use to produce the fine print, and at the same time I can generally expect to have less wastage of materials. However, the most significant thing is that my prints have improved enormously as a result of using this method of printing. I'm sure that you have many high-contrast negatives sitting in your files waiting to be printed. Give them an airing and print them using this method of split-grade printing – and discover for yourself that contrast is an ally that has been waiting for years to be used.

# Print Colour and Toning

I believe that the colour of the final print will influence the viewer's response and I therefore take that into consideration when making the print. There are many ways to manipulate the colour of a black-and-white print, ranging from choice of paper, developer brand and dilution to toning in selenium, gold or one of the many other toners that are readily available.

Because the colour of the final print is very subjective, I recommend that you spend some time at the end of each printing session testing different developers and dilutions, even toning old prints in a variety of toners. And be adventurous in the tests. For example, use very dilute developers and leave the print to process for more than your standard time – I have processed prints for up to 1 hour in very dilute developer and was extremely pleased with the very warm prints that resulted from that experiment. One of my favourite effects is a split-toned print where I tone a print for about 60 minutes in selenium, wash for 20 minutes and then tone in gold for up to 90 minutes.

# Print Dry Down

When making black-and-white prints, I make all the decisions relating to exposure and burning in by assessing the wet test strip. Only before making the final print do I adjust the exposure I have decided on to allow for dry down. This phenomenon affects fibre papers more than resin-coated (RC) papers and is responsible for prints being much

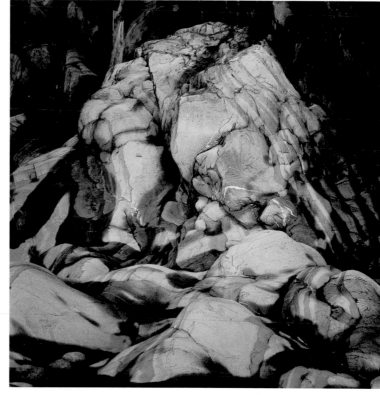

## Rock, Friog, Wales

*I made these three prints on Ilford Warmtone VC fibre paper because it tones well. You can see that the print toned in selenium is slightly cooler in tone than the untoned print, and there is an increase in contrast because the low values are darker. The print toned in selenium and gold is also higher in contrast for the same reason, and is significantly cooler than the print toned in selenium only.*

120 KODAK T MAX 100 DEVELOPED IN HC110 1 TO 31 FOR 8 MINUTES AT 20°C; PRINTS MADE ON ILFORD WARMTONE VC FIBRE PAPER, DEVELOPED IN ILFORD MULTIGRADE.

ABOVE
*Untoned version.*

ABOVE RIGHT
*Toned in selenium diluted 1 to 9 for 10 minutes.*

RIGHT
*Toned in selenium diluted 1 to 9 for 25 minutes, washed for 20 minutes, toned in gold for 45 minutes, then washed for a further 20 minutes.*

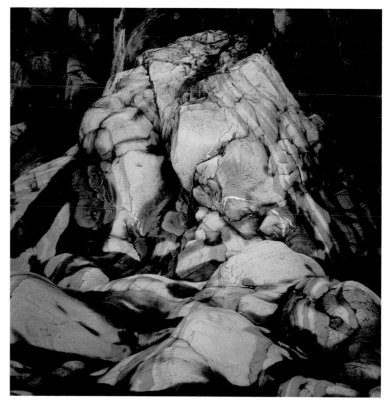

**Colin**

*No dry-down factor applied. You can see how the detail is lost in the door to the right of the figure and the deep black creates the feeling of a solid wall blocking entry. The impression of bright sunlight is also quite subdued.*

**Colin**

*This is how the wet print looked after applying the 11 per cent dry-down factor. You can see that there is no detail or tone in the white hat and very little in the light-toned walls.*

darker when they are dried. Correctly exposed wet prints look exciting and glow – but how often have you been disappointed when you view the print once it is dry? This is dry down.

The simple solution to this problem is to anticipate the amount of dry down that will occur and allow for it when making the final print. There is a very simple test you can carry out that will eliminate any need for you to think about the problem of dry down. Because papers can have a different dry-down factor, you will need to test all the papers you use.

## Calculating the Dry-Down Factor

Select a negative with a good range of tones and make a straight print with no burning or dodging which, when wet, shows the high-lights as you wish them to be in the final dried print. (You do not need to make large prints for this test, since the dry-down factor does not change with paper size – I cut a 10x8in sheet of paper into four and make small prints.) Make a second identical print. Identify these two prints as nos 1 and 2 in pencil on the back. Make a note of the exposure, then calculate 8 per cent of the time and deduct this from the exposure given to print no. 1. Make a print using the revised exposure and mark 8 per cent on the back. Follow this procedure using 9, 10, 11 and 12

**Colin**
*After assessing the exposure from the wet test strip, I applied a dry-down factor of 11 per cent to this print. The exposure was made on a very bright, sunny day and I wanted to express this in the final print. The white golf hat was lit by bright sunlight and I chose to keep the delicate, almost paper-base white tonality in the final print to reflect this. The detail in the door adds a feeling of depth to the image.*

ILFORD DELTA 100 DEVELOPED IN ID11 1 TO 1 FOR 6.25 MINUTES AT 20°C; PRINT MADE ON GRADE 4 ORIENTAL SEAGULL FIBRE PAPER, AND DEVELOPED IN ILFORD MULTIGRADE.

per cent, remembering to mark each print with the dry-down factor used. After fixing, wash as normal and dry all the prints except no. 1, which should be left in a holding tray of fresh water. I use a microwave to speed up the drying process.

## Assessing the Results

Compare the dried prints with the print left in the holding tray. Comparison of the wet no. 1 print with the dry no. 2 print will illustrate the extent of the dry down. The dry-down factor for the paper tested is the percentage shown on the back of the dried print that matches the wet print in the holding tray. Thereafter, when making the

final print, reduce the exposure given to the test strip by the dry-down factor for the paper being used.

In the 25 years that I have been making black-and-white prints, I have found that the dry-down factor is likely to fall between 8 and 12 per cent. I test all the papers I use once a year, as paper characteristics can change over a period of time. Remember that the final print, when wet, will look lighter than the test strip. My final prints have no tone at all in the highlights when wet but I know that they will dry down to look the same as the wet test strip, so I am not tempted to make a second, slightly darker, print.

| Exposure wet test strip | Exposure 8 per cent dry down | Exposure 9 per cent dry down | Exposure 10 per cent dry down | Exposure 11 per cent dry down | Exposure 12 per cent dry down |
|---|---|---|---|---|---|
| 5 | 4.6 | 4.6 | 4.5 | 4.4 | 4.3 |
| 6 | 5.5 | 5.4 | 5.4 | 5.3 | 5.2 |
| 7 | 6.4 | 6.4 | 6.3 | 6.2 | 6.1 |
| 8 | 7.4 | 7.3 | 7.2 | 7.1 | 7.0 |
| 9 | 8.3 | 8.2 | 8.1 | 8.0 | 7.9 |
| 10 | 9.2 | 9.1 | 9.0 | 8.9 | 8.8 |
| 11 | 10.1 | 10.0 | 9.9 | 9.8 | 9.7 |
| 12 | 11.1 | 10.9 | 10.8 | 10.7 | 10.6 |
| 13 | 12.0 | 11.6 | 11.7 | 11.6 | 11.4 |
| 14 | 12.9 | 12.3 | 12.6 | 12.5 | 12.3 |
| 15 | 13.8 | 13.6 | 13.5 | 13.3 | 13.2 |
| 16 | 14.7 | 14.6 | 14.4 | 14.2 | 14.0 |
| 17 | 15.6 | 15.5 | 15.3 | 15.1 | 14.9 |
| 18 | 16.5 | 16.4 | 16.2 | 16.0 | 15.8 |
| 19 | 17.5 | 17.3 | 17.1 | 16.9 | 16.7 |
| 20 | 18.4 | 18.2 | 18.0 | 17.8 | 17.6 |
| 21 | 19.3 | 19.1 | 18.9 | 18.7 | 18.5 |
| 22 | 20.2 | 20.0 | 19.8 | 19.6 | 19.4 |
| 23 | 21.1 | 20.8 | 20.7 | 20.5 | 20.0 |
| 24 | 22.1 | 21.8 | 21.6 | 21.3 | 21.0 |
| 25 | 23.0 | 22.7 | 22.5 | 22.3 | 22.0 |
| 26 | 23.9 | 23.7 | 23.4 | 23.1 | 22.8 |
| 27 | 24.8 | 24.6 | 24.3 | 24.0 | 23.7 |
| 28 | 25.7 | 25.5 | 25.2 | 24.9 | 24.6 |
| 29 | 26.7 | 26.4 | 26.1 | 25.8 | 25.5 |
| 30 | 27.6 | 27.3 | 27.0 | 26.7 | 26.4 |

I now use a Stop Clock Professional Enlarging Timer which has a built-in feature that automatically accounts for dry down when it is activated. Before I had the Stop Clock Timer, I used the table reproduced above to calculate the correct adjusted exposure to account for print dry down. All times are in seconds. To adjust for dry down, reduce the final print exposure to the time shown in the column opposite the wet test strip time at the dry-down factor you have established for the paper you are using. For example: if the wet exposure is 21 seconds and the dry down factor is 11 per cent, the adjusted exposure is 18.7 seconds.

# Bleaching

There are times when the contrast of the final print is too low. All is not lost, as it can be increased by the application of potassium ferricyanide, a solution that lightens highlights when applied with an old spotting brush or cotton wool. Commercially available as Farmer's reducer, potassium ferricyanide can be purchased as raw chemicals and mixed as you need it. Pot ferri, as it is commonly known, is a poison and should be stored in a clearly marked container and handled with care.

If you choose to mix your own pot ferri from raw chemicals, start by mixing 10g of potassium ferricyanide in 100ml of warm water to make a 10 per cent stock solution. To use it as a working solution, pot ferri has to be diluted further, otherwise the bleaching action is too vigorous and virtually impossible to control. A good starting point is to mix 5ml of stock solution with 300ml of water and 50ml of normal-strength print fixer. It is preferable for the solution to be too weak rather than too strong.

Prints can be bleached in normal light at any time after fixing. My preference is to bleach during the printing session as soon as the print has been fixed for 50 per cent of the normal time. If this is not possible, fully fix the print and wash and dry as normal. When you are ready to bleach it, place three trays in the working area, with water in the first to use as a holding bath. Place a sheet of plate glass on which to lay the print across the top of the second tray, and put print fixer in the third. Place the prints in the water holding bath for at least 10 minutes before starting, to ensure that they are well soaked. Mix the solution of pot ferri just before you begin, as it has a short working life. Place the wet print on the glass and remove the excess water with a small rubber squeegee to ensure that the bleach will not run outside the area on which you are working. Keep a large swab of cotton wool charged with fixer close by, so that you can neutralize the bleach immediately if it gets out of control.

When bleaching very small areas I generally use an old spotting brush to apply the pot ferri; otherwise, a swab of cotton wool about the size of a standard watch face works well. Apply the solution and keep the swab or spotting brush moving at all times. After about 10 seconds, apply fixer from the large swab of cotton wool over the area you have been working on, to stop and neutralize the bleaching action. Alternatively, you can use running water from a hose to stop the bleaching action, but this requires a wet area in your darkroom. If you do not have this facility, you can use a tray of plain water to rinse the print after each application of fixer and then start the process again. If you do use water to stop the bleaching, it is a good idea to immerse the print in the tray of fixer after every third application of the bleach, to ensure that it is fully neutralized. I adopted this method many years ago, when my prints began to stain in the areas I had previously bleached – I have not had a stained print since. Staining generally occurs when the bleach is too strong or has been left on the print for too long. Once the print has stained, it is permanent.

After the first application, you should not see any change in the tonality of the area being bleached. If you do, the bleach is too strong and needs further dilution. I normally expect to apply the bleach at least three to

bleach on any print tonality and achieve very interesting and creative results. Try the method described, and when you have learned to control it, start experimenting on old prints with stronger bleach to see what can be done.

# Ferricyanide Bath

A very old method of adding a sparkle to highlights, which was used by photographers in the 1930s and 1940s, is a ferricyanide bath. Using this method, you can deliberately overprint and bleach the highlights back by immersing the whole print in a weak solution of potassium ferricyanide. Initially, the ferricyanide will lighten the highlights without affecting the darker tones, consequently increasing the contrast of the print. Prolonged bleaching will eventually begin to affect the darker tones. The procedure is as follows.

Prepare a weak solution of ferricyanide, starting with 10ml of the 10 per cent solution (see page 89) and 50ml of print fixer in 2 litres of water, and test it for strength using an old print. When you are satisfied with the dilution of the bleach, place the presoaked print in the ferricyanide solution and gently agitate the tray for 30 to 40 seconds, before removing to stop the bleaching by immersing it in a tray of fixer or water. Inspect the highlights and repeat until the print is to your liking.

Before you try these methods on final prints, practise on old prints until you have learned how to control the bleaching process. Like many techniques used in making fine black-and-white prints, bleaching requires a lot of patience.

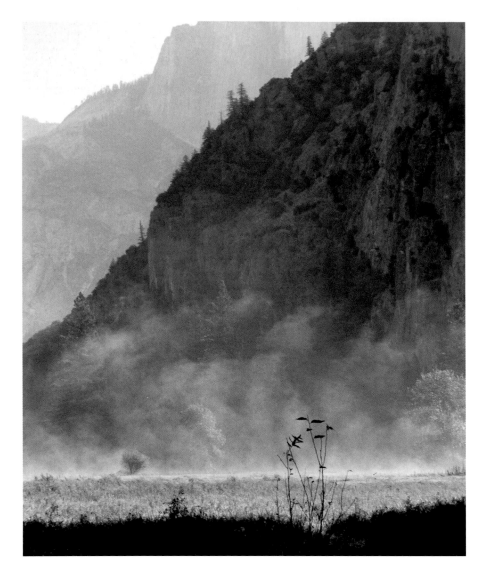

**Meadow, Yosemite Valley**
*Unbleached print.*

ILFORD DELTA 100 DEVELOPED IN ID11 1 TO 1 FOR 6.25 MINUTES AT 20°C. PRINTS MADE ON GRADE 4 ILFORD WARMTONE VC FIBRE PAPER USING SPLIT-GRADE PRINTING, DEVELOPED IN FOTOSPEED GRADE SELECT.

four times before I notice any change in the tonality. When you spot the first lightening of the highlights, work very carefully by applying the bleach and immediately neutralizing it with water or fixer. If you can see the bleach working in one application it is likely that you will not be able to control and stop the action, and the end result will almost certainly be an area of paper base white instead of the delicate highlight detail you had visualized.

I bleach only highlights using this method, but I do know of photographers who use

# The Role of the Printer

When I go into the darkroom to make prints, I think of myself as a problem solver. I have had an idea, seen an event or witnessed some quite exquisite light that I have captured on film, and I want to commit it to an expressive black-and-white fine print. I have a negative and some photographic chemistry and paper, and I know that I am facing some difficulties in making the print. Over the years that I have been making prints I have experienced many disappointments, emerging from a printing session less than happy with the results of my endeavours. Consequently, I am pretty much obsessed with finding a way to solve all the printing problems I have encountered and have spent many happy hours doing just that in the darkroom – but I have never forgotten that the content of the print is by far the most important aspect of photography.

In this chapter, I have covered the main darkroom techniques that I employ in making black-and-white prints and I suggest that you try them to see how they work for you. There are many different darkroom dodges and methods, and you should remember that sometimes there are several different options that will solve the same problem. Each will produce a subtly different end result, but none of them is wrong – your job is to decide which is best for you. Sometimes you will need to use more than one technique to produce the result that you visualize. If you know what you want and spend time learning and perfecting the darkroom techniques described here, you will have little difficulty in deciding how to solve your printing problems. The techniques I have explained are merely a starting point for you to use and perhaps modify when you think you have worked out a method that suits you.

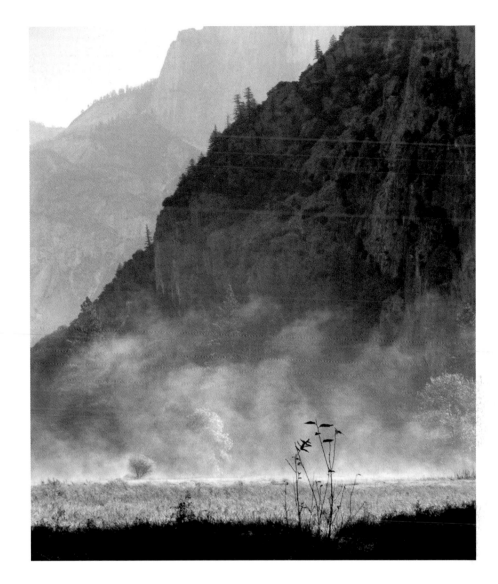

**Meadow, Yosemite Valley**
*This print was bleached to create the impression of mist lit by sunlight. I made this photograph on an early autumn morning, as the mist was beginning to disperse. I did not have much time to capture the light, as I arrived at the spot a little too late. I had to work quickly, but I knew that I had missed the best conditions and would have to do some manipulation on the print to re-create the quality of the light and mist that I saw.*

# 5 Case Studies

The photographs shown in the following pages are some of my favourites. In selecting them, I have put together a set of images that express my views and feelings about the subjects I choose to photograph. In the accompanying text I have described why I decided to make the photograph, as well as how I visualized it and made the final print. To make the prints, I have used the various techniques described throughout the book in an attempt to help you understand how I think at all stages in the process. Please remember that these are *my* views and methods, and are most definitely not the only way to make successful photographs. The techniques I describe work for me – but my aim is to help you to find your own direction and work out your own methods in your photography.

**Tree, Yosemite**

*Yosemite is truly a wondrous place and I have had the pleasure of making photographs there several times. I made this image one autumn morning in a meadow close to the campsite where I was staying. The overnight dampness had turned to rising mist, and as the temperature continued to rise the mist began to burn off, so I had to work quickly to capture the magical quality of the light. I would have preferred a more elegant and shapely tree, but because I had very little time left before the mist disappeared completely I used the tree shown here. I shot the negative on a Mamiya 645 with a 210mm Sekor lens. The final print conveys the atmosphere I saw at the time I made the exposure and, on reflection, I am pleased that I didn't find a more conventional tree, as this image is really about light.*

ILFORD DELTA 100, DEVELOPED IN ID11 1 TO 1 FOR 8 MINUTES AT 20°C; PRINT MADE ON ILFORD WARMTONE VC FIBRE PAPER USING SPLIT-GRADE PRINTING, DEVELOPED IN FOTOSPEED WARM TONE.

MAKING the fine black-and-white print is the final step in our journey from loading the film into the camera, seeing the subject and pre-visualizing how it is to be presented, and making the correct decisions relating to exposure and development. We have considered all the technical matters to be learned and practised to get to this point in the process. I refer to these technical matters as the 'how' of photography – how to expose and process the film; how to recognize and use the light that is so important to our photography; how to make the pilot print to help us make decisions about crop, tonality and contrast. The ways in which we apply judgment and use all these techniques to make the fine black-and-white print are very important considerations in the art of photography.

However, we also have to ask ourselves *why* we make photographs. I consider this to be the key to successful image-making. Are we making the photograph to express a feeling, and if so, what is the feeling? Are we telling a story? Are we recalling a memory? Whatever the reason, it is necessary to know if we are to communicate it in the final print. I hope that this book will help you determine both the 'how' and the 'why' of your photography.

**Dawn, Death Valley**
*Burning and dodging plan.*

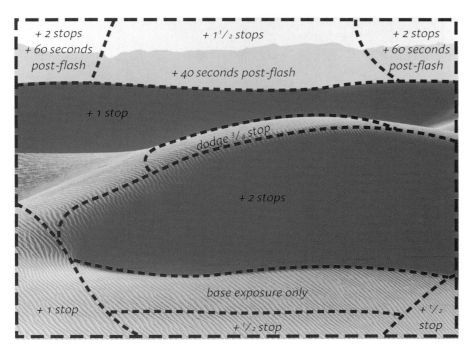

# Dawn, Death Valley

Death Valley in California is one of my favourite photographic locations and this image was made on the most memorable day of my many visits there. I recall arriving at the dunes at about 4am on that early autumn morning, to allow myself sufficient time to walk to the location where I knew the dawn light was likely to be at its best. Making photographs in Death Valley can be fraught with difficulties: assessment of light values can be tricky, leading to underexposed negatives; there is a surprising lack of contrast, even at dawn when this image was made, so you have to expose and develop the film to build contrast; equipment has to be kept wrapped in bags to minimize the danger of being engulfed in sand, and there is the frustration of having to deal with footprints left by the many visitors attracted to the dunes. When I arrived that morning, the wind had blown away the footprints from the previous day – I knew that Lady Luck had smiled on me and the conditions were right for me to make some memorable images.

I have photographed sand – both in deserts and on beaches – for a number of years, concentrating on impressionist shape and form in both high- and low-key tonality. Sometimes I see nude female form and sometimes I concentrate on the abstract created by the play of light across the sand, as was the case when I framed this image in my Mamiya 645 fitted with the 80mm Sekor lens. Because of the intensity of the light bouncing around the bright sand, the shadows in Death Valley are always well lit, and are never the satanic black holes that I have portrayed here. Consequently, I chose to underexpose the

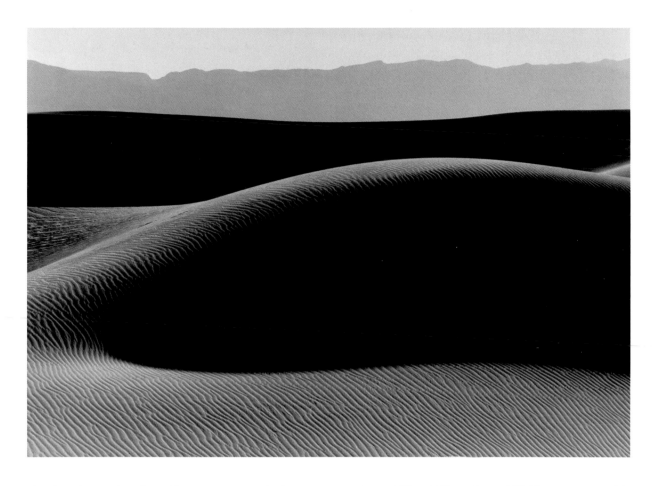

**Dawn, Death Valley**
*The final print as pre-visualized.*

120 Ilford Delta 100, developed in ID11 1 to 1 for 12.5 minutes (a 2-stop increase) at 20°C; print made on Ilford Warmtone VC fibre paper with grade 5 dialled into the contrast control on the enlarger, developed in Fotospeed Warm Tone and toned in selenium.

shadow by 1 stop less than my normal placement. I metered the darkest area in the large central shadow and instead of closing down the lens by 1 stop I closed it down by 2 stops. I checked the contrast range by taking a meter reading from the brightest highlight in the sky, but not directly into the sun, and counted 4 stops' difference from the shadow reading I had just taken. Because this was a normal contrast range, I knew that I could increase development by up to 2 stops to boost the contrast, so I fitted the back marked for plus development on the camera and made the exposure. As I had decided to increase the contrast, the film was developed for 12 1/2 minutes – 3 1/2 minutes longer than the time I use for normal development.

I used Ilford Warmtone VC fibre paper with maximum hard filtration, equivalent to grade 5, to achieve the tonality and contrast that I visualized. When I made the print, the first exposure was based on getting the right tonality along the top of the curved central dune, but because I knew that I intended to apply a significant amount of selective burning in, I had to dodge that area to compensate for light spillage as I carried out that manipulation (see pages 73–5). The burning and dodging plan shows the manipulation necessary to make this print. This interpretation is well removed from the reality of the morning when I made the exposure, but it does reflect how I visualized the dunes and the light striking them.

**Rocks and water**

ABOVE RIGHT
*Base exposure, soft filtration only to produce tonality in highlight. Note how little tone is required in the highlight at this stage.*

BELOW RIGHT
*Pilot print, given base exposure on soft and hard filtration.*

# Rocks and Water

To create the smooth texture in the water in this image, I used the multiple-exposure technique described on pages 59–62. The small stream, in a private valley in north Northumberland, was full of water following several days of heavy rain – in fact, it was still raining when I made the photograph. The volume of water produced turbulence that would not convey the peaceful contentment I always feel when I visit this location and that I wanted to express in the final image, so I decided to use multiple exposures in the camera to achieve my visualization of the subject. To get to my chosen viewpoint I needed to set up the tripod in the water, so I had to stand in the stream in my ordinary hiking boots, with the water reaching up to my knees.

I metered the darkest shadow and reduced the exposure by 2 stops from the meter reading; I determined that the subject had a contrast range of 4 stops by taking a reading from the brightest highlight in the water, which indicated that I could give the film normal development (see pages 20–1). Because I had decided to use multiple exposures, I stopped down the lens to f22 and that determined a single exposure of $^1/_4$ second. I had decided to use $^1/_{125}$ second as the multiple-exposure shutter speed, and calculated that I had to give 32 exposures to arrive at the metered exposure. I actually gave 37 exposures, as I made this negative using a very old Minolta Autocord twin-lens reflex medium-format camera with a fixed 80mm lens. Cameras of this vintage are not electronic and consequently the shutter speeds can be inconsistent, hence the need to compensate.

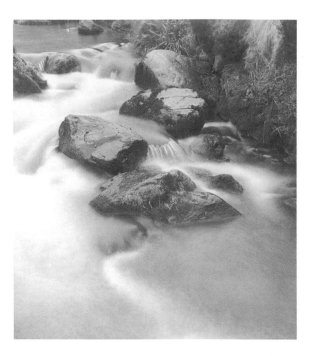

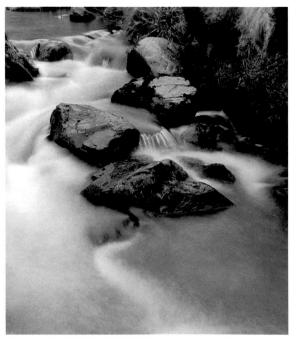

I also made a negative that was given the $^1/_4$ second single exposure, so that I could compare it with the negative given multiple exposures. By comparing the multiple- and single-exposure negatives of the same

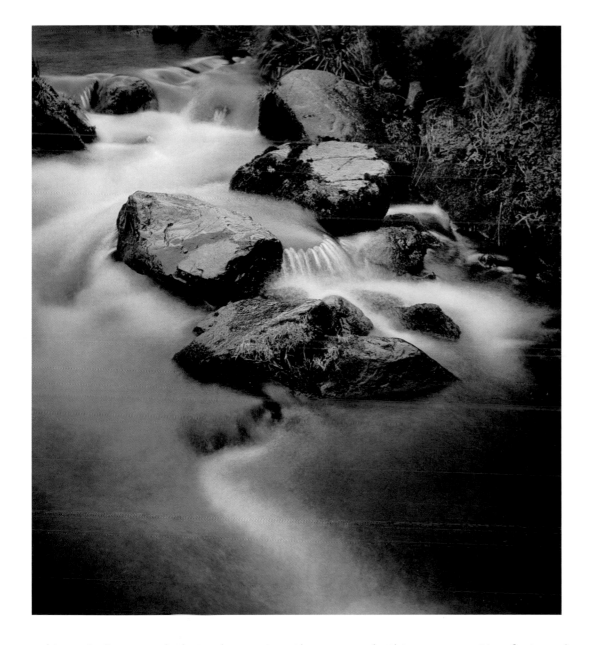

**Rocks and water**

*Final print. The negative was given 37 exposures at ¹/₁₂₅ second – compare this with the single exposure to see how the multiple exposure has created a tranquil feel in the image.*

120 KODAK TRI-X, DEVELOPED IN HC110 1 TO 31 FOR 6 MINUTES AT 20°C; PRINT MADE USING SPLIT-GRADE PRINTING ON ILFORD WARMTONE VC FIBRE PAPER, DEVELOPED IN FOTOSPEED WARM TONE AND TONED IN SELENIUM.

subject, I discovered that when using the Minolta the multiple-exposure negatives received less exposure and consequently were thinner, with less detail in the shadows. I worked out an adjustment by trial and error and subsequently added 10–15 per cent to future multiple exposures to compensate for this inconsistency. Incidentally, I now use a Mamiya 645 with electronic shutters and still apply this compensation factor when I make photographs using multiple exposures. The negatives are slightly more exposed, but I prefer this to underexposure.

The print was made using the split-grade printing method described on pages 81–4. You can see from the burning and dodging plan that in certain areas I have used both grades when burning in.

**Rocks and water**

*Note how the turbulence in the water generates a very restless feel in the single-exposure image.*

PRINT MADE FROM A NEGATIVE GIVEN ONLY A SINGLE EXPOSURE OF ¹/₄ SECOND.

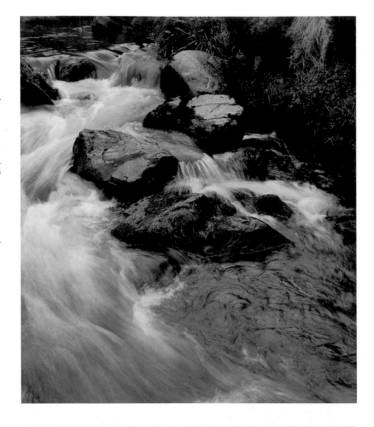

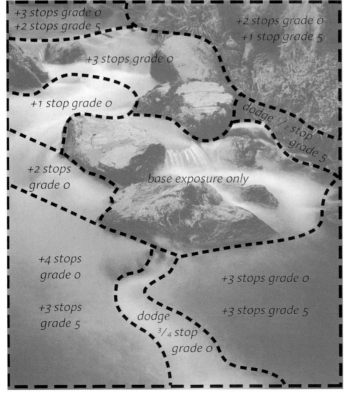

+3 stops grade 0
+2 stops grade 5

+2 stops grade 0
+1 stop grade 5

+3 stops grade 0

+1 stop grade 0

dodge ¹/₂ stop grade 5

+2 stops grade 0

base exposure only

+4 stops grade 0

+3 stops grade 0

+3 stops grade 5

+3 stops grade 5

dodge ³/₄ stop grade 0

**Rocks and water**

*Burning and dodging plan.*

# Seat, Hope Gap

The South Downs of Sussex are one of my favourite photographic locations in the UK. When lit by early or late light, the rolling downs offer quite beautiful abstracts and remind me of the sand dunes of deserts I have visited and love to photograph. Why, then, did I choose to photograph a seat overlooking the sea? The answer is that I photographed the *light* – some good advice that I was given many years ago by the late John Delaney, a landscape photographer who taught me to look and see (see page 38).

The photograph was made early one autumn morning, when the light was soft and the sun occasionally broke through the gentle mist that often accompanies the incoming tide. I visualized the scene as predominantly grey to capture the softness of the light, but included the seat to introduce a degree of contrast and a secondary point of interest after the breaking light. I metered the mid-tones of the sea and sky, but not the brightly lit areas, and exposed as

RIGHT

**Seat, Hope Gap**

*Post-visualized print.
Both versions work,
but I feel that this is a
better interpretation.
By producing a
negative that was
carefully exposed and
developed, I had the
option of changing the
tonality of the final
print and the feel of
the image.*

120 KODAK TMAX 100,
DEVELOPED IN HC110
FOR 8 MINUTES 1 TO 31
AT 20°C; PRINT MADE ON
ILFORD WARMTONE VC
FIBRE PAPER WITH GRADE
4 DIALLED INTO THE
CONTRAST CONTROL ON
THE ENLARGER,
DEVELOPED IN FOTOSPEED
WARM TONE AND TONED
IN SELENIUM.

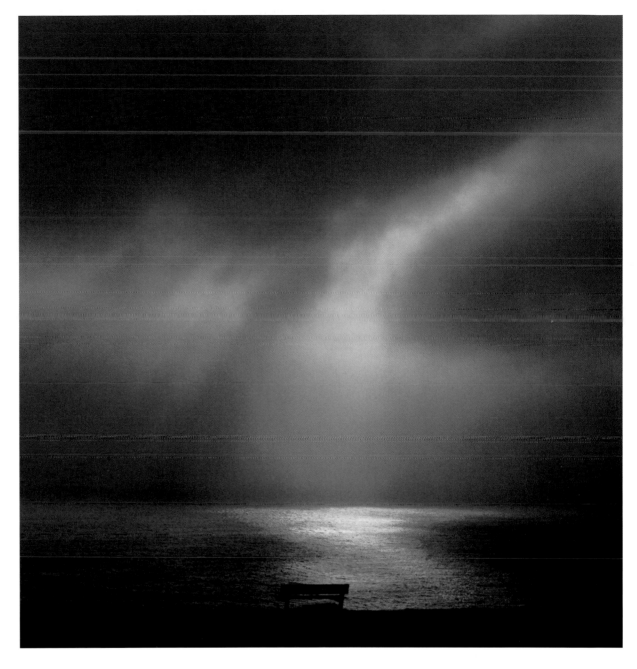

OPPOSITE

**Seat, Hope Gap**

*Pre-visualized print. I
don't think this works
as well as the post-
visualized version.*

PRINT MADE ON KODAK
EKTALURE GRADED FIBRE
PAPER, DEVELOPED IN
FOTOSPEED WARM TONE
AND TONED IN SELENIUM.

indicated by the meter. In effect, I exposed for what I saw as mid-grey in the final print and ignored the seat and dark foreground, as I was not too worried about a possible lack of detail in these areas. The film was processed for normal development.

At the time that I made the exposure I had visualized the photo as conveying the gentle light of the day, but when I made the print I felt that it was lacking the sparkle and vibrancy needed to lift it out of mediocrity. I decided to take a different approach and create a mood not in evidence on the day by using darkroom manipulation skills and a little imagination.

# New York Kiss

Hallowe'en in New York is a wonderful opportunity to make candid street photographs. The parade on 6th Avenue attracts many colourful characters who are very happy to be photographed and do co-operate when asked. When the parade is over, the streets are full of people just enjoying the occasion – and still happy to be photographed.

There are problems to be overcome, in that the event starts in the early evening and ends in the early hours of the following morning – consequently, there is a distinct lack of available light. Flash is an option, but I do not like the results and prefer to use fast film – Ilford Delta 3200 for this image – and if necessary push it and increase development to improve contrast. There is a price to pay for such abuse of film, for detail will be lost in the shadows and grain will increase, but I am quite happy to work with these problems. There are times when grain adds a dimension to a photograph and I think this image is a good example.

**New York kiss**
*Final print as pre-visualized. Compare this with the pilot print to see how the burning in helps direct the eye to the girl's face, which is the important element in the image.*

35MM ILFORD DELTA 3200 RATED AT 25,000 ISO, DEVELOPED IN ILFORD DDX 1 TO 4 FOR 14 MINUTES AT 22°C; PRINT MADE ON ORIENTAL SEAGULL NO. 4 GRADED FIBRE PAPER, DEVELOPED IN ILFORD MULTIGRADE.

The negative for the image was made in a subway station at about 2am, after the festivities had ended and I was making my way back to my friend's apartment. I spotted that the couple were interested only in each other and felt I had an opportunity to make a photograph that would fit into a body of work that I was compiling called 'Intimate Moments'. When I am photographing in crowded places I prefer to use a 20mm Nikor lens on my Nikon F90X, to give myself every chance to respond to situations and make photographs without having to worry about missing shots as I change lens. I think this is the best compromise in these conditions. Consequently, I had to move into a position close to the couple to fill the frame and get the best angle, so I leaned on the side of the metal pillar at right angles to the couple and made only two exposures before the train arrived. However, I was happy, because I knew when I made this exposure that I had released the shutter at the right time and made an interesting image.

I had a number of options as to how to make the final print that I had visualized when I made the exposure. The key element in the image is the young lady, so it was clear that considerable burning in was required to eliminate unwanted information and balance the weight of the tonality throughout the final print. I had to decide whether to expose for the skin tone and burn in the remainder, or expose for the darker surrounding tones and dodge the girl's face. My approach to making prints is first to establish the tonality and contrast in the element I consider to be the most important, or key, area of the image. Having done that, I then set about the task of building, or adding to, the tonality of the

ABOVE
**New York kiss**
*Print after burning and dodging but not post-flashed. Compare this with the final version that has been post-flashed, in addition to the same burning and dodging as shown here.*

TOP
**New York kiss**
*Pilot print.*

**New York kiss**

*Print given no base exposure, showing only the burning and dodging I carried out. Note that there is still some detail in the girl's face that is the result of allowing some light spillage during the burning in. This method helps reduce obvious haloes when carrying out excessive manipulation.*

supporting elements in the image by burning and dodging. I refer to this method as 'incremental printing' and compare it to building a house, where you would lay a solid foundation and build upwards until the construction is complete.

I decided to base my starting exposure on the skin tone (see pages 73–5) and burn in the surrounding area. However, I knew that during the burning in there would be some light spillage onto the girl's face – in fact, I deliberately allowed this to happen – and to compensate for this spillage I dodged the face for part of the starting exposure. While I do carry out tests at each stage to determine the correct base exposure and degree of

burning in required, when dodging in these circumstances I tend to rely on experience. A reasonably good starting point would be about ¹/₄ stop or, if working in real time, about 20 per cent of the base exposure. You will soon learn to make an accurate judgment, once you have made a few prints in which you have to carry out this step. Having decided on the base exposure, I made the first print and applied the dodging and burning in that I considered necessary.

When I assessed the print, it was obvious that further work was required to subdue the bright highlight behind the girl's head. Again, I could have used a number of different methods. I could have burned in the area, but a considerable amount would have been required to reach the tonality needed and that choice would have darkened the area above the highlight to an unacceptable density. I could have burned in the highlight using a hole in a card (see pages 74–5), but extra spillage of light onto the top of the girl's head would have been unacceptable.

There are always a number of options open to you when manipulation is required to make the final expressive black-and-white print. Choosing the best option or combination is the result of knowing how the different methods work and their effect on the print, and applying your own judgment and preferences. For this print, I decided to use my post-flashing technique combined with a water bath when developing the print (see pages 77–81).

The final print shows considerable grain and is quite dark and coarse, but I think it conveys the intimacy of the moment because those qualities contrast with the obvious message and softness in the girl's expression.

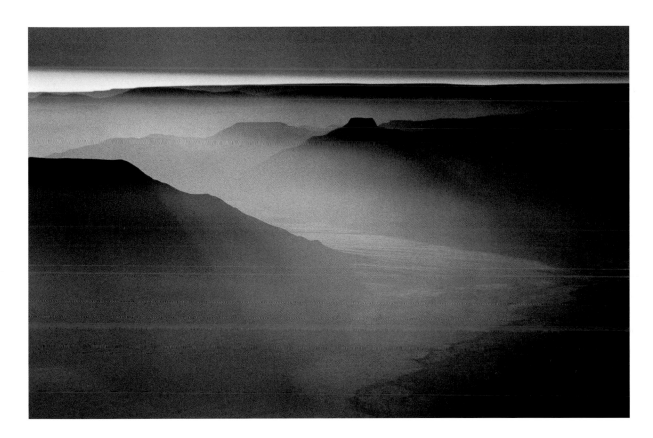

# Sunrise, Namibia

Finding the best viewpoint is always uppermost in my mind, especially when I make photographs in the landscape. Sometimes the predictable viewpoint – where the camera is held at eye level – works, but I am always prepared to explore the area that I'm photographing, and that can involve anything from wading up to my waist in water to finding a precarious foothold on a narrow ledge up a cliff face. I have often sat in a plane at 10,000m (35,000ft) watching the sunrise or sunset and wished that I could be out on the wing of the aircraft with a camera on the tripod to make the exposure. We can all dream. However, sometimes a dream can come true, as it did for me when I had the opportunity to take a dawn ride in a hot air balloon during a trip to Namibia. I am not at all happy about being in high places without at least two Rolls Royce engines attached to the wings of the craft in which I'm travelling, but I could not refuse this opportunity.

Because of the limited space in the basket, taking tripods and medium-format cameras was not an option. I took only one Nikon F90X body and a 70/210mm Nikor zoom lens. The balloon took off about 10 minutes before sunrise and was at 1,000m (3,500ft) when the sun popped up above the distant horizon. I knew that I would have only a limited time to make exposures before the magic of the dawn light burned up and disappeared, so I had given some prior thought to how I would approach making the photographs. I decided to portray the sunrise in a very low-key, dramatic image and therefore exposed for

the light just off the brightest highlight. Had I exposed for the brightest highlight, the negative would have been totally under-exposed and I would have been unable to show even a little detail in the ground below. The exposure that I chose to use was not sufficient to show any detail in the flat hills, but that was not an issue as I had visualized them as silhouettes.

I was shooting straight into the light, and its savage intensity as the sun rose above the horizon ruled out the effective use of a lens hood. I therefore had to find a means of blocking the light, or flare would have rendered the negatives unusable. Fortunately, the basket has to be attached to the balloon, and the support on one corner proved a very effective lens hood. I simply placed the support between the lens and the sun to block the direct light and, using the lens at its full 210mm length, photographed the sunrise past the edge of the support. When the print was made, I used an old technique whereby the development is reduced to produce a very warm image without resorting to toning it in sepia.

**Ocean City boardwalk**
*Colder-toned version made on Oriental Seagull no. 4 graded fibre paper.*

# Ocean City Boardwalk

There are occasions when a potential photograph presents itself and you have to respond instantly if you are to make the exposure and capture the moment. These situations are not confined to candid or documentary photography, where a fleeting expression is the reason for making the photograph. When photographing the landscape, there are times when the light itself is fleeting and easy to miss if you are not ready to make the exposure.

No matter where I photograph, or which camera format I am using, I make as many preparations as possible in advance, so that if a fleeting moment arises I can respond quickly and at least make an exposure. When I'm making candid or street photographs, I take a meter reading from the back of my hand in the prevailing light and set the camera to overexpose by 1 stop from that reading, so that I can respond instantly to any photo opportunity. Even if the light has changed a little, I know that I will have the necessary information on the negative to make a print. Obviously, given time, I make sure that I take a careful meter reading, but that is not always possible. Pre-visualization requires planning so that you are prepared for all eventualities.

I made this exposure late one evening, when I was walking along the boardwalk in Ocean City, Maryland, and saw a potentially interesting situation. The light of the early summer evening was crisp and clear as I approached the Ghost Train, one of the fairground rides, to see steam pouring out of several pipes along the front of the building.

**Ocean City boardwalk**
*Pre-visualized print. Note how the different print colour and slightly higher contrast change the impression of mist in the evening light. Compare this warm print with the colder version made on a different paper of the same grade, to see how this version shows more contrast and increased grain.*

35MM ILFORD DELTA 3200, DEVELOPED IN AGFA RODINAL 1 TO 10 FOR 12 MINUTES AT 20°C; PRINT MADE ON ILFORD WARMTONE VC FIBRE PAPER WITH GRADE 4 DIALLED INTO THE CONTRAST CONTROL ON MY ENLARGER, DEVELOPED IN ILFORD MULTIGRADE.

Together with the dim light provided by a few spotlights, the steam produced a man-made mist and created a wonderful atmosphere, introducing some mystery into the scene that confronted me. The figure was striding through the steam towards me and I had little time to consider my options before he walked past, so I quickly made an exposure using my Nikon F90X loaded with Ilford Delta 3200 and fitted with a 20mm Nikor lens. Although I stayed in the spot for another 30 minutes and made a few more photographs, I felt that the first exposure, shown here, was the image that conveyed the atmosphere I saw and felt on the night. The planning I always carry out had again proved to be the difference between success and failure.

# Legs and Boardwalk

Seaside resorts offer numerous photographic opportunities, both in and out of season. This image was made on the boardwalk in Ocean City, Maryland, where I was leading a field trip on a workshop designed to help the participants to see and respond to photographic situations. When I saw this lady approaching me wearing her very striking tights and heavy boots – together with the diagonal lines of the boardwalk – I knew that there was a strong photograph to be made. The simplicity of the straight lines of the boardwalk and the hoops on the tights required a third contrasting element, and luckily this was supplied by the heavy black boots. A successful image was there for the

**Legs and boardwalk**

*This image can be cropped in many ways to produce variations on the same theme. Spend a few minutes seeing how many different variations you can find: it is a good exercise that helps develop your ability to see and arrange elements in a photograph.*

35mm Kodak Tri-X, developed in Fotospeed FD30 1 to 9 for 6 minutes at 20°C; print made on Ilford Warmtone VC fibre paper, developed in Fotospeed.

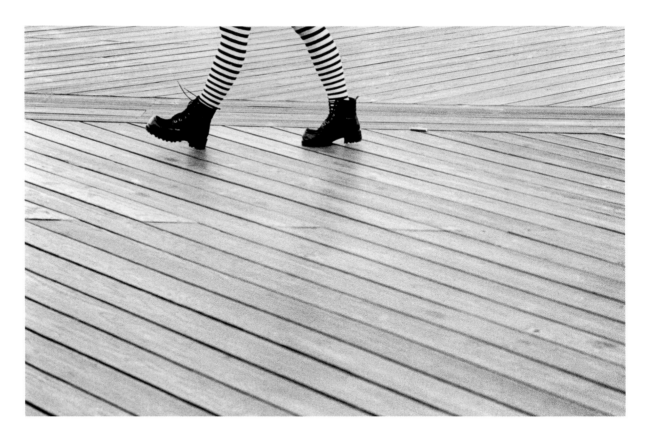

making: all that I had to do now was eliminate the many people passing me on that hot summer's day.

I had to work quickly, as the girl was approaching a group of people that would have killed the simplicity. I framed the image as seen in the print – if I had included more of the figure I would have over-complicated the simple, graphic qualities. I managed only one exposure before she was surrounded by people, but I knew as I released the shutter that I had captured the image I had visualized just a minute or so earlier.

When making photographs in these situations, you need to be prepared to respond to the opportunities that pop up, otherwise they will pass you by before you can set up the camera and make the exposure. I had my camera set up to expose for a skin tone, my normal

practice when I photograph in the street, and it worked for me here even though I photographed only the legs and boardwalk. The negative is well exposed, with detail throughout, and confirms the benefit of being prepared. I have taught myself to be aware of changing light and developing situations so as to respond without delay, and again this discipline worked for me when I made this image.

However, it is interesting to note that without serendipity all the planning and discipline would have been useless. I was lucky to have chosen this particular point, on several miles of boardwalk, at which to demonstrate how I select an area as a 'stage' where I make street photographs (see page 43), although I did not use the stage as I had pre-visualized, and the girl with the tights just happened to appear.

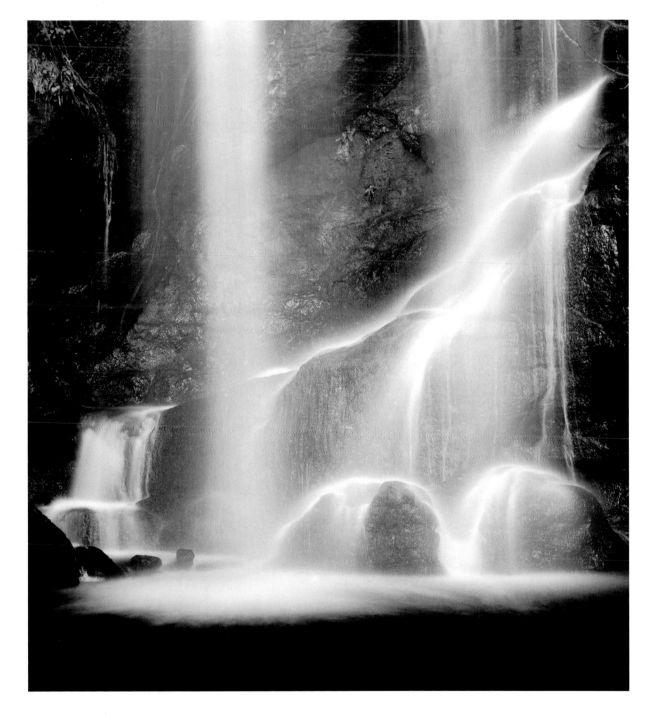

**Roughting Linn**
*The long exposure of 20 seconds helped create the appearance of a shaft of light instead of water. The negative was given 20 single 1-second exposures.*

120 KODAK TRI-X, DEVELOPED IN HC110 1 TO 31 FOR 8 MINUTES; PRINT MADE ON ILFORD WARMTONE VC FIBRE PAPER USING SPLIT-GRADE PRINTING, DEVELOPED IN FOTOSPEED WARM TONE AND TONED IN SELENIUM.

# Roughting Linn

This waterfall is probably among my three or four favourite locations – and it's only 8km (5 miles) from my home in Northumberland.

I have made photographs of Roughting Linn every year since 1977, and will continue to do so until I can no longer carry my equipment to this magical place. Because of its location, Roughting Linn is rarely lit by the

sun; consequently, the place can be quite dark and long exposures are often required. The image shown here, made in 1978, was given a 20-second exposure in 20 x 1-second multiple exposures using my old Minolta Autocord with a fixed 80mm lens. The fine spray from the waterfall was quite heavy, and was blowing towards me as I set up the tripod, so I attached a yellow filter to the camera lens for protection. I used this filter simply because I was a relative novice to photography and not aware of the existence of skylight filters. After making each of the 20 exposures, I carefully wiped the water from the front of the filter before I released the shutter to make the next exposure.

The contrast range was 4 stops, even though the light is quite subdued in Roughting Linn, so I processed the film as normal. When I made the print, I wanted to convey the impression of light that I always experience when I visit the waterfall. The water is usually quite dark and has a slightly dirty appearance, so I knew that I would have to use a harder paper grade, or I could use split-grade printing (see pages 81–4) to achieve the effect I visualized. I decided on the latter option, and dodged the water during the soft-filtration exposure to create the appearance of a shaft of light. Split-grade printing gives the option of burning and dodging during either of the two exposures to produce subtle changes in contrast; for example, reducing the soft filtration will increase the contrast and density, while reducing hard filtration will lower the contrast and density. The decision to dodge hard or soft filtration is subjective and has to be based on your own personal taste; it is a very useful tool to use when making fine prints.

# The Road to Monument Valley

Monument Valley has been a very special place for me since, as a young child, I first saw a John Wayne Western that had been filmed there. I did not know the name of the location until I took an interest in photography and purchased a book that included an image of Monument Valley. I decided that one day I would visit the place. I eventually did make it to Arizona in 1991 and have returned a number of times since.

The image shown here was made in 1993 as I drove from Utah into the valley in the early afternoon, with the sun high in the sky. I visualized a dramatic image, but the harsh afternoon light and virtually cloudless sky offered little in the way of the drama that I saw in my mind's eye. I used my Mamiya 645 with the 35mm Sekor lens to introduce a feeling of space and openness into the image, with the road leading to the buttes of Monument Valley playing an essential role in the arrangement. As I set up the Benbo Mk1 tripod I was using at the time, disaster struck: one of the castings that the central bolt fits into, and which holds the legs together, broke. Fortunately, the Benbo is a very versatile piece of equipment and I was able to carry out a repair that allowed me to use the tripod with limited movement for this image and the rest of the trip. I have privately referred to this image as 'Broken Benbo Road' since I made the print.

The negative was made using Kodak TMAX 100 and I exposed for the darkest shadow that I could find in the landscape. Because of the high sun the contrast in the landscape was quite low, but I decided to expose and

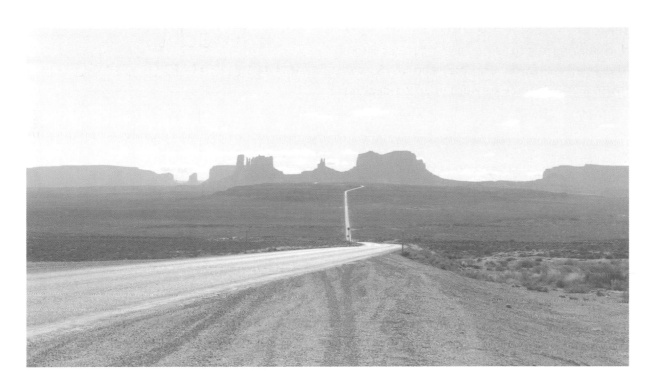

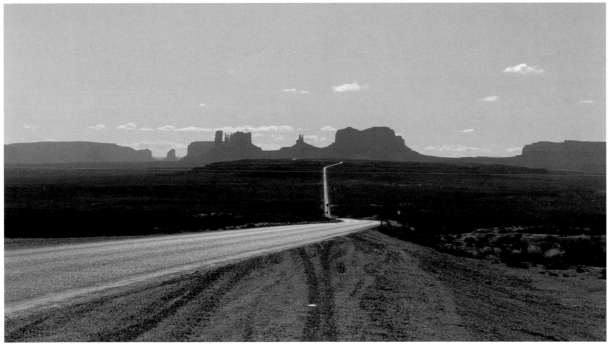

**The road to Monument Valley**

TOP
*Print given soft filtration only.*

ABOVE
*Pilot print given base exposure on both soft and hard filtration.*

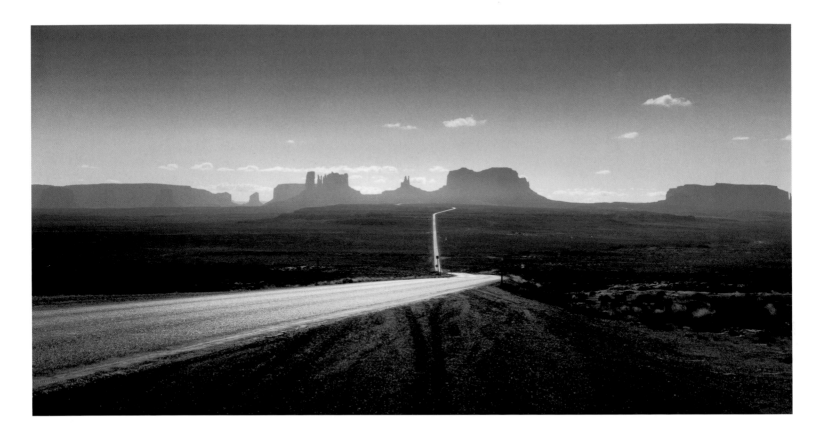

**The road to Monument Valley**

*This image was made in mid-afternoon with the sun high in the sky – consequently, the landscape was flat and lacking in contrast. I introduced a little drama and contrast by burning and dodging selected areas of the final print. Compare this with the pilot print to see the effect of this manipulation.*

120 KODAK TMAX 100, DEVELOPED IN HC110 1 TO 31 FOR 8 MINUTES AT 20°C; PRINT MADE ON ILFORD WARMTONE VC FIBRE PAPER USING SPLIT-GRADE PRINTING, DEVELOPED IN ETHOL LPD.

develop the film normally and introduce the drama I visualized when I made the print.

I thought about using grade 5 paper to make the print, but decided on split-grade printing because I had visualized a fairly dramatic interpretation and wanted to show some tone and detail in the road, which is the brightest highlight (see pages 81– 3). I made a soft test strip and chose a base exposure that produced a very delicate tonality in the road at the point at which it turns to the left. The hard exposure was based on the tonality in the central band of landscape in front of the distant buttes. To produce the tone required in the road, I had to dodge that area during the soft-filtration exposure. I also dodged the buttes during the hard-filtration exposure to introduce recession and enhance the feeling of space and distance. Finally, I burned in the sky and foreground on both soft and hard filtration to add the drama I had visualized when I made the exposure. I chose to burn in with both hard and soft filtration to control the contrast in those areas: burning in with soft filtration would have produced the same density, but the end result would have been too muddy; burning in with hard filtration would have introduced too much contrast and the danger of blocking up the darkest areas in the foreground.

# Red Pike

The English Lake District is a wonderful location for landscape photographers, as it is quite compact and offers a wide variety of excellent landscape photo opportunities. The notoriously unpredictable English weather is even more changeable in the Lake District and adds to the photographic potential, for the rapid changes in the light that accompany the volatile weather regularly transform the landscape.

The image of Red Pike was made early one very stormy winter morning as the clouds were being blown across the sky by a strong wind. I was driving to my chosen location and noticed the clouds open and briefly illuminate Red Pike, before closing to leave only dull grey, flat light. I stopped the car and set up my tripod in a field to wait for the light to

appear again. In fact, the wind was so strong that even my Benbo Mk1 would not stand without some evidence of movement, so I wedged my Mamiya 645 into a dry stone wall to hold it steady. I waited for perhaps 20 minutes before the light finally appeared, and had time to make only one exposure before the sky closed up for a second time.

Although I had to wait some time for the light to appear, and because it appeared only briefly, I had no time to take any meter readings in the conditions that I wanted to photograph, so I had to estimate the exposure I intended to give. I knew that when the light broke it would be very bright, and I did not want to overexpose the highlight and produce a negative that would present difficulties when making the print, so I decided I would rather underexpose and lose shadow

**Red Pike**
*The pre-visualized version shows the effect of the breaking light on the snow-covered hill. Careful application of pot ferri in the clouds and snow introduced the impression of light. When bleaching, I use it only to lighten the highlights.*

120 ILFORD FP4, DEVELOPED IN ID11 1 TO 1 FOR 9 MINUTES AT 20°C; PRINT MADE ON ILFORD WARMTONE VC FIBRE PAPER WITH GRADE 5 DIALLED INTO THE ENLARGER, DEVELOPED IN ILFORD BROMOPHEN.

detail. The resulting negative lacks detail in the darkest shadows, but this does not concern me as the image is about the light in the sky and on Red Pike.

I made the print on Ilford Warmtone VC fibre paper, using the grade 5 setting on my Zone VI VC cold cathode enlarger, to produce the contrast I needed in order to convey the brightness of the light breaking on the snow-covered hill. The first print was no better than satisfactory and certainly did not convey the impression of light I wanted to show, so I had to employ other means to achieve this. I could have given a base exposure to produce the dark tones and dodged the snow-covered hill and cloud to introduce the feeling of light, but I decided that this approach would not allow me the control to make a satisfactory print. It is likely that the dodging would have been too obvious, particularly in the sky. In addition, dodging the hill would have lightened the areas that were not covered in snow and reduced the contrast

**Red Pike**
*Before bleaching: compare this with the final version to see how the bleaching has increased the contrast, particularly on the snow-covered hill.*

in that area of the print, and again this approach was not satisfactory. Finally, I decided to use local bleaching as the best method to achieve the result that I visualized when I made the exposure.

When I made the print, I burned in the sky and deliberately allowed some light to spill over into the lighter cloud and snow-covered hill, in effect overprinting those areas of the image. I prepared a small quantity of potassium ferricyanide in readiness to bleach the print (see pages 89–90). The final print does convey the brilliant light I saw when I made the exposure, as the bleach has lightened the snow but not the darker areas and consequently has increased the local contrast. Because I mixed a very dilute pot ferri solution, I could maintain total control when bleaching the areas in question.

# Tulip on Black Silk

Making still-life photographs is my way of relaxing after a hectic period when I may have been travelling extensively or leading a demanding workshop. I like to keep both the lighting and the subject matter as simple as possible and tend to put together household objects, flowers, or various bits of wood, rock or metals that I collect on my travels. I sometimes press flowers and also allow them to wither and dry, as I did with the tulip used in this image.

I almost always use the available light coming into a room through the window, although it is not necessarily sunlight as I often prefer the soft light of a grey, cloudy day. The image shown here was made using strong sunlight diffused by net curtains, with the still life set-up being placed far enough from the window so that there was no strong light falling on the subject and causing strong shadows. I also placed a large piece of white mount card along the side of the set-up furthest away from the window to bounce some light back into the darker parts of the image. I used my MPP 4x5in field camera fitted with a 150mm Schneider lens to make the exposure. I chose to use the black silk as a background because silk can be arranged into quite elegant shapes; black silk reflects quite a lot of light, so you can break up solid, dark areas by using a curved arrangement to catch subdued highlights, and I like the effect this produces.

When making my prints, I always consider the selection of the paper/developer combination to be an important part of how the final black-and-white print will look. I prefer warm brown prints for my still lifes and landscape pictures, and I have spent a considerable amount of time working out

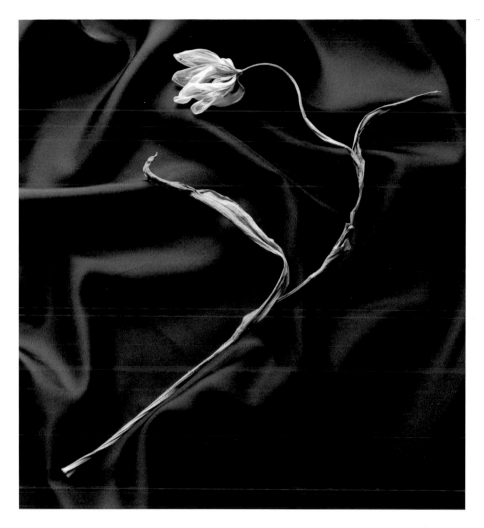

**Tulip on black silk**
*Final print. Compare this with the version on the next page to see the effect of changes in exposure and development when making the print. This print was given full development and shows more contrast. Although still warm in colour, it is cooler than the print given increased exposure and reduced development.*

4x5in Ilford FP4, developed in ID11 1 to 1 for 10 minutes at 20°C; print made on Ilford Warmtone VC fibre paper with grade 2 dialled into the contrast control of the enlarger, developed in Ethol LPD for 3 minutes.

how to produce the contrast and print colour I wish to use with any image. One of the methods I use to control both contrast and colour at the same time is exposure and development of the print. The two prints shown here were made using Ilford

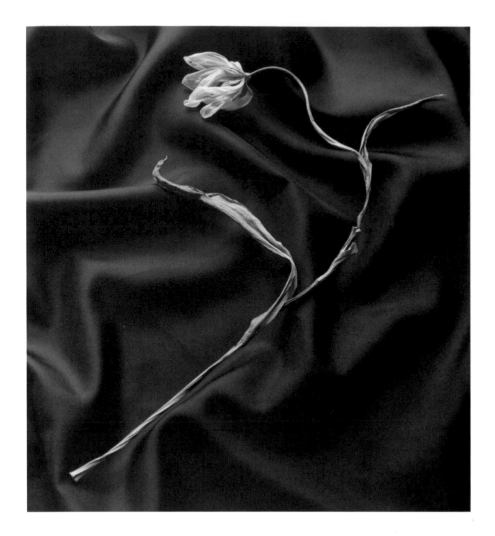

# Hedgerow

This image was made a short time after a light shower on a day when I was leading a workshop on a field trip. As we walked along a country lane, I spotted this arrangement of leaves in the hedgerow and was attracted by the variety of textures and shapes. Ansel Adams' trailside images are some of my

**Tulip on black silk**
*I increased the exposure for this version by ³/₄ stop and reduced the development by 50 per cent. The result is a reduction in contrast and a warmer brown print.*

PRINT MADE ON ILFORD WARMTONE VC FIBRE PAPER WITH GRADE 2 DIALLED INTO THE CONTRAST CONTROL OF THE ENLARGER, DEVELOPED IN ETHOL LPD FOR 1¹/₂ MINUTES.

Warmtone VC fibre paper processed in Ethol LPD paper developer diluted 1 to 3. I first made a test strip with the enlarger contrast control set to grade 3 to determine the correct exposure based on a development time of 3 minutes: the first print is the result of that combination. I then increased the exposure by ³/₄ stop and reduced the development by 50 per cent to produce the second print.

## Hedgerow

*This set of prints illustrates the effect of toning in selenium and gold, and split toning the same print in both. This print is toned in both selenium and gold, and when you compare it to the untoned version you will see a slight increase in contrast that is one of the effects of selenium. You will also see that the lower tones are slightly warmer, while the leaves that are lighter in tone are cooler – the effect of gold toning. When split toning, use the selenium toner first, followed by the gold after washing the print.*

120 ILFORD FP4, DEVELOPED IN ID11 1
TO 1 FOR 9 MINUTES AT 20°C; PRINT MADE ON
ILFORD WARMTONE VC FIBRE PAPER, DEVELOPED
IN ETHOL LPD.

favourites and have influenced my seeing, so when I set up this image I decided that it would be my homage to him.

The light was gentle, and subdued by the delicate cloud cover typical of a showery summer day. I framed the image in my old Minolta Autocord, loaded with 120 Ilford FP4 roll film, and metered the darkest shadow deep in the bottom of the hedgerow. I normally want to see clear detail in the shadows, but on this occasion I decided that they were insignificant and exposed 1 stop less than indicated by the meter, for the dark leaves just behind those at the

## Hedgerow

OPPOSITE ABOVE
*Untoned version.*

OPPOSITE BELOW
*Gold-toned version.*

LEFT
*Selenium-toned version.*

FILM AND PRINT DETAILS
AS FOR SPLIT-TONED
PRINT.

front (see pages 20–1). Because of the soft light there were only 2 stops of contrast in the framed image, so I marked the film to increase development by 1 stop (see pages 24–5).

I made the print on Ilford Warmtone VC fibre paper because it responds well to both selenium and gold toning, and I had decided to use both for the final print. Because of the lack of contrast when I made the exposure, and although I had increased the film development by 1 stop, I had to set my enlarger contrast control to grade 4 when I made the final print. The base exposure was given so as to achieve the tonality in the lighter leaves in the top part of the print, and as a result the remainder of the print required considerable burning in to darken it to the desired tonality. My favourite print of the four shown here is the one that has been toned in both selenium and gold.

# Ballinasloe Horse

I have always enjoyed watching horses, even though I have never owned one nor wished to ride one. I just think that they are elegant when they move, and appear so peaceful and dignified when seen standing in a field. I have tried to photograph horses quite a few times without any success, because I felt that the results did not show the qualities I think they possess. In October 1999 I went to Ireland to see and photograph the Ballinasloe Horse Fair, which is reputed to be the biggest gathering of its kind in Europe.

The fair is held in a huge field in the town of Ballinasloe, and subjects – not only horses, but also people and interesting situations – are just waiting to be photographed. I had been walking around the field for less than 45 minutes when I saw about 25 horses herded close together in a small temporary pen. The subject of the image shown here was in the centre of the pen. He was surrounded by restless horses, but he was standing very still and looked quite dignified.

I entered the pen with a 210mm Nikor lens on my Nikon F90X and got as close to the horse as I could while still focusing the lens at the longest focal length – when I had first spotted the horse in the pen I had decided to use the 210mm lens at the widest aperture and focus accurately on the eye, throwing everything else out of focus. I worked myself into a position to place the horse in profile, and used the back of the horse immediately in front to form an out-of-focus base to the image. I metered the head and opened up the lens by 1 stop from the indicated reading to ensure that the negative would show the detail in the light-coloured horsehair. I managed to make one more exposure before the horses around me started to get restless and I decided that it was time to leave. The image was made in quite bright sunlight but the contrast range was normal. The final print is successful because I think it conveys the dignity and elegance I always associate with horses.

**Ballinasloe horse**

*This image demonstrates the benefits that can be gained from spending a little time looking for a suitable viewpoint. I made this photograph by working my way into a pen holding about 25 horses, in order to use out-of-focus parts of the surrounding horses. I could have made the image from outside the pen, but it would have included unwanted background detail.*

35MM ILFORD DELTA 400, DEVELOPED IN ID11 1 TO 1 FOR 9 MINUTES AT 20°C; PRINT MADE ON KODAK EKTALURE GRADED FIBRE PAPER, DEVELOPED IN FOTOSPEED WARM TONE.

# First Communion, Ardoyne, North Belfast

There are occasions when the odds stack up against us in our search for expressive photographs and we have to accept a compromise when making the final print. This image is part of a project I did in Belfast and was grabbed as the family, who were late and hurrying to their daughter's first communion, approached me just as I was about to enter the church. I had no time to take proper readings and made the exposure with the camera settings as they had been for the previous photograph. Although I have a Nikon F90X that has an automatic exposure facility, I prefer to use it on the manual setting and have found that my negatives are very consistent because I make judgments as to which part of the image I will use as the basis of the exposure. When using it in the automatic mode, the meter can be fooled by tricky lighting conditions: it will be influenced by the highlights and consequently will underexpose the shadows.

The problems I faced with this image were the contrast range between the adult's dark clothing and the white dress that the child was wearing. In addition, the pavement was wet following a heavy shower, and a few minutes before I made the exposure the sun broke through the clouds, creating a very bright highlight behind the feet. In different circumstances and with more time, I would

have increased the exposure and reduced the development to help control the high contrast (see pages 22–4). I could also have used a soft film developer such as Tetenal Neofin Doku, which would have greatly reduced the contrast of the negative. After I had made the exposure, I realized that I would have a contrast problem with this image and I did consider reduction in the development of the roll of Fuji Neopan 400, but eventually I decided to deal with this problem when making the print.

When I processed the film my fears were confirmed, for not only was the negative very high in contrast but the dark clothes worn by the adults were perhaps 1 stop underexposed. I could have used a soft paper grade to deal with the contrast, but felt that I would lose the 'snap' I like to see in the final print. I decided to use Ilford Multigrade VC fibre paper and employ two grades and a water bath in making the final print. Instead of using grade 0 and 5 as I do when split-grade printing, I dialled grade 3¹/₂ into the contrast control of my Zone VI VC cold cathode enlarger to make the first exposure. I still had to deal with the problem of printing detail into the white dress and decided to use my usual method of burning in the highlights on grade 5, followed by a controlled post-flash using white light. When dealing with a highlight, the logical approach would suggest that a softer paper grade would be used to burn in. When I lead darkroom workshops I find that many printers use grade 0 to burn in difficult highlights, and while this method does work, the end result can look muddy and degraded. In any highlight there are some darker tones and it is these that create the texture; burning in with grade 5 gives better separation

than with grade 0, and I therefore think that mine is actually the more logical approach.

The final print was made by the method described above, using a card with a small ragged hole to burn in selectively the white dress and the highlight on the wet pavement (see page 74). I post-flashed the whole sheet to complete the manipulation carried out at the enlarging stage (see pages 78–81) The print was developed in a single-bath solution, but was also passed through a water bath to help control the contrast further (see page 77).

The Belfast project was a very rewarding experience and during the two years that I worked in the city I made a number of images of children that I consider to be some of the best documentary photography I have made. 'First Communion, Ardoyne, North Belfast' is one of my favourite images from the series, because I think that it conveys the feelings and commitment of the family to the importance of the day. It is not always necessary to make photographs that identify the subject in order to convey the message.

**First communion, Ardoyne, north Belfast**
*Print with no post-flashing or water bath given.*

FILM AND PRINT DETAILS
AS FOR THE FINAL PRINT.

# Trees in Winter, Belford

Winter is a wonderful time to make landscape photographs. The trees have an identity and shape and are not heavy with leaves, which can hide their real elegance and beauty. Snow can add so much, by masking and simplifying unwanted elements in a fussy background to the main subject, while ice creates quite exquisite shapes and patterns. Then it all disappears, leaving only memories and, hopefully, a handful of precious negatives.

This image was made using my MPP 4x5in field camera, just a few miles from my home in Northumberland early one morning after an overnight snowfall. I metered the snow in sunlight and checked the contrast range by metering the darkest part of the trunk of the tree on the right. The contrast range was normal at $4\frac{1}{2}$ stops, so I decided to open the lens by 2 stops from the reading I made from the sunlit snow and develop the film normally. Because I used a yellow filter to give more separation in the sky, I then compensated by further increasing the exposure by 1 stop.

When I first printed this image in the late 1980s, I used no. 2 graded paper that produced quite a soft, gentle print that I liked at the time. However, as the years passed and my preferences changed I started to make the print on harder papers to produce more contrast. When I look at those prints now I am appalled by the coarseness introduced by the contrast, although I do like the 'snap' it produced. The print shown here was made using a combination of hard paper and controlled development, using two baths, to achieve the balance between high contrast and the soft, gentle delicacy that I feel the image needs.

I now print this image on Oriental Seagull grade 4 paper because it will provide the contrast required, it is a cold rather than a warm paper, and it responds well to toning. I used a two-bath print developer to allow me to control the tonality of the image very precisely as I watched it develop in the solution. I based the print exposure on achieving the delicate tonality required for the sunlit snow in the foreground, and the remainder of the image took care of itself. The print was placed in the hard solution of my two-bath developer for about 20 seconds (see page 77–8) and then moved to the soft bath, where I could watch the image develop slowly and either move it back to the hard bath or stop it when I felt that the tonality and contrast were right.

Let me explain my approach to the use of two-bath development. My normal method is to place the print in the hard solution until the first appearance of tonality, at which point the print is placed in the soft bath. Here development is slow, so you can watch the image gradually develop and stop the process when you see that the correct tonality has been reached. I never have any problems building contrast and producing deep, rich blacks when using this method, even though the print receives only a short development in the hard bath. In any event, the print can be transferred back to the hard bath for a while if you feel that it lacks depth and contrast.

Finally, the print shown here was toned in gold to cool the image further by introducing the characteristic blue produced by this toner. The final print successfully conveys the subtle delicacy I visualized when I made this very traditional winter photograph.

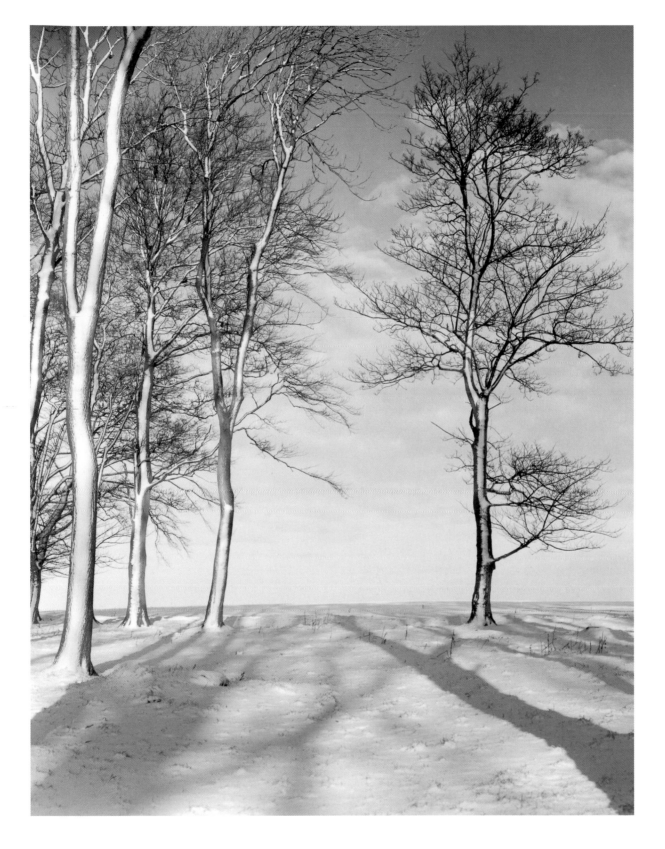

**Trees in winter, Belford**

*Pre-visualized print, made using two-bath development to achieve the contrast I required, and then toned in gold so as to introduce a very delicate blue tone to the image.*

4x5in Ilford FP4, developed in ID11 1 to 1 for 10 minutes at 20°C; print made on Oriental Seagull no. 4 graded fibre paper, developed in Fotospeed Grade Select.

# Rock Pool

Pulling together all the elements that make a successful image requires you to know what you want in the final print. You need to observe the light; you need to know about the materials you are using; you need to know where to be when the light is at its best, which requires planning; you need to find the best viewpoint – and sometimes you also need to be patient. This image required all the above on the morning when I made the exposure. The negative was made on Ilford FP4 using my MPP 4x5in field camera, on an infuriating day when the sun only occasionally popped out from behind heavy rain clouds to provide tantalizing glimpses of exciting potential photographs.

For many years I had carried a vision of a rock pool in my mind where the pool represented an eye, so I constantly looked for suitable pools whenever I ventured into the landscape. Eventually the long search was rewarded, when I found this pool on a beach in Wales where I was holidaying. The pool, left by

the outgoing tide, was a perfect shape but it needed light to make it live as I had visualized. I set up the camera at an angle where the light would reflect in the water when the sun broke through the cloud, and sat back to wait. The first time the sun did break through, the reflection in the water was so strong that it created too much flare and I lost the effect I was looking for. I realized that I required a huge chunk of luck, as I needed the sun to break through the cloud but also the cloud to be reflected in the water to eliminate the flare. I also realized that as I was waiting for this to happen the sun was moving in the sky behind the cloud, so the correct viewpoint was changing.

Over a period of more than 90 minutes the sun broke through the cloud several times and always created too much flare, but it did allow me to make the small adjustments needed in the angle of the viewpoint to ensure that when both sun and cloud were reflected in the pool I would capture it on film. Eventually the sun partially broke through the cloud and I had time to make just one exposure with both reflected in the pool, before the conditions changed again. Another worry was the fact that the water was gradually evaporating, as you can see from the damp area around the edge of the pool, although this did provide an impression of an eyelid in the final print. I assure you that I did not plan or visualize that, but credit it to serendipity.

This is one of my three favourite landscape photographs and worth the frustration I experienced while I was waiting for the elements to work in my favour, but fearing that it would never happen and my visualized image would not live. Patience on the day was the real reason that I got to make the photograph and we should never forget to use it when we have to.

**Rock pool**

*Final print as pre-visualized, which succeeds because of the careful choice of the viewpoint. The highlight was bleached using pot ferri.*

4X5IN ILFORD FP4, DEVELOPED IN ID11 1 TO 1 AT 20°C; PRINT MADE ON ILFORD WARMTONE VC FIBRE PAPER WITH GRADE 5 DIALLED INTO THE CONTRAST CONTROL OF THE ENLARGER, DEVELOPED IN ETHOL LPD.

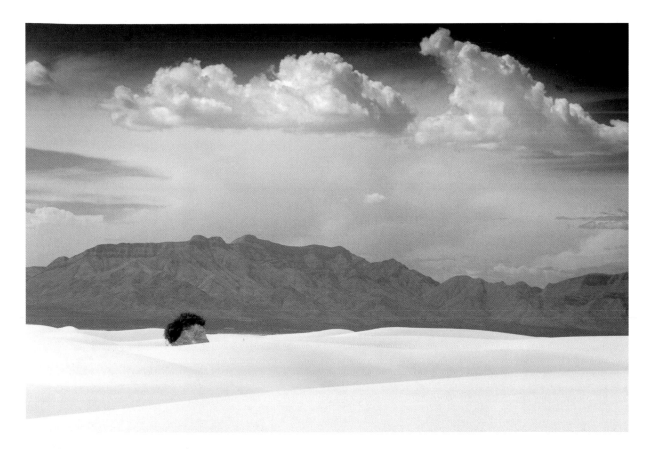

**White Sand Dunes, New Mexico**

*I pre-visualized this final print as an image that would be toned in both selenium and gold. Compare the warmth of the untoned print with the split tones of this version.*

120 ILFORD DELTA 100, DEVELOPED IN ID11 1 TO 1 FOR 9 MINUTES AT 20°C; PRINT MADE ON ILFORD WARMTONE VC FIBRE PAPER USING SPLIT-GRADE PRINTING, DEVELOPED IN ETHOL LPD.

# White Sand Dunes, New Mexico

I have visited the southwest states of America many times, as I find the arid deserts quite beautiful, if sometimes inhospitable to an Englishman who does not enjoy excessive heat. I have said elsewhere that I love to photograph sand dunes and make graphic impressionist images. However, I felt that the white dunes in New Mexico, situated in a basin surrounded by mountains, would be better portrayed in a more traditional type of landscape photograph.

On the day that I made the exposure for this image, I set off into the dunes fairly early in the day with the intention of finding a location to make best use of the late light. Because this was my first visit to the White

Sand Dunes, I had to explore and photograph at the same time. When entering such areas, and because of the heat that prevails, it is essential to carry several litres of water at least and take regular drinks to prevent dehydration. On this occasion I took 7 litres (1¹/₂ gallons) with me, since the early morning heat was worse than I had experienced in similar places. I discovered later in the day that it was probably the best decision I made on that trip.

I found this location at about 2pm, several hours after I had started my exploration, and knew that the elements were right for the image of the dunes that I had visualized. I decided to make the exposure immediately, partly because there were clouds around and they were a necessary element. However, by far the most important reason was that I was

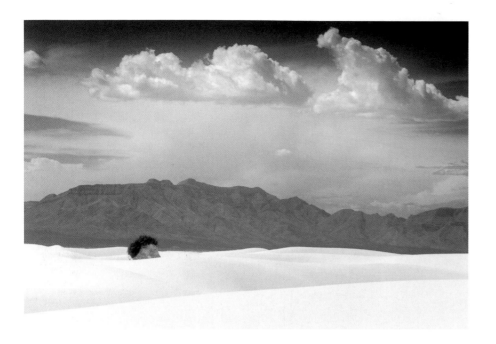

**White Sand Dunes,
New Mexico**
*Untoned version.*

# Resting Pigeon

I was born in the mining village of Ashington in Northumberland, where many of the miners spent their free time on allotments, either growing flowers and vegetables or looking after racing pigeons. In the late 1980s it was clear that the mining industry was dying, and so I decided to make my first documentary work before it finally disappeared. I photographed this racing pigeon one bright summer's day using a Nikon FM2 with a 24mm Nikor lens that I had borrowed from a friend, because I had never owned a 35mm camera.

The pigeon was sitting quite peacefully and was beautifully lit, but I knew that it might fly away as I approached since these birds are easily frightened. Because I had only the 24mm lens I had to get quite close, which I managed to do, but I made only two exposures before the bird moved. I exposed and developed the film normally even though the contrast was quite high, as I am always confident that I can deal with that problem in the darkroom. Modern film will hold about 12 to 14 stops of contrast, so it will record information in most circumstances; however, the big problem is getting that information on to the paper.

This image was relatively simple to print, but the problem lay in getting detail in the feeder and the shelf on which it sits. I chose to make the print on Ilford Warmtone VC fibre paper, because I intended to tone it in selenium and I preferred a slightly warm print for the image. Because of the high contrast in the window, feeder and shelf, I decided to pre-flash the paper to help reduce the contrast (see pages 78–80). After pre-flashing the

nearly out of water and was suffering badly from the effects of heat. I knew that I could not hang around for several hours waiting for the late light.

I metered the dark top of the dying tree in the mid-distance and reduced the indicated exposure by 1 stop, marking the film for normal development because the contrast range was 5 stops (see pages 20–1). I used my Mamiya 645 with a 210mm Sekor lens and loaded with Ilford Delta 100 to make the negative, then struggled back to my vehicle – vowing never to get myself into the same situation again. When I got back to my tent and thought about the day, I realized that the savage sunlight reflected from the white sand was the cause of my problems, and for the rest of that trip always waited until after midday before I ventured into the dunes.

I made the print on Ilford Warmtone VC fibre paper because of its response to toning – and I had visualized an image split-toned in selenium and gold (see page 84).

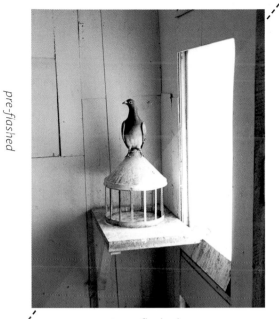

ABOVE
**Resting pigeon**
*One half of this print is pre-flashed to show the effect.*

FILM AND PRINT DETAILS AS FOR THE FINAL PRINT.

paper, I made the base exposure and burned in the left-hand side to give the print better balance. The feeder and the shelf were selectively burned in for 8 stops, using a card with a small, ragged oval hole in the centre to direct the light to the exact spot that needed attention (see pages 73–5). I also burned in the window, using a card cut to the exact shape, to reduce the extreme brightness of the light, because although I wanted to retain the impression of sunlight I thought that it needed to be slightly darker than the pilot print. The bonus here is that the burning in brought through a suggestion of the wooden pillar holding up a canopy outside the loft.

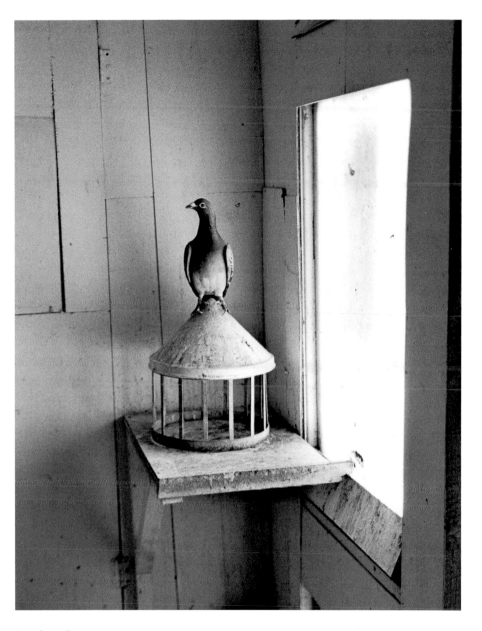

**Resting pigeon**
*This final print has been pre-flashed to help reduce the contrast and put detail into the highlights.*

35MM KODAK TRI-X, DEVELOPED IN HC110 1 TO 31 FOR 8 MINUTES AT 20°C; PRINT MADE ON ILFORD WARMTONE VC FIBRE PAPER WITH GRADE 4 DIALLED INTO THE CONTRAST CONTROL OF THE ENLARGER, DEVELOPED IN ILFORD MULTIGRADE AND TONED IN SELENIUM.

# Fire in the Falls Road

I was being driven to Belfast airport at the end of a few days' photography for my project on children, when I spotted smoke and flames in the sky at the bottom of the Falls Road and asked my friend to take me there. When we arrived, I found that a church was on fire as the result of an electrical fault. I grabbed my camera and started to make photographs of the children gathered around the church. I was amazed that there appeared to be no security to prevent people from getting too close to the fire. At one point I actually entered the church behind the leading firemen, making photographs along the way, before the roof in front of us collapsed.

The children were still running all over the place as I came out of the church, saw the leaking hose and the dog trying to drink the water, and quickly made this exposure. I did make a few others of the dog, but chose to print this image because it has the best shape and arrangement. For details of how I made the print, see 'The Ballet', an image that was made in the same location just a few minutes after I made this photograph.

# The Ballet

This image was made within a few minutes of 'Fire in the Falls Road' and the negatives are identical in contrast. I used this location as a stage (see pages 43–4) and waited for images to present themselves, only occasionally having to move to create more

**Fire in the Falls Road**
*This photograph demonstrates how the use of lines and gesture can direct the viewer to look at the important part of the image.*

35MM FUJI NEOPAN 400, DEVELOPED IN KODAK HC110 1 TO 31 FOR 6 MINUTES AT 20°C; PRINT MADE ON ILFORD MULTIGRADE IV FIBRE PAPER WITH GRADE 3½ DIALLED INTO THE CONTRAST CONTROL OF THE ENLARGER, DEVELOPED IN FOTOSPEED WARM TONE.

**The Ballet**
*Final print, showing how post-flashing deals with the difficult contrast problems of bright sky and wet reflections.*

35MM FUJI NEOPAN 400, DEVELOPED IN HC110 1 TO 31 FOR 6 MINUTES AT 20°C; PRINT MADE ON ILFORD MULTIGRADE IV FIBRE PAPER WITH GRADE 3¹/₂ DIALLED INTO THE CONTRAST CONTROL OF THE ENLARGER, DEVELOPED IN ILFORD MULTIGRADE.

photographs. As I made the exposure, the movement of the children reminded me of a dance, hence the title 'The Ballet'.

As I started to make photographs at the scene of the fire, I metered my hand and opened up the lens by 1 stop – my normal procedure in situations like this, where things are happening very quickly and there is little time to think about anything other than making as many photographs as possible. The whole incident lasted only about 20 minutes and during that time I exposed several rolls of 35mm film. I knew the reading I had used would ensure that I recorded enough information to enable me to make a print. The film was developed normally, because when I checked the contrast range after the photography was complete there was a maximum of 5 stops of contrast.

The only problem I had in making the prints lay in dealing with the very bright background

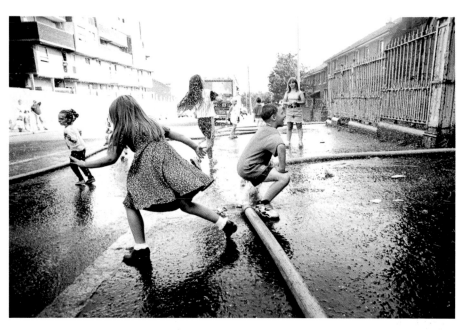

**The Ballet**
*Print given base exposure plus burning in, but without the post-flashing that the final version received.*

FILM AND PRINT DETAILS AS FOR THE FINAL PRINT.

and the wet pavement. I used grade 3½ paper to make the print and burned in around the left side and bottom left, simply to balance the tonality with the darker right side. I dealt with the bright background and wet pavement by post-flashing the whole print (see pages 78–81). Finally, I burned in the sky with white light, post-flashing, to put a little more tone into the sky. I have a small light source, powered by a 9-volt battery and with a built-in timer, attached to my enlarger that allows me to use white light to burn in or flash when required. Because the sky is on the edge of the print, it is a simple matter of switching on the flasher and burning in as you would if you were using image-forming light. Obviously, you need to make a test to determine the correct time. With a little practice you will soon learn to use this method of dealing with skies and difficult highlights such as street lamps or wet roads, as I did in this print. In effect, you are applying a controlled fog to the image, but when carried out with care it cannot be seen.

**Shankhill Road**
*Pilot print, with no burning and dodging.*

FILM AND PRINT DETAILS AS FOR THE FINAL PRINT.

# Shankhill Road

These children were playing on waste ground on the Shankhill Road in Belfast, and as soon as I appeared armed with a camera I was surrounded by excited youngsters asking me to make their photograph. I made a few photographs knowing that the results were likely to be predictable, but this is part of the process of relaxing your subject when making documentary pictures.

After a few minutes, many of the children returned to what they had been doing before I arrived, but the three in the image here stayed with me and we chatted about what they were up to. I knew that they were now not concerned about the camera, and consequently I was likely to have the opportunity to make some worthwhile photographs. After a few minutes spent chatting, and for no apparent reason, the boy in the centre stuck out his tongue and I released the shutter to capture the image. I had no time to frame the photograph and made the exposure with the camera held in my right hand at about waist level. The image here is made from the whole negative. I had followed my normal practice of setting up the camera to expose for the prevailing light, so that I would be ready for anything that happened. I have to recognize that without the Nikon F90X I would probably have struggled to make this photograph, as the automatic focus feature is very efficient and quick and without it the image would probably have lacked sharpness. I did not visualize this image, but I did respond quickly to what happened in front of me, an essential factor when photographing on the streets.

The print was relatively simple to make, the

main problem being the dark skin tones in the faces of the two smaller children. I dodged the face of the boy for $^1/_2$ stop and the face of the girl for $^1/_3$ stop, and held back the dark coat of the boy in the centre. As I burned in the top of the image, I also gave the head of the central boy an extra $^1/_6$ stop exposure.

Photographing children playing will produce strong images if you work at it. They are always likely to do the unexpected, and once you gain their confidence they are generally very natural and will ignore the camera.

### Shankhill Road
*Final print of a grabbed shot, showing the effect of dodging and burning, particularly in the face of the boy eating crisps.*

35mm Fuji Neopan 400, developed in Kodak HC110 1 to 31 for 6 minutes at 20°C; print made on Ilford Multigrade IV fibre paper with grade 3$^1/_2$ dialled into the contrast control of the enlarger, developed in Ilford Multigrade.

# Tree, Buttermere

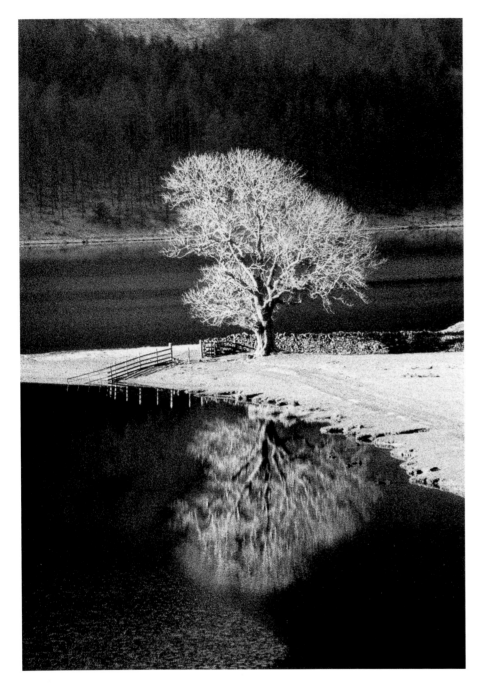

**Tree, Buttermere**

*Placing the subject in the centre of the frame is often frowned upon, but it can work – as I think this does.*

<small>35mm Ilford Delta 3200 rated 25,000 ISO, developed in Agfa Rodinal 1 to 10 for 14 minutes at 20°C; print made on Oriental Seagull no. 4 graded fibre paper, developed in Ilford Multigrade.</small>

This tree at Buttermere in the English Lake District is probably the most photographed tree in the UK. I have often photographed it myself, and have always used medium- or large-format cameras loaded with slow or medium-speed film to produce a high-quality negative and a virtually grain-free print. When I made this image I was using my Nikon F90X loaded with pre-production Delta 3200, as at that time I was testing the film for Ilford. The quality of the prints made from the negatives produced in my early tests was quite remarkable, and I was at the stage in the tests when I was beginning to push and abuse the film far beyond the suggested speed of 3200 ISO. I loaded a fresh roll and decided to try it at 25,000 ISO, thinking that it was unlikely I would produce a usable negative. The highest ISO setting on the Nikon is 6400 so I set the camera at that, metered the subject in my normal way and made the decisions required to give the correct exposure. I finally closed down the lens by 2 stops – in effect underexposing the film by 3 stops. I quickly exposed the roll on a variety of subjects, from open landscape to close-in detail in ice and grasses, and marked the film for push development.

I decided to process the film in Agfa Rodinal and had no other option but to guess the dilution and time. I cut the film into three sections in the same way as when I carry out my normal film speed tests (see page 17) and loaded one part into the tank. I had decided to use Rodinal at a dilution of 1 to 10 to process the film and chose a time of 14 minutes at 24°C as a starting point. I chose Rodinal because it is an acutance developer and is known to improve edge sharpness and increase grain, and my

feelings about grain were changing as a result of testing Delta 3200. Previously I had avoided any process or combination that was likely to produce grain, as I did not like it. The negative that the image here was made from was on that first section of film. Since I carried out the first test I have modified the times and dilution I use for this combination, as the early negatives are quite dense owing to a significant increase in the base fog of the film that I understand is caused by the strength and temperature of the developer. The dilution and time that I now use is 12 minutes at 1 to 25 at 22°C, and the result is a significant reduction of base fog.

The print here was made on Oriental Seagull no. 4 graded and did need some work in the darkroom, particularly in the band of snow, which required 2 stops more burning in and the use of a water bath in the development (see page 77). The interpretation was partly driven by the strength of the light on the tree, and I decided that the low-key treatment of the background hillside and foreground water would introduce an almost infrared feel to the image.

When I saw the print from this film/developer combination, I was both surprised and pleased. I had expected to see totally unacceptable grain and significant evidence of the image breaking up, but that is not so. Certainly the detail shown in the print is limited, but the grain and contrast introduce an element of impressionism rather than absolute reality and the image has a feeling and atmosphere not evident in my other photographs of the tree. The search for the fine black-and-white print that conveys my feelings is the real reason why I make photographs, and I do not consider that any

perceived technical failings of either the process or the materials are relevant. I think we should explore any means of expression and push boundaries where we can.

# The Buttermere Pines

This image was made at the same time, and on the same roll of film and it received the same development as 'Tree, Buttermere'. The only difference in the two images is the interpretation of two very similar photographs. I cannot say that I pre-visualized either image, since I did not know how the film would respond to the treatment it received in the tests. Both images are the result of post-visualization when I made a proof print and, after some consideration, decided how I would interpret them. I thought that a warm tone would suit this print and set out to introduce the appearance of a charcoal drawing by making the print on Ilford Warmtone VC fibre paper.

**The Buttermere Pines**
*Made in the same location and on the same day as 'Tree, Buttermere', this print shows how a different paper and treatment can introduce some significant change in the final result.*

35MM ILFORD DELTA 3200 RATED 25,000 ISO, DEVELOPED IN AFGA RODINAL 1 TO 10 FOR 14 MINUTES AT 20°C; PRINT MADE ON ILFORD WARMTONE VC FIBRE PAPER WITH GRADE 5 DIALLED INTO THE CONTRAST CONTROL OF THE ENLARGER, DEVELOPED IN FOTOSPEED WARM TONE AND TONED IN SELENIUM.

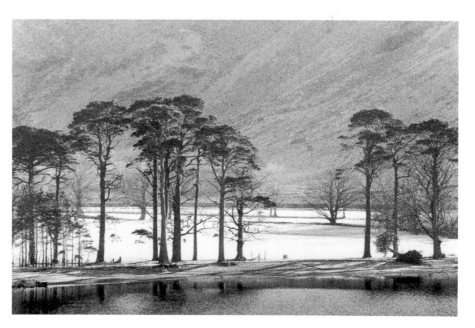

# The Reverend Arthur Llewellyn-Jones

I have made few formal portraits during the years that I have enjoyed a passion for making photographs. When I have been motivated to make a portrait, I have avoided using studios and the paraphernalia associated with them, preferring to use the available light coming in through a conveniently placed window.

I first met Arthur when he officiated at a wedding at which I was a guest; I enjoyed the way he carried out the service and gained the impression that he was a very interesting man. At the reception I was introduced to him and eventually asked if I could make his portrait; he agreed, saying that I was only interested in his lined face. I could not deny that, but told him that I thought his face indicated that he had lived a full life.

I made the portrait in his study, using a window to his left as the main light source. My old Minolta Autocord loaded with Kodak Tri-X was set up on the tripod, with a long cable release attached so that I could detach myself from the camera. As we sat and chatted, I used the cable release to make exposures when I saw an expression or reaction that I liked. The image here was made as he responded to a call from his wife, who popped her head around the door to ask if we wanted tea or coffee and Arthur turned to look in her direction. I spent a fascinating afternoon – not making photographs, since I exposed only eight frames, but listening to him talk about his life and interests.

I learned a lot that afternoon about making photographs of people, probably the most useful point being that communication and conversation are more important than exposing many rolls of film. Arthur is truly an exceptional man.

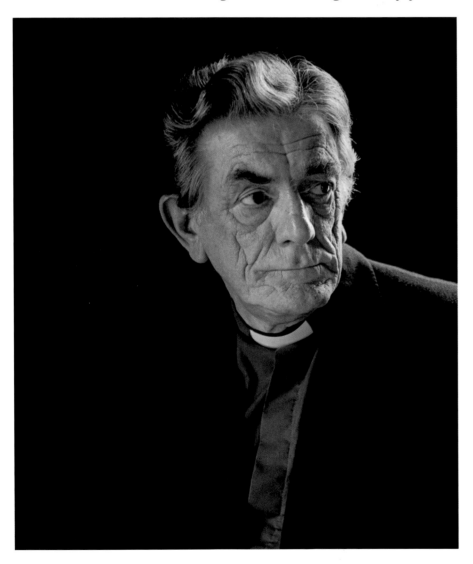

**The Reverend Arthur Llewellyn-Jones**
*The low-key print that I pre-visualized using available window light. The portrait session was a success because we both relaxed by having an enjoyable conversation. The print was passed through a two-bath developer to help deal with the bright highlights on Arthur's hair and face.*

120 KODAK TRI-X, DEVELOPED IN HC110 1 TO 31 FOR 6 MINUTES AT 20°C; PRINT MADE USING ILFORD WARMTONE VC FIBRE PAPER USING SPLIT-GRADE PRINTING, DEVELOPED IN FOTOSPEED GRADE SELECT TWO-BATH AND TONED IN SELENIUM.

# Dead Lilies (Homage to Blakemore)

For nearly 20 years I have been influenced and helped by John Blakemore, a photographer known for the vision that is inherent in his exquisite black-and-white prints. John has quietly guided me through one or two difficult periods in my photography and I think it is time that I said thank you to him. I made this image in 1994: if you look closely, you will see the date on the *Sunday Times* newspaper that was used as a background for the lilies. John had been making photographs of tulips for some time and they were the inspiration for this image. For some years I had been making photographs of single lilies, but had never attempted to set up a complex arrangement such as this one.

When I photograph flowers, I often let them dry naturally and keep them in boxes for future use, and that is why I had these dying lilies when I came to make this image. I placed the arrangement on a table directly in front of a window that had a net curtain hung up to diffuse the light. The contrast

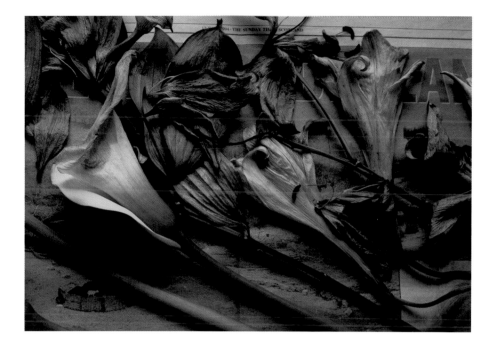

was normal, and the film was exposed and developed accordingly.

When I set up the photograph I visualized quite a delicate high-key print, but when I made the print I thought that it was weak and uninteresting and decided to try a different tonality. I made a number of proof prints from mid-grey in tonality to very low key, and decided on the interpretation shown here. I made the print on Ilford Warmtone VC fibre paper using my split-grade printing method (see pages 81–4).

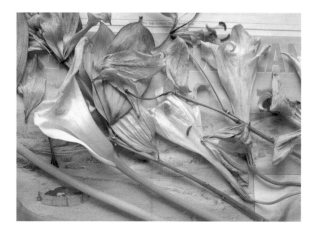

**Dead lilies (homage to Blakemore)**
*Final post-visualized print. Compare this with the untoned version to see the effect of the split toning in selenium and gold.*

120 ILFORD FP4, DEVELOPED IN ID11 1 TO 1 FOR 9 MINUTES AT 20°C; PRINT MADE ON ILFORD WARMTONE VC FIBRE PAPER USING SPLIT-GRADE PRINTING, DEVELOPED IN FOTOSPEED WARM TONE AND SPLIT-TONED IN SELENIUM AND GOLD.

FAR LEFT
*Untoned version.*

LEFT
*Pre-visualized version.*

FILM AND PRINT DETAILS AS FOR THE FINAL PRINT.

# Entrance, Antelope Canyon

I first saw photographs of Antelope Canyon, Arizona, in *Visual Symphony*, a book of photographs by Bruce Barnbaum, and was immediately captivated by the shapes, textures and quality of light. That was in 1986, and I had to wait five years before I was able to enjoy the experience of walking into Antelope Canyon to see these qualities at first hand.

The shapes, textures and light are truly amazing, and it seems to me that photographs are there to be made wherever you look.

The first photograph I made was of the entrance shown here and I used my Mamiya 645 with the 80mm Sekor lens. When I metered the darkest shadow with my old analogue Soligor spot meter the needle barely moved, such was the lack of light in that area. On the other hand, when I metered the brightest highlight the needle flew past the top end of the scale, an indication that I was dealing with something like 16 stops of contrast.

I visualized an image that would show the intensity of light together with an impression of luminosity in the darkest shadow, and felt that this combination would demonstrate the shapes and textures so evident in the canyon. I did not want any blocked-up shadows in the final print if at all possible, so I metered the darkest shadow on the left and gave an 8-minute exposure based on that reading, and then marked the film for −2 stops development (see pages 22–4). The negative is still underexposed in the shadows despite the long exposure, although there is sufficient detail there to show in the print.

I made the print using my split-grade printing method, but did employ some selective burning and dodging between the two grades

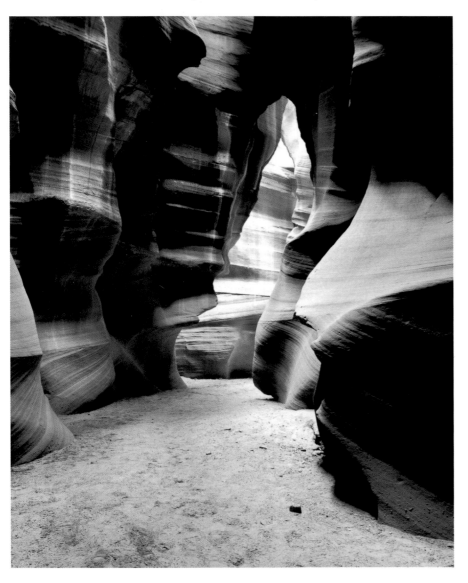

**Entrance, Antelope Canyon**
*Final print from quite a difficult negative. Because of extreme contrast this print was post-flashed, passed through a water bath, and had selective burning and dodging on both grade 0 and grade 5. Compare this print with the pilot print showing straight hard and soft exposures.*

120 Ilford FP4, developed in ID11 1 to1 for 6 minutes at 20°C; print made on Ilford Warmtone VC fibre paper using split-grade printing, developed in Fotospeed Warm Tone and toned in selenium.

(see pages 81–4). I first determined the two base exposures needed and made a pilot print; when I assessed it, I felt that the shadow area on the left was too dark and almost totally blocked, so I had to reduce the exposure in that area. Split-grade printing gives you the option of burning and dodging on either hard or soft filtration and therefore allows for quite subtle changes in tonality and contrast. In my description of split-grade printing in chapter 4, I stated that the soft filtration takes care of the highlight tonality and the hard filtration introduces the contrast and density, so it is logical to reduce the exposure of the hard filtration when less print density is required. However, if you reduce the exposure given to hard filtration to reduce the density you will also slightly reduce the contrast, but reduction of the soft filtration will reduce only density and is likely to increase the final contrast. I do not advocate the same approach to every print where this is a problem, but I regularly make subtle changes throughout a print by selectively reducing and increasing either soft or hard filtration. The flexibility of split-grade printing makes it a powerful tool, for it will provide options and control not available when using a single grade.

Despite applying a 2-stop reduction in the development, some of the highlights still required considerable manipulation by burning in with soft filtration and the application of post-flashing – see the burning and dodging plan for full details. The most difficult of these highlights is at the top of the image, where the savage Arizona light floods into the canyon. I could have used only image-forming soft filtration to reduce the brightness of this highlight, but the final result would have been unacceptable because the surrounding darker tones would probably have blocked up before the highlight reached the desired tonality. When post-flashing is applied to these areas the highlights are noticeably darkened, but it has little effect on the lower values. Post-flashing in this way is a technique that I frequently use to deal with unavoidable and relatively unimportant highlights.

**Entrance, Antelope Canyon**
ABOVE RIGHT
*Burning and dodging plan. Base exposure soft filtration 25.4 seconds, hard filtration 16 seconds.*

RIGHT
*Pilot print, with no burning and dodging on either grade.*

FILM AND PRINT DETAILS AS FOR THE FINAL PRINT.

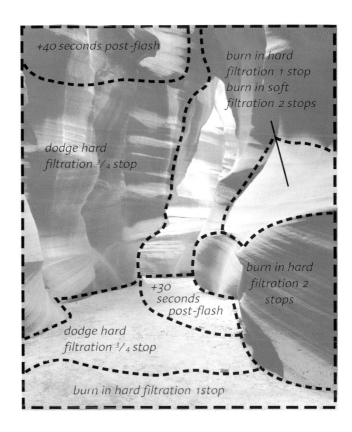

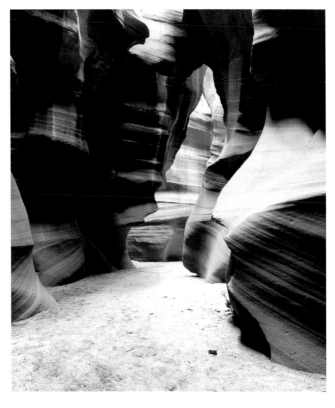

# Transformation

I have made many photographs where water is the subject or a strong supporting element, and have always felt that it can provide elegance, impressions of power and mystery, and simple beauty when it is included in the image. For many years I searched for a combination of rocks with water, to photograph what I saw in my mind as a transformation. Over time, I made several negatives when I thought that I'd found the right combination, but all were failures. I was leading a workshop in Scotland when I found the combination that I knew would provide the elements for which I'd been searching to convey my impression of transformation. I was exploring an area around a small stream that was full following several days of heavy rain, when I saw the rocks emerging from the water and knew that the combination was perfect for my visualized image.

I placed the tripod as near to the edge of the stream as possible, set up my Mamiya 645 fitted with the 80mm Sekor lens and framed up the image. I metered the dark rock and reduced the indicated exposure by 1 stop, my normal practice (see pages 20–2). I determined that the contrast was normal by taking a meter reading from the whitest water in the stream and counting the stops back to the shadow reading. Because the photograph was made very early in the morning the light levels were quite low, so the conditions dictated the exposure of 4 seconds that contributed to the feeling of the final image by creating the soft, cotton-wool appearance of the water.

The print was relatively simple to make using split-grade printing (see pages 81–4), and I only had to burn in the top left area of darker water and rock. I chose to use only grade 0 to carry out this burning in, to produce a softer appearance in the amorphous rock just along the surface of the water as it cascades over a hidden ledge. If I had used grade 5 to burn in, it would have increased the contrast and produced a harder edge to that area, which would have been unacceptable.

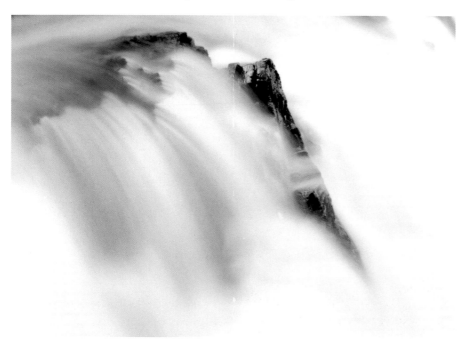

**Transformation**

*I made this photograph with impressionism in mind and it is not intended to be a depiction of water cascading over rocks. The image succeeds for me, because the dark rock that is clear of the water – the only part of the image that is sharp – represents transformation, and in my imagination has changed its form as it emerged.*

120 Ilford Delta 100, developed in ID11 1 to 1 for 9 minutes at 20°C; print made on Ilford Warmtone VC fibre paper with grade 5 dialled into the contrast control of the enlarger, developed in Fotospeed Warm Tone.

# Slate Quarry

The English Lake District can be a very rewarding location when looking to make landscape photographs, but the lakes are there because it rains frequently and this sometimes makes photography virtually impossible. This image was made when I was spending a week on a photographic holiday near Lake Coniston. It rained every day – and I do mean rain.

The only day on which I ventured any distance from the house I had rented was to visit an abandoned slate quarry not far away. My thinking was that wet slate could be an interesting photographic subject. I made a few exposures when I reached the quarry, but the rain clouds were so heavy that the light was dim and the contrast range little more than 1 stop. Just as I was leaving, I noticed a fairly large hole at the bottom of a slate rock face, and when I inspected it I found that it was the entrance to a tunnel leading down into slate below ground. It was not high enough to walk down, so I crawled in on my hands and knees until I reached the end, some 10m (30ft) down.

The rainwater was running through the ground, into the tunnel and down the slate, making the conditions quite unpleasant, so I decided to get out and return to the house.

When I turned and looked back, the low light that was available lit the wet slate facing the entrance, generating quite a bit of contrast and providing significant separation in the rock. I decided to make a photograph of the wet slate, so set my Minolta Autocord on the tripod and framed the image shown here. I cannot remember how I metered the subject, but I do know that the exposure was

**Slate quarry**
*Print showing the result when the highlight received over 10 stops of burning in with soft filtration only.*

FILM AND PRINT DETAILS AS FOR THE FINAL PRINT.

**Slate quarry**
*Final print, showing how post-flashing and burning in on grade 5 can deal with a difficult highlight.*

120 KODAK TRI-X, DEVELOPED IN HC110 1 TO 31 FOR 8 MINUTES AT 20°C; PRINT MADE ON ILFORD WARMTONE VC FIBRE PAPER USING SPLIT-GRADE PRINTING, AND DEVELOPED IN ETHOL LPD.

**Slate quarry**
*The pilot print, given both soft and hard exposures using split-grade printing but with no burning in or post-flashing. The difference between this and the final print is made by the post-flashing.*

FILM AND PRINT DETAILS
AS FOR THE FINAL PRINT.

several minutes. After making this photograph, I left the quarry and returned to the rented house, to spend the remainder of the holiday making photographs of most of the artefacts contained in it.

When I processed the film, I totally forgot that I had made one exposure on the roll that had more than 1 stop of contrast, and increased development by 2 stops in an attempt to salvage something from a disappointing week. When I inspected the dry film, the only image worth looking at was the wet slate, but the increase in development had pushed the negative density in the slate to serious levels. I did try to make a print on graded paper, but it was almost impossible to get any detail into the brightest highlight in the wet slate, even when I pre-flashed the paper and used two-bath development, so I consigned the negative to the filing system.

When I started to use the post-flashing technique (see pages 80–1), I thought of this image and made a print using that method to see if I could improve on my previous efforts. The final result was more than satisfactory, as I succeeded in showing the detail in the highlight and also subdued the tonality of all the small, irritating highlights in the image. These can be quite difficult to deal with when burning in with image-forming light.

# Tattoo Man

At the time of writing, body piercing and tattoos are very much in fashion, and while I have no wish to adorn my body with such decoration I am grateful to those who do, for it does help to give some interest in a photograph.

I have led many workshops in candid street photography and found that a good proportion of photographers are hesitant to approach someone who has tattoos and piercing. This is unfortunate, since I have found most people with tattoos to be very friendly and more than willing to be photographed. This man worked in a salon specializing in piercing and tattoos and proved to be an excellent, if somewhat shy, model. I spent about 15 minutes talking to relax him before I started, as I planned to use a 20mm lens on my Nikon F90X to make the photographs and knew that it would be an intimidating experience for him. Normally when I make candid photographs I don't talk to the subjects, as I am usually on the move and do not spend a lot of time in the same place. However, because I stayed in this salon for over an hour I did engage the man in conversation, and at times directed him as if in a studio portrait session.

I loaded the camera with Kodak Tri-X and metered the face, then opened the lens by 2 stops from the indicated exposure. Because

the fluorescent lighting in the salon provided a very flat light for portrait photography, I moved the man into a position away from direct overhead lighting to ensure that the eye sockets did not fall into deep shadow. The background was very bright, but there was little I could do to subdue it other than to burn in when I made the print. However, I did make the exposure with the lens set at f2.8 to throw the whole background out of focus, in order to separate the man from the busy detail behind him.

The print was made on grade 4 Ilford Warmtone to help build the contrast that was not present when the negative was exposed. I did make a trial print on grade 2 Ilford Warmtone as this would have helped when burning in the very bright background, but the lack of contrast produced by that combination was totally unacceptable. In any event, I believe the image needs a strong, low-key print to give the subject a presence, so I had to find another way to deal with the background. I could have used a very soft grade to burn in as I was using VC paper, but this would have resulted in a noticeable difference in contrast between the background and the main subject. Finally, I decided to burn in on grade 4 and then paint with white light around the very brightest areas to the left and right of the head – in effect, I deliberately fogged the highlights just enough to take them down from paper base white.

The final black-and-white print succeeds in showing the tattoo man here as a slightly fearsome character – not at all a true representation of him. It is more of a preconceived notion that many people have of individuals they regard as nonconformist.

**Tattoo man**
*This photograph works in both traditional black-and-white and as a digital image because the subject is so strong. The use of a 20mm wide-angle lens has distorted the face slightly, to produce a more sinister feeling in the portrait. Compare this treatment and final print to the digital version in chapter 6.*

35mm Kodak Tri-X, developed in Fotospeed FD30 1 to 9 for 6 minutes at 20°C; print made on Ilford Warmtone VC grade 4 fibre paper, developed in Ethol LPD.

# 6 Digital Black and White

The growth and development of digital imaging has provided photographers with yet another tool in the search for expression in making black-and-white prints. I do not see it as a replacement for the traditional wet black-and-white methods described in this book, but I do envisage the two disciplines working together to help us produce new hybrid images. I hold the view that they can and will complement each other, and we should learn to recognize and use their respective strengths to take our image-making in new directions. At this stage I have to say that good photographs are always the result of the photographer seeing and responding to situations and light, and Adobe Photoshop and the digital process are simply tools that we use, in much the same way we use a Zone VI VC cold cathode enlarger or a roll of our favourite film.

I write this at a time when digital image-making, using a computer to manipulate and control contrast, has made giant steps forward, but the weakness in the chain is the mechanical process used to make the prints. Using a series of dots to form an image on paper will not produce the same tonality as a silver print. Having said that, the results to be achieved with the equipment and materials currently available are excellent, and I am sure that, given time, the manufacturers will improve their products even further.

**Tree, Monument Valley**
*I have never made a satisfactory traditional print of this image, but when I scanned the original 4x5in negative and worked on it in Photoshop I very quickly achieved the pre-visualized print. I guess this must be a victory for Photoshop over the traditional wet darkroom.*

## Modern-day Rasputin

*My wife and I were enjoying Christmas lunch and a stimulating conversation with Mike and his parents Fred and Joan, when I made a point that differed from Mike's view and he gave me an icy stare. Instead of responding with a counter point, I asked him if I could make his portrait after lunch, as I had seen a 'modern-day Rasputin' in the look. I visualized a stark, high-contrast print, and exposed and developed the 4x5in negative accordingly. The black-and-white traditional print was made on grade 5 Agfa Brovira, sadly now obsolete, and I bleached the face to almost paper base white. I have not made a print from that negative for many years and thought that it would be a suitable subject for digital manipulation, so I went into my old files to find the negative and was shocked to detect a hint of deterioration, so I now had a more important reason to commit the image to the digital process. This version required very little work to reach the desired result: I simply adjusted the contrast until I had just a slight hint of tone in the skin.*

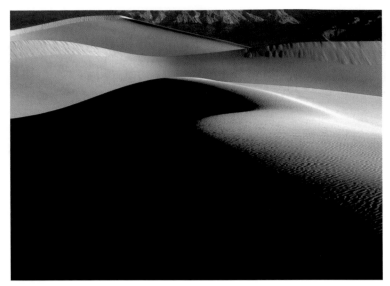

**Dunes, Death Valley**

ABOVE LEFT
*The original photograph was made on 120 Fuji Velvia transparency film using my Mamiya 645.*

ABOVE RIGHT
*The colour transparency converted to black and white from the original RGB scan.*

My approach to making digital images is to avoid trying to repeat what I can do in the darkroom using conventional materials, but to explore the medium to produce images that are different from the traditional black-and-white photograph. In any event, even though black-and-white prints made using inkjet equipment and materials are high quality, they cannot yet match the traditional silver print.

## Organizing Your Work

Before we explore the image-making benefits offered by Photoshop, I think we should look at working methods and the organization of your files. You can soon find yourself in an administrative mess and waste a lot of time locating images if you don't set up a simple system of directories and work flow.

I have a master scan file for both colour and black-and-white images and save every scan as soon as it is completed. When the scanning session is finished, I access each file and carry out any retouching that is required – then never again use it to work on. When I access the file to carry out any manipulations and other work, I make a copy of the original file, rename it and save it to a work file directory; again, I have one each for colour and for black and white. When the work on the image is finished, including sizing, I save it to a completed image directory, so that it can be accessed quickly when I wish to make a print.

When I am working on a project or assignment, I create the above system of directories and use them for the duration of the work, saving them to CD when the work is completed. I also regularly save to CD both the scans and finished files of my personal images, so that I can free up disk space in the computer.

## The Digital Negative

One step in the direction of creating the marriage of traditional wet photography with digital is to use Photoshop to produce an inkjet negative and make prints using alternative processes, such as cyanotype,

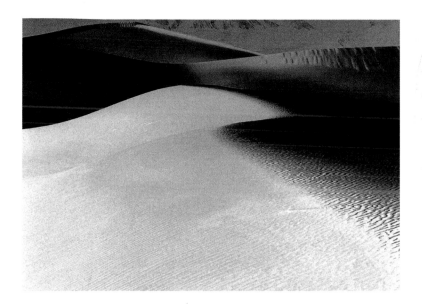

that generally require a negative higher in contrast than is needed to make a traditional silver print. Until we had the benefits of Photoshop, photographers using the alternative processes had to make silver negatives solely for that purpose, or go through the tedious process of making copy negatives from an original. Using Photoshop to create negatives for the alternative processes is a relatively simple operation, and they can be made from colour negative or transparency, and black-and-white negative originals.

# Dunes, Death Valley: Making an Inkjet Negative

For this example, I used a transparency saved in a pre-determined directory. I name a directory for the storage of scans and file the original scan here, then make a copy on which to carry out adjustments. I use the following procedure to make digital negatives.

**To make a digital negative**

1 Scan the original transparency or negative at 300dpi as RGB (red, green, blue) and save.
2 Make a copy and adjust it to the desired size in Photoshop. Remember that you will be making a contact print, so set the size accordingly.
3 If you are using colour, convert to black and white: click on image>mode>grayscale.
4 Convert to negative: click on image>adjust>invert.
5 Adjust the contrast to the required level: click on layer>new adjustment layer>curves.
6 Save.

Because of the negative contrast required to make a cyanotype or argyrotype print, when you first use this method a little trial and error is required to produce the right density and contrast in the negative. Once you have made a few negatives, you will soon learn to adjust the contrast to the correct level at the first attempt.

**Dunes, Death Valley**

ABOVE LEFT
*Inkjet negative.*

ABOVE RIGHT
*Cyanotype print made on watercolour art paper from the inkjet negative.*

To produce the negative, the file is printed out on OHP inkjet film. I use an Epson 1290 printer and set the output to 2880dpi to ensure the best print quality and minimize the possibility of detecting any pattern of dots. For the best results, use the printer on colour setting. Although you can use it on the black-only setting, there is an increased possibility of seeing the dots.

When manipulating the image, you do have the option of adding a small amount of random grain, which helps to break up the uniform pattern of dots. I usually do this using the first of the following two options:

1 Click on filter>noise>add noise, then click the box marked Gaussian grain and add not more that 5 per cent – that is, just enough to replicate the grain of a film such as Kodak Tri-X.
2 Click on filter>texture>grain and set the intensity to not more than 10 but leave the contrast at the default setting of 50.

The inkjet negative is a practical choice as a replacement for the silver negative in the alternative processes, but you must expect to see different results. The silver negative is a continuous tone and will produce a smoother print than an image printed on the inkjet OHP film supplied worldwide by Permajet.

# The Digital Darkroom

The limitations of the inkjet printing process dictate to me those images that I can scan and manipulate in Photoshop, and use to make successful inkjet prints. The problems lie in printing the most delicate highlights in the image, for it is asking a lot of the printer and grey inks to put down a white just above paper base. Consequently, I choose the images that I use in the digital process with great care, avoiding at all costs large areas of very bright highlights, although I don't mind very small highlights that are paper base white.

When I decide to make a digital print, I start from the same point as I do when making a traditional black-and-white print: I visualize the image and then find a way to create it in Photoshop, just as I would when working with chemicals in the darkroom. I think it is important that we remember the skills and discipline we have used in the chemical darkroom for many years and apply them to making digital images. My instincts tell me that the two disciplines each stand alone, but we should also look to combine them to widen the scope of black-and-white photographic art.

# Tattoo Man: Making a Black-and-White Digital Image

I make most of my digital prints from traditional black-and-white negatives, although I do occasionally use both colour negative and transparency material. The image used here was generated from a 35mm negative made on Ilford Delta 3200 film, scanned at 300dpi in RGB mode on an Imacon Flexitight Photo film scanner and saved to my master scan file. I prefer to keep my original scans low in contrast, as I find that building contrast in Photoshop gives me more control and flexibility.

I copied the original file and converted it to grayscale, then created a layer to adjust the image to the required contrast (click on layer>new adjustment layer>curves). I carry out all adjustments using individual layers for each step, as this allows me to switch between layers to see how the manipulations are affecting the image. This method also allows me to dump a layer if I don't like the result or if I make a mistake, without losing any work done up to that stage.

## Burning and Dodging

I knew that the image I visualized required considerable burning in to deal with unwanted highlights, so I adjusted the contrast to suit the skin tone. The next step deals with the burning in itself.

Photoshop is equipped with a burning and dodging tool, but I prefer to use a new layer and the airbrush tool. Click on layer>new> layer, and the new layer box will be displayed. Click on the mode box, select 'soft light' and click on the bottom box to display 'fill with soft-light-neutral color 50% gray'. This creates a layer filled with mid-grey: to burn in using this layer, set the background colour to black; to dodge, set the background to white.

Any of the painting tools can be used to burn and dodge, giving you absolute control over the process. This method works because you are adding density to the layer when burning in or subtracting density when dodging. The degree of burning or dodging is controlled by inputting a value in the pressure box displayed when you select airbrush from the toolbar: a higher value produces darker tones when burning in and lighter tones when dodging. Because I prefer to build tone gradually, I use lower values in the pressure control

situated on the toolbar. The control allows you to input a value up to 100 per cent, but I rarely use it so high. You will soon learn what works for you as you practise using the airbrush. The method also allows you to use as many layers as you wish to burn and dodge, which means you can apply small amounts in each layer

**Tattoo man**
*The original scan made on an Imacon Flexitight Photo from a 35mm negative on Ilford Delta 3200.*

until you reach the desired tonality. You will need to practise this method to help you determine the values that work for you.

To carry out the burning in I created a new layer, identified as 'burn 1', and selected a 300pt airbrush that allowed me to burn in the bulk of the background quickly. I then selected a smaller point-size brush to burn in the fine detail in order to tidy up the areas around the face. The overhead lighting produced dark shadows in the eye sockets, so I lightened them by creating a new layer and dodging them as described above. At this point I made a print to assess the effect of the manipulation and decided that the skin tone of the face was too dark, so I used the lasso tool to isolate the head and adjusted the contrast by tweaking the curve.

The final step that I carry out on all images is to sharpen the image using the unsharp mask filter. Click on filter>sharpen>unsharp mask and adjust as required, although you should take care not to overdo the amount input as it can produce too much noise and unpleasant edge effects in the final print. I keep the amount value as low as possible but never more than 80 to 100, with the threshold value around 1 to 1.5.

## Using the Gradient Tool to Simulate Flashing

The bright highlights in the background on both sides of the head were particularly difficult to deal with as they are quite small. I used a smaller brush size to give me more accuracy and take the tone down a little, but I prefer to use the gradient tool, which is similar to using the flashing technique that is so effective when making traditional black-and-white prints. This process is carried out on another layer: click on layer>new>layer and use the lasso tool to isolate the area on which you are going to work. To soften the edges and blend them with the surrounding area, click on select>feather and the feather selection box will be displayed. I usually choose 10 to 20 pixels in the feather radius box and find that the blending is invisible.

To apply the flashing effect, click on the gradient tool and then on linear gradient on the toolbar at the top of the display and set the background to black. You can change the light source by selecting your choice in the mode box on the toolbar – I generally use either soft or hard, and occasionally normal. You now need to decide on the degree of opacity you wish to use: click on the opacity box on the toolbar and input the required value. The display is shown as a percentage and I suggest that you start with a lower value and practise until you get the hang of it. The final step is to click and drag inside and across the area selected with the lasso tool. The tone you are applying is graded from dark to light, so to make sure that it covers the whole of the selected area you need to drag beyond the limit of your selection with the lasso tool. You can also change the effect of the gradient tool by clicking and dragging in different directions from your starting point.

I darkened the highlights in this image by applying the gradient as described several times, using only 5 per cent opacity to build up tone gradually in the whole area. The benefit of using the gradient tool in this way is that it affects highlights more significantly than the darker tones and maintains separation throughout the area on which you are working. Once you have mastered the method it is quick and easy to apply.

**Tattoo man**

TOP LEFT
*Adjusting contrast on new adjustment layer*

TOP RIGHT
*Creating burn 1 layer.*

MIDDLE LEFT
*Burning in on burn 1 layer on airbrush setting with large brush size.*

MIDDLE RIGHT
*Burning in small highlights on burn 1 layer on airbrush setting with small brush size.*

BOTTOM LEFT
*Burning in small highlights on burn 2 layer on airbrush setting with small brush size.*

BOTTOM RIGHT
*When I made the first print after carrying out the manipulations, I decided to dodge the eye sockets as I felt they were too dark. This shows the effect of the dodging seen on dodge 1 layer.*

## Tattoo man

**TOP LEFT**

*Dodge 1 layer switched off.*

**TOP RIGHT**

*In the first print the skin tone was too dark, so I lassoed the head and then adjusted the contrast.*

**MIDDLE LEFT**

*Lassoing the right-hand highlight to apply gradient.*

**MIDDLE RIGHT**

*Setting the pixel selection for the feather radius.*

**BOTTOM LEFT**

*Completed print with all layers switched on.*

**BOTTOM RIGHT**

*Layer 2 gradient switched off.*

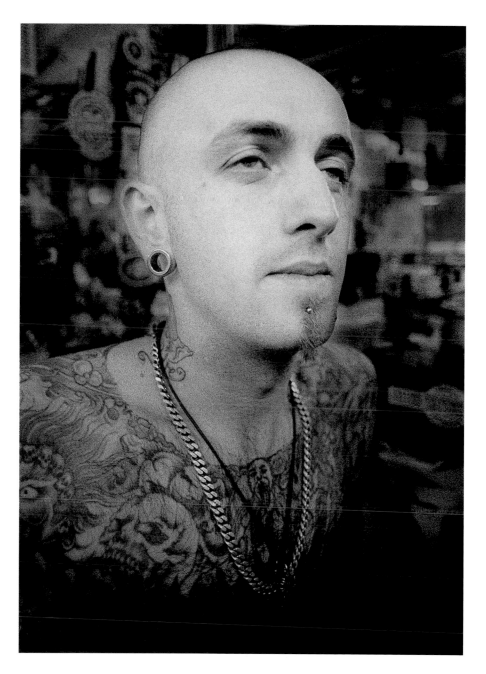

**Tattoo man**

TOP LEFT
*Layer 2 gradient, burn 2 layer switched off.*

MIDDLE LEFT
*Layer 2 gradient, burn 2 layer and burn 1 layer switched off.*

BOTTOM LEFT
*All layers switched off.*

ABOVE
*Final print*

# Nude Dune, Death Valley: Where Photoshop Beats the Wet Darkroom

The power of Photoshop as a creative tool is considerable, but we have to remember that it was originally produced for use by the graphic design industry. Consequently, there are many tools in there that can divert the photographer's attention away from producing black-and-white images and into the world of gimmickry. I think Photoshop has much to offer the black-and-white photographer as a creative tool, but we must apply discipline and avoid the many choices available that are not designed for fine art images. Having said that, I have found a couple of filters that have enabled me to produce images I cannot make in the conventional darkroom.

This image, already seen on page 48, provides an example of how Photoshop helped me to introduce a significant change in the final print. This is one of my favourite landscape photographs and, as I explained in chapter 2, the high-key image was post-visualized, as I had pre-visualized a very dark print when I made the exposure. I decided to make a high-key digital print, similar to the final traditional print but using one of the textured art papers available for digital printers as I thought that it would suit the image. I like these papers and there is no comparable paper available to use when making silver

**Nude sand dune**
*Original scan from 645 negative on 120 Ilford Delta 100.*

prints. As I was carrying out adjustments to the digital file, I decided to change the tonality at the top and bottom of the image and very quickly produced the result for which I was looking.

Having scanned the negative and adjusted the contrast and tonality, I clicked on the magic wand tool on the toolbar and clicked on the mid-grey tone at the top of the image to achieve a very precise capture of that area. I wanted to darken the whole area to full black and decided to use the brightness/contrast control (click on image>adjust>brightness/contrast) as the quickest and least complicated method. By reducing the levels of both I realized the desired result. I used the same method to deal with the foreground sand, but because I wanted to hold some detail I reduced brightness and increased contrast. I never use the brightness/contrast control to deal with the normal contrast requirements when adjusting an image, as it is a linear control and simply makes all tones either lighter or darker, but it proved to be ideal for this application.

## Adding Grain to Mask Highlights

When I made the final print, I noticed a small highlight of very delicate tonality at the top left side of the image. A useful way to mask this weakness is to add a very small amount of grain to the highlight, which also adds tone and the impression of detail. Use the lasso tool to isolate the area where you wish to add grain, then click on filter>noise>add noise and a box will be displayed. Click the Gaussian box and adjust the amount – 4 or 5 per cent should be sufficient to add just enough grain without it being obvious. Because you are

**Nude sand dune**
*This view shows how the magic wand tool lassos an area and creates a clean edge.*

*The settings used in the brightness/contrast control to darken the top of the image.*

*The settings used in the brightness/contrast control to darken the bottom of the image but retain a hint of detail in the rippled sand.*

## Nude sand dune

RIGHT
*Using the lasso tool to isolate the bright highlight in readiness to apply grain.*

FAR RIGHT
*The add noise box, showing the amount and type of grain added.*

BELOW
*Final print.*

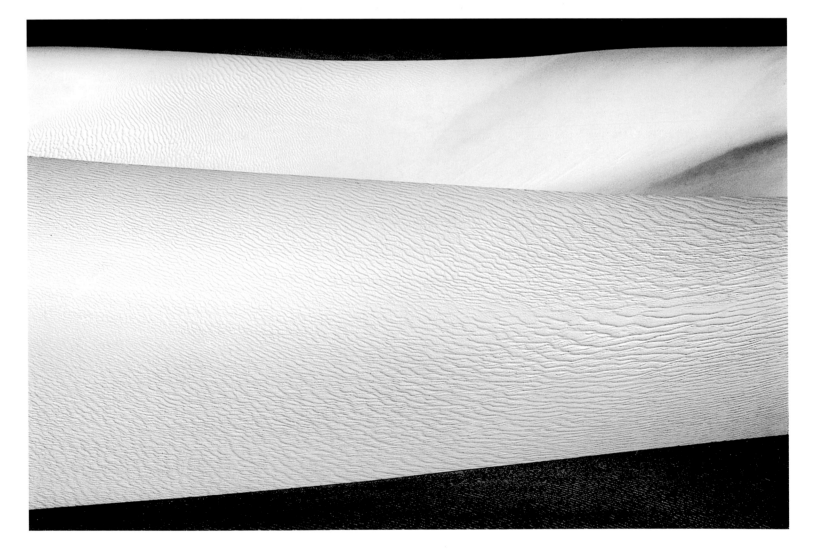

adding grain in one area only it is essential that you apply a very small amount, otherwise it will look obvious and unnatural.

The final digital print adds another dimension to the image that I could not reproduce in the wet darkroom. No matter how carefully any burning in is carried out on a traditional black-and-white print, it is impossible to match the accuracy of Photoshop in masking the areas darkened in this image, and some light spillage into surrounding areas is inevitable; consequently, a clean edge between the two tones cannot be achieved in the darkroom.

Since I made the digital print on Lyson Standard Fine Art paper and using Small Gamut inks, I prefer the digital version to the traditional black and white. I am also encouraged that Photoshop and digital imaging have provided me with another tool to produce a third visualization of the same subject, from the same negative.

# Flower Stem: Motion Blur

I discussed the use of movement in creating expressive negatives and images on page 62, but it is created in the camera and there is little chance of introducing it effectively in the darkroom. Photoshop includes a motion blur filter that does provide limited opportunity to create movement without the final result looking false and contrived. Provided the choice of image is right, the filter is used with care and sensitivity, and it is not overdone, I believe that the end result can work.

I made the original negative of this tulip many years ago and have never achieved a

**Flower stem**
*Original scan, modified in readiness to apply blur.*

*Blur applied as described in the text.*

*Blur applied in the wrong direction, as described in the text.*

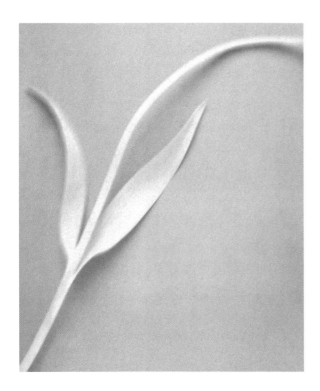

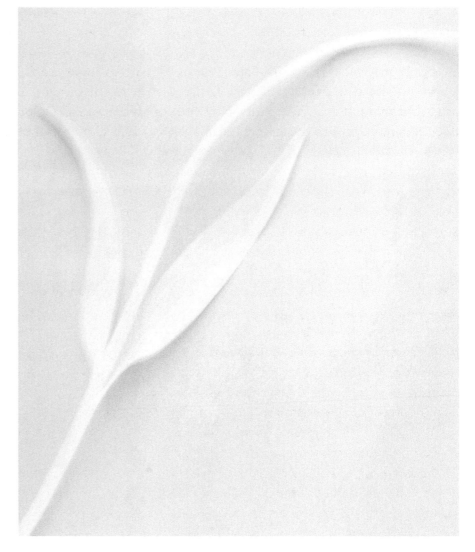

**Flower stem**

ABOVE
*Blur applied before the contrast is adjusted.*

RIGHT
*Final print after the contrast has been adjusted.*

satisfactory traditional black-and-white print, despite printing the image in a number of different ways from very high key to low key and in high and low contrast. I always came to the conclusion that it needed another element for it to have any chance of succeeding. I decided to try to introduce that element in Photoshop by adding movement into the image.

After scanning the 4x5in negative, I made a preliminary adjustment to the contrast using the new adjustment layer. I had visualized an extremely delicate high-key print to

be made on one of the art papers, but if the contrast and tonality had been adjusted to the correct levels I would have been unable to apply the motion blur because I could barely see the image. I discovered this by adjusting the contrast and tonality to the correct levels on my first attempt.

Click on filter>blur>motion blur to display the motion blur box, and by adjusting the angle and distance you can change the direction and degree of blur to suit your visualization. When I use movement in any

image, I usually try to include something that is sharp, and I felt that it was essential here. By adjusting the angle control to match the direction in which the right-hand leaf is pointing, I could retain just a hint of sharpness. Changing the angle to the opposite direction introduces total blur and the image just looks out of focus. Finally, I adjusted the contrast and tonality to the required levels using a new adjustment layer and made the print on Lyson Standard Fine Art paper with Small Gamut quad inks.

## Some Thoughts on Printing

Unlike traditional black-and-white printing in the darkroom, where we can exercise some control as we rock the tray and watch the image appear and develop, the digital print cannot be controlled once the process has started. It is fair to say that controls similar to those we apply in the wet darkroom are available to us in Photoshop, but the whole process of making digital prints has to be much more disciplined if we are to produce the best possible end result.

When I make traditional wet prints I frequently make snap judgments and pull prints before they have had full development, or increase development beyond the time I gave the test strip. These decisions are based on experience and the fact that I can observe the image and apply a judgment that will affect the print. Digital printing does not allow for that creative luxury, although Photoshop does give us the great benefit of seeing the image on a screen before we commit it to the print. However, there is still the problem of

getting on the print what we see on the screen and that involves using a calibration system, which can be expensive and, according to some people, not really successful.

At the time of writing I have not committed myself to purchasing an expensive calibration tool, because of contradictions in the advice I have been given. I have taken the trouble to use the calibration system built into Photoshop and found that it did improve the output to match what I saw on the screen. I have also applied the years of experience I've had in the darkroom in making judgments under safelight conditions. When you think about it, every time you make a black-and-white print you make a judgment based on a test strip, then develop the image in chemistry that is subtly changing as it ages, and sometimes make a second judgment as to whether to pull it or leave it to develop further. I consider these disciplines and judgments to be no more difficult than those to be made in digital printing. In selecting the papers and inks we use to make digital prints we have the chance to introduce a degree of control and consistency, by making sure that we obtain and use the proper profile that matches both products.

## The Way Forward

I have enjoyed sharing my passion and skills with you through the pages of this book, and hope that you have learned new techniques that will help you to see and make fine black-and-white prints. I trust that the methods and techniques are described in understandable and logical terms, but most of all I hope that you have been motivated to make black-and-white photographs and prints, no matter

whether it is in the traditional manner or by digital capture and output.

As we entered the twenty-first century, photography had begun to feel the effects of perhaps the most significant changes in image-making since 1839, when Henry Fox Talbot first fixed an image on a piece of paper. Instead of capturing an image on film or paper and using chemicals to make it live, we are now faced with electronic capture and storage; instead of using words such as film and variable-contrast paper, we now talk of pixels and digital files. The world of image-making is embroiled in massive change, and many photographers are frightened and confused as to where it will eventually take them. I know the feeling, as a few years ago when I first saw and talked about this new way of making photographs I too experienced fear. However, when I thought about it I realized that it was no more of a threat to my beloved black-and-white photography than Fox Talbot's discovery of fixing the image was to the painters of his day.

The dedicated traditional black-and-white photographers will still make fine silver prints, hopefully using some of the techniques described in this book. Certainly, interest in the traditional methods will decline to some extent, but they will not disappear. I believe that wet black-and-white photography will integrate with digital photography to produce a new way forward in seeing and recording images. At the same time, both will continue along their own road, as the manufacturers of digital equipment and consumables find new ways to capture and store pixels and, perhaps most importantly, improve the method of making the final print or even invent a complete new system. I wonder if 2039 will prove to be as significant as 1839 was to the world of image capture, and the fascinating passion for making fine black-and-white prints.

**White Mountains, California**

*This print was made from a colour transparency scanned in RGB and converted to monochrome in the channel mixer, then printed on an Epson 1290. I chose to make the print using only the black ink, because the lightest tone in the image is just above mid-grey so I did not have to worry about how the printer would deal with a very delicate highlight.*

## Pepper Erotica

*Seeing and making black-and-white photographs is a passion that I have always taken seriously, but I have also made sure that I never lost sight of the need for it to be fun. This image is my homage to Edward Weston, one of my top three favourite photographers, therefore I treated the making of this photograph very seriously but at the same time had great fun. I spent weeks looking for a distorted pepper, and when I found this one the local greengrocer thought I was crazy to want to photograph it, and even more crazy because I thought it looked like a female nude – subsequently he didn't charge me for it. I spent a few hours making photographs of it with my newly acquired 4 x 5 MPP field camera and learned a great deal about large format photography as I did so, but I also had great fun finding angles and using the available light to create the image I wanted. When I took the contact print of this negative to show the greengrocer the fruits of my labour he thought that it was a nude study – we had a great laugh when I told him that it was the pepper he had given me the previous week and that after making the photograph I ate it in a salad and really enjoyed it. Pepper Erotica is not the best photograph that I have ever made, but every time I view it I am reminded that we should not lose sight of the need to smile as we make our photographs.*

Film 4 x 5 Ilford FP4 developed in ID11 1 to 1 for 10 minutes at 20°C. Print made on Fotospeed Lith paper processed as a normal full-toned black-and-white print instead of in lith developer, developed in Fotospeed Warm Tone.

# Acknowledgments

I wish to thank the following companies who have supported me with materials and equipment:

Calumet UK
Focal Point
Fotolynx
Fotospeed
Ilford Imaging UK Ltd
Lyson
Nova Darkroom Products
Permajet
Photon Beard
R H Designs
Silverpoint Ltd
The Studio Workshops

I would like to thank the following people who have helped, supported and encouraged me in my photographic endeavours and in writing this book.

John Blakemore
Peter Bowerman
Stephen Brierley
Claire Bruce
Ian Callow
Anne and Henry Cassidy
William Cheung
Richard Collins
Mike de Vorchick
Ian Edwards
Catherine Fehilly
Ed Gordon
Chas Halsey
John and Jan Herlinger
Sarah Hoggett
Roger Hooper
Iain James
Beverley Jollands
David Kilpatrick
David Lane
Gareth Macdonald
Peter J. Mayhew
David Milne
Richard Newman
Martin Reed
Jim Ritchie
Maggie Ritchie
Jim Walker
Colin Westgate
Dr David Wheeler

Sarah Widdicombe
David Williams
John and Michelle Young

I have to thank the team at David & Charles for their help in guiding me through the writing of this, my first book.

Finally, thanks to my wife Marjorie for her help, encouragement and understanding – not only in writing this book, but in all that I have done and achieved in our years together.

# Index

Illustrations in *italic*

Adams, Ansel 6, 8, 21, 30, 46, 66, 114
airbrush tool 145–6
Antelope Canyon, Arizona 134–5, *134–5*; Chimney *39*
anticipation 65
aperture 16, 41, 42, 60
Ardoyne first communion 118–19, *118–19*
Artog, Wales *60*

background 14, 113, 139, 146
balloon, photographing from 103–5
Barnbaum, Bruce 134
Belfast *49*, 118–19, *118–19*, 126–9, *126–9*
Birmingham *43*
Blakemore, John 6, 30, 133
bleaching 30, 76, 89–90, *91*, 112
blending 146
blur/movement 50, 53, 62, *62*, 153–5
brightness/contrast control 151, *151*
buildings *4, 10, 11*, 22–4, *23–7*, 26, *68*
burning in 72–6, *73–5*, 84, 94–8, 101–2, *101*, 108, 110, 112, 115, 119, 125, 128–31, 134–6, 138, 139, 145–6, *147*, 153

cable release 132
calibration system 155
candid photography 45, 73, 100, 104, 138–9
Caponigro, Paul 6, 30, 66
car headlights *71–2, 82–3*
chair *50–1*
children *46, 49*, 119, 126, *126–9*
clouds *2, 3, 34*, 59, 62
colour 84, 113

contrast 14, 20–5, 30–2, *31*, 35, 43, 48, 50, 54–8 *passim*, 61, 70, 72–3, 76–84, 89, 94, 95, 101, 108, 110, 112–15, 118–20, 124, 134–6, 140, 143–7, 151, 154, 155;
control 76–81
cutlery 14, *12*

Dakota hut 22–4, *23–5*
Damaraland, Namibia *7*
darkroom equipment 70–1, 155
Death Valley *37, 48*, 94–5, *95, 142–3*, 143–4, 150–3, *150–2*
Delaney, John 38, 98
density 20, 22, 25, *33*, 48, 55, 61, 108, 110, 135, 138, 143, 145
depth, of field 41, *42*; tonal 30–2
developer 54–9, 72, 77–8, 84; Agfa Rodinal 56, 58, 130; DD/FF 58–9, *59*, Ethol LPD 14; Fotospeed 72, FD30 59; Ilford Bromophen 72, 77; Kodak Dektol 72, 77; Pyro 55–6; Tetenal Centrabrom S 72, 73, Neofin Doku 55, 119, Neopress 56
development 13, 14, 17–26, *18–19*, 68, 73, *76–7*, 77–8, 114, 115, 155; compensating 54–6; minus 17, *18–19*, 20, 22–4, 55, 134; normal 17, 19–21; plus 17, *18–19*, 20, 24–6, 95, 138; two-bath 77, 120, 138; uneven 22; water-bath 77–8, *78*, 102, 119, 131
digital technology 8, 70, 140–56
dilution, developer 21, 54, 56, 58–9, 72–3, 84, 113, 130, 131
directories 142
distortion 41
dodging 72–6, 94, 95, 98, 101–2, *101*, 108, 110, 112, 129, 134–5, 145, 146, *147–8*
doorways *4, 10, 11*

dry down, print 84–90, *86–7*, calculating 86–7
Dublin *63*

edges 63, *64*, 146
enlarger 70, 79–80, 112, 114, 115, 119
essay, photo 45–7, *46*
exposure 10, 13–17, 20–6, 35, 38–43, 45, 68, 75, 80–8, *82*, 95, *96*, 102, 104, 111, 114, 118, 120, 132, 135–7; multiple 59–62, 96–7, 108, calculating 60–1

feather *30*, radius 146, *148*
film 13–27, 53–4; Delta 3200 58, 100, 131
filters 35–8, *36*, 70, 108; blur 153; Gaussian 151; polarizing 35; unsharp mask 146
fixer 89, 90
flare 122
flasher, print 79, 128
flashing, pre- 76, 78–80, *80*, 124, 138; post- 76, 78–81, 102, 119, 128, 135
flowers *13*, 14, *36*, 113–14, *113–14*, 133, *133*, 153–5, *153–4*
focus 42; auto 44, 49, 128
fogging 79, 131, 139
Fox Talbot, Henry 156
framing 63–4, *63–5*
Friog, Wales *85*

golden mean 63
gradient tool 146
grain 25, 26, 39, 50, 53, 58–9, 68, 100, 102, 130–1, 144, 151, 153

halo effect 74
Harley Davidson *78*
hedgerow 39, 114–15, *114–16*
highlights 12–14 *passim*, 22, *39*, 55, 61, 72, *75*, 77–86 *passim*, 90, 102, 104, 110,